Kathrin Friedrich, Moritz Queisner, Anna Roethe (Hg.)
Image Guidance
Bedingungen bildgeführter Operation

Bildwelten des Wissens
Band 12

Kathrin Friedrich, Moritz Queisner, Anna Roethe (Hg.)

IMAGE GUIDANCE
Bedingungen bildgeführter Operation

DE GRUYTER

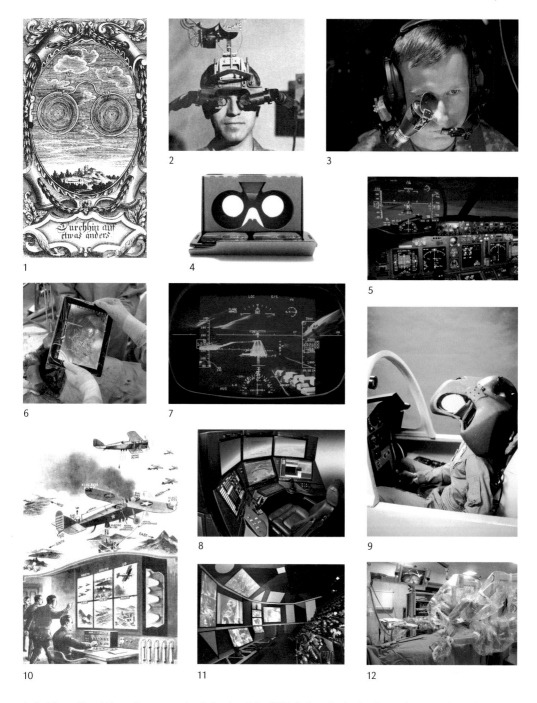

1: Emblem: „Durchhin auf etwas anders", Kupferstich, 1707. 2: Ivan Sutherland: Head-mounted-Display, 1968.
3: Pilot eines Apache Longbow Helikopters mit monokularem Display. 4: Google Cardboard 2.0, stereoskopische
VR-Brille mit eingeschobenem Smartphone, 2015. 5: Head-up-Display eines Boeing 737-832 Cockpits. 6: Tablet-
Computer mit Planungsdaten während einer Leberoperation. 7: EVS-3000 Enhanced Vision System, © Rockwell
Collins. Terrainerkennung bei schlechter Sicht. 8: General Atomics: Advanced Cockpit Ground Control Station,
Kontrollstation einer Kampfdrohne, 2015. 9: Thomas Furness: Visually Coupled Airborne Systems Simulator, 1982.
10: Hugo Gernsback: The Pilot-less radio television plane directed by radio, 1931. 11: Charles und Ray Eames:
Information Machine, Ovoid Theater, IBM Pavillon der New York World's Fair, 1964–65. 12: Ferngesteuerte
Roboterarme des da Vinci Si-Operationssystems, 2009 von Intuitive Surgical eingeführt.

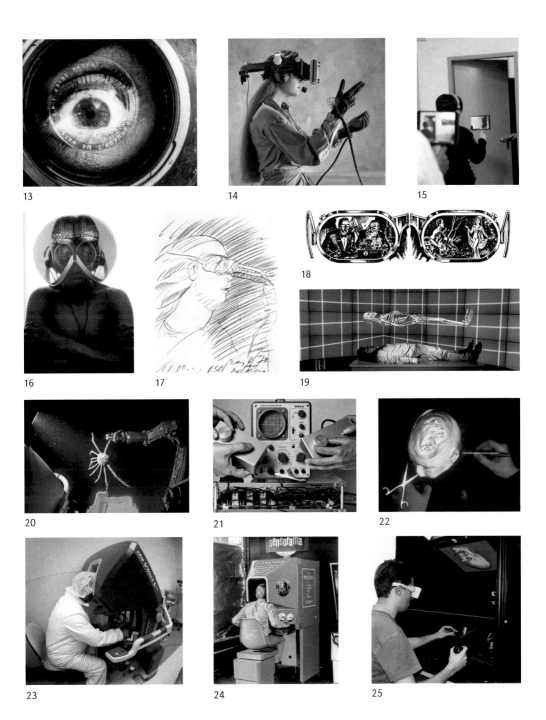

13: Dziga Vertov: Der Mann mit der Kamera, Still, 1929. **14:** NASA: Virtual Interface Environment Workstation (VIEW), 1989. **15:** Rimini Protokoll: Situation Rooms, ein Multi Player Video-Stück, 2013. **16:** Ben Rose: Haus-Rucker-Co: Flyhead (Environment Transformer), Wien 1968. **17:** Alfons Schilling: Mantegna mit meinen Augen, 1973. **18:** Lumen Winter: Pygmalion's Spectacles Cover, 1935, Detail. **19:** CAVE2 (Cave Automatic Virtual Environment), Anwendung für medizinische Ausbildung, 2012. **20:** Ferngesteuerter Robotergreifarm eines Tiefseetauchboots. **21:** T42 – Tennis for Two, Oszilloskop-Bildschirm und Controller, Rekonstruktion von William Higinbothams analogem Computerspiel von 1958, 2011. **22:** Virtuelles Werkzeug des ImmersiveTouch-Systems, 2010. **23:** Steuerkonsole des da Vinci Si-Operationssystems, 2009 von Intuitive Surgical eingeführt. **24:** Morton Heilig: Sensorama, 1962. **25:** Chirurg interagiert mit dem ImmersiveTouch-System, 2010.

Inhalt

Editorial

Ein zentrales Merkmal militärischer Drohnenoperationen ist die räumliche Trennung menschlicher Sinne und technischer Sensoren. Sowohl die Steuerung unbemannter Luftfahrzeuge als auch das Wissen über eine Situation – die sogenannte *situational awareness* – erfordern eine Sichtbarkeit auf lange Distanz. Bilder werden zur maßgeblichen, oftmals zur einzigen Handlungs- und Entscheidungsgrundlage.

Die zentrale visuelle und operative Schnittstelle zwischen Mensch und Sensorsystem bildet eine sogenannte *ground control station*, wie sie ausschnitthaft auf dem Titelbild dieses Bandes dargestellt ist: Als zentrale Steuerungseinheit bestimmen ihre Darstellungsmodalitäten, Softwareanwendungen und Eingabegeräte die Formen und Möglichkeiten des Eingreifens. Während sich militärische Aufklärung immer schon maßgeblich auf Bilder stützt, bringt diese Bedingung des bildgeführten Zugriffs auf ein Operationsgebiet Verschiebungen des militärischen Bildgebrauchs mit sich. Mit der räumlichen Mobilität von Sensor- und Netzwerktechnologien verbindet sich ein neuer Typ von Intervention, in dem militärisches Eingreifen nahezu in Echtzeit durch Bilder an- oder fehlgeleitet wird. Wenn Visualisierungspraktiken zwischen militärischem Personal und Einsatzgebiet vermitteln, erzwingt dies geradezu die Frage danach, was Bilder zeigen oder nicht zeigen. Eine Auseinandersetzung, die zur Disposition stellt, wie Bilder Sehen und Handeln in einem operativen Prozess ermöglichen, erschweren oder verhindern, und die damit zugleich die Abläufe und Folgen dieser neuen Form der Kriegsführung dokumentiert und die technologisch-pragmatischen Bedingungen des bildgeführten Eingreifens aufzeigt.

Das Vokabular bildgeführter Militäroperationen ist dem medizinischen Sektor entlehnt. Hier, besonders in der Chirurgie, haben sich die Techniken des Zeigens und der Sichtbarmachung im Zuge der Einbindung von Echtzeitbildgebung und robotischen Applikationen in die Handlungsroutinen und -abläufe im Operationssaal grundlegend verändert. Nicht Körper, sondern Bilder werden in zunehmendem Maße selber zum primären Referenzobjekt ärztlichen Sehens und Handelns. Insbesondere minimalinvasive Operationsverfahren etablieren Wahrnehmungs- und Anwendungssituationen, in denen der visuelle Zugriff auf das Operationsgebiet sowie die Handhabung und Navigation von Instrumenten ausschließlich durch den Blick auf einen Bildschirm vermittelt werden. Im Vergleich zur offenen Chirurgie, die weiträumige Schnitte erfordert, um den Operationsort freizulegen, werden in der minimalinvasiven Chirurgie spezielle Instrumente durch kleine Öffnungen ins Körperinnere eingeführt. In Ermangelung eines direkten Blickkontakts müssen Bild und Bewegung auf der Basis eines komplexen Zusammenspiels von Datenerfassung, -übertragung und -visualisierung synchronisiert werden. Visualisierungsverfahren fungieren hier nicht

mehr nur als Hilfsmittel oder Unterstützung; sie sind eine Bedingung der Möglichkeit ärztlichen Handelns.

Die Beispiele sollen zeigen, dass Bilder immer auch im Kontext von Handlungsprozessen betrachtet werden müssen. In Bereichen wie der Luft- und Raumfahrt, der Architektur, der Gestaltung oder bei Computerspielen macht die zunehmende Verschaltung von Technologien, Körpern und Objekten durch visuelle Schnittstellen die Betrachtung zur Benutzung: Planung, Navigation und Intervention gehen ineinander über und sind nur noch in Kenntnis eines entsprechenden handlungsbezogenen Bildwissens sinnvoll durchführbar. Die Analyse dieser Handlungsmächtigkeit von Bildern erfordert eine entsprechende Betrachtung spezifischer Anwendungskontexte. *Image guidance* als theoretisches Konzept bezeichnet daher nicht allein bestimmte Bildmuster und -ästhetiken, sondern schließt auch deren iteratives Zusammenspiel mit Strukturen und Prozessen ein, die auf reale Konsequenzen ausgerichtet sind. Hieraus folgt ein Wechselverhältnis von Bild und Handlung auf der Ebene der Datenverarbeitung (etwa durch die Vorschreibung von Arbeitsroutinen durch bildgebende Algorithmen), auf der Ebene der Visualisierung (etwa der Gestaltung von grafischen und taktilen Schnittstellen) und auf der Ebene der Benutzung, wie sie sich aus bestimmten Anordnungen von Mensch und Maschine ergibt.

Und es zeigt sich dabei ein methodisches Dilemma: Gerade wenn es darum geht, bildgeführte Handlungs- und Entscheidungsprozesse nachzuvollziehen, wird die Analyse auf die Darstellungsebene von Bildern verengt. Betrachtungs- und Handlungssituationen in Kontexten von *image guidance* basieren aber in der Regel auf der Analyse von Anwendungssituationen, welche sich jedoch selbst nicht ohne Weiteres abbilden lassen. Hier liegt die nächste Herausforderung für etablierte Ansätze der Bildanalyse. Obgleich bildgeführte Praktiken kontextspezifisch und anwendungsbezogen analysiert werden müssen, stellt die Bestimmung übergreifender Merkmale von *image guidance* eine Möglichkeit dar, um sowohl die Theoriebildung voranzutreiben als auch einen möglichen Austausch zwischen verschiedenen Praxisfeldern zu befördern.

Der vorliegende Band richtet den Blick deshalb nicht allein auf die spezifische Repräsentationsfunktion oder Darstellungskonvention von Bildern, sondern insbesondere auf die Situationen, in denen sie zu Medien der Steuerung und Handlungsanleitung werden. So soll gezeigt werden, wie umfassend *image guidance* als Darstellungs-, Wahrnehmungs- und Handlungsprinzip auch dort wirksam wird, wo ihre Mechanismen und Konsequenzen noch nicht einmal absehbar sind.

Sabine Ammon

Generative und instrumentelle Bildlichkeit: Warum computerbasierte Fertigungsverfahren keine Form der *image guidance* darstellen

Kaum ein anderer Bereich ist in seinen Praktiken derart von Bildtechnologien geprägt wie Architektur und Produktentwicklung, wo sie in engem Zusammenhang mit Handlungen stehen.[1] Von frühen konzeptionellen Überlegungen bis zur Ausführung spielen bildbasierte Schnittstellen als Reflexionswerkzeuge und instrumentelle Anleitungen eine zentrale Rolle, ohne die Entwurf, Planung und Fertigung nicht denkbar wären. Computerbasierte Technologien verstärken diese Besonderheit, da die neuen Modellierungsverfahren hochgradig von Bildpraktiken dominiert sind.

Der Einzug automatisierter Verfahren erlaubt es mittlerweile sogar, die Produktion direkt an die Planung anzuschließen, ohne den digitalen Datentransfer zu unterbrechen. Gerade hier, in der engen Verschmelzung von computerbasierter Planung und Ausführung durch automatisierte, additive und subtraktive Fertigungsverfahren, könnten womöglich auch Formen von *image guidance* anzutreffen sein. Formen der Bildsteuerung also, wie sie in der modernen Medizintechnik zu finden ist und dort chirurgische Eingriffe auf der Basis computerbasierter Systeme bezeichnet, die einen visuellen Handlungsrahmen liefern.[2] ↗ **Abb. 1a**

Ein wichtiges Kennzeichen von *image guidance* ist die Kopplung präoperativ gewonnenen Bildmaterials (in der Regel tomografische Aufnahmen, die für die Planung des Operationsverlaufs weiter aufbereitet wurden) mit Echtzeitbildern. Die Verschmelzung von Planbild und intraoperativer Visualisierung erlaubt es, den chirurgischen Eingriffsort mit großer Präzision anzusteuern, was insbesondere bei minimalinvasiven Maßnahmen von großer Bedeutung ist. ↗ **Abb. 1b** Durch die iterative Rückkopplung des tatsächlichen Befunds mit der Planung kann im Operationsverlauf unmittelbar und flexibel auf Änderungen reagiert und können notwendige Anpassungen vorgenommen werden.

Obwohl sich vermuten ließe, dass vergleichbare Bildpraktiken auch in Architektur und Produktentwicklung Anwendung finden, soll im vorliegenden Essay behauptet werden, dass es sich hierbei gerade nicht um Formen der *image guidance* handelt, selbst wenn sie einem umfassenderen Begriff „bildlicher Anleitung"[3] zuzurechnen sind. Insbesondere das Beispiel der subtraktiven und additiven Fertigung zeigt nämlich,

1 Vgl. Sara Hillnhütter (Hg.): Planbilder. Medien der Architekturgestaltung (Bildwelten des Wissens, Bd. 11), Berlin u. a. 2015; Sabine Ammon, Inge Hinterwaldner (Hg.): Bildlichkeit im Zeitalter der Modellierung. Operative Artefakte in Entwurfsprozessen der Architektur, des Designs und Ingenieurwesens, München u. a. 2016.

2 Kevin Cleary, Terry M. Peters: Image-Guided Interventions. In: Technology Review and Clinical Applications, Annual Review of Biomedical Engineering, 2010, Bd. 12, S. 119–142.

3 Oliver R. Scholz: Bilder in Wissenschaften, Design und Technik. Grundlegende Formen und Funktionen. In: Dimitri Liebsch, Nicola Mößner (Hg.): Visualisierung und Erkenntnis. Bildverstehen und Bildverwenden in Natur- und Geisteswissenschaften, Köln 2012, S. 47.

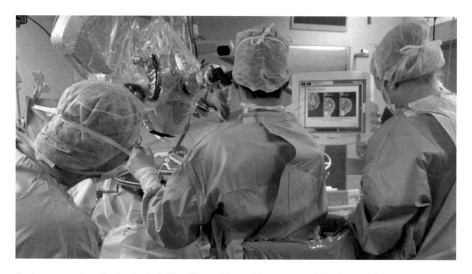

1a: Intraoperatives Setting in der bildgeführten Neurochirurgie. Im Bildvordergrund das OP-Mikroskop und Instrumente, deren räumliche Position automatisiert nachverfolgt werden kann. Im Bildhintergrund Navigations- und Kontrollbildschirm.

dass die Bedeutung der bildlichen Anleitung durch die derzeitigen computerbasierten Technologien sogar zum Verschwinden kommen kann.

Auf der anderen Seite stellt diese Einschätzung kein abschließendes Urteil dar. Wo in Zukunft für dieses Feld durchaus Formen der *image guidance* – vor allem im Zusammenhang mit Verfahren der *augmented reality* – zu erwarten sind, soll ein kurzer Ausblick andeuten. Damit versteht sich dieser Beitrag zu Bildpraktiken in Architektur und Produktentwicklung als ein Plädoyer für eine weitere begriffliche Differenzierung, um Unterschiede von Bildfunktionen zu verdeutlichen und darüber auch das Schlagwort der *image guidance* zu schärfen.

Generative und instrumentelle Bildlichkeit in den Entwurfsdisziplinen

Wer über Architektur und Produktentwicklung spricht, bewegt sich im Feld der Entwurfsdisziplinen – oder, in der einflussreichen Charakterisierung von Herbert Simon, den „Wissenschaften vom Künstlichen".[4] Für Entwurfsdisziplinen im engeren Sinn lassen sich in einer groben Einteilung zwei unterschiedliche Phasen unterscheiden.

4 Simon verwendet allerdings einen sehr weiten Begriff der Entwurfswissenschaften: „Jeder ist ein Designer, der Abläufe ersinnt, um bestehende Situationen in erwünschte zu verwandeln. [...] So verstanden ist das Entwerfen der Kern jeder beruflichen Ausbildung; hauptsächlich dadurch unterscheiden sich die praktischen Berufe von den Wissenschaften. Ingenieurschulen – und ebenso Schulen für Architektur, Wirtschaft, Pädagogik, Recht und Medizin – befassen sich hauptsächlich mit dem Prozeß des Entwerfens." Herbert A. Simon: Die Wissenschaften vom Künstlichen, Berlin 1990, S. 95. In Abgrenzung dazu sollen mit dem hier verwendeten Begriff der Entwurfsdisziplinen nur jene (Wissenschafts-)Bereiche angesprochen werden, bei denen – wie etwa im Ingenieurwesen, in Architektur oder Design – Ent-

1b: Überlagerung der Röntgenaufnahme mit Echtzeitbildern der Operation.

Gemäß eines weit verbreiteten Denkmusters beginnt die Entstehung neuer Artefakte mit einer „geistigen Vorwegnahme" des zukünftigen Gegenstandes, auf deren Grundlage sich nach erfolgreicher Planung die Umsetzung eines „realen Dings" anschließt.[5] In der Praxis allerdings ist diese Unterteilung selten trennscharf. Im Bauwesen finden selbst während der Realisierung auf der Baustelle Änderungen der Planung statt, wenn beispielsweise unerwartete bauliche Gegebenheiten, neue ökonomische Zwänge oder Planungsfehler auftreten – was eher die Regel als die Ausnahme ist. Ebenso ist in der Produktentwicklung ein langwieriger wechselseitiger Prozess zwischen Planung und Umsetzung zu beobachten, der sich über zahlreiche Stufen von Prototypen bis zu Probeserien entfaltet und in dem die scheinbar antagonistischen Phasen ineinander übergehen.

In den Prozessen von der Konzeption bis zur Umsetzung spielen Bildtechniken eine zentrale Rolle. Heuristisch lassen sich zwei primäre Funktionen unterscheiden, in denen sie operativ wirksam werden: jene der *generativen* und jene der *instrumentellen* Bildlichkeit.[6] Bei der *generativen* Bildlichkeit sind Handlungen von Bedeutung, die

wurfshandlungen einen besonders signifikanten Anteil ausmachen und vor allem zur Entwicklung von Artefakten eingesetzt werden.

5 Aristoteles: Metaphysik. Bücher VII u. VIII, übers. v. Wolfgang Detel unter Mitarbeit v. Jula Wildberger, komment. v. Wolfgang Detel, Frankfurt a. M. 2009, Buch 7, 1032b. Diese Frage wird in der Literatur teilweise im Zusammenhang mit Modellen und Modellierungsverfahren diskutiert, siehe Sabine Ammon: Epilog. Vom Siegeszug der Bildlichkeit im Zeitalter der Modellierung. In: Ammon, Hinterwaldner (s. Anm. 1), im Druck.

6 Der hier verwendete Begriff der Bildlichkeit geht auf Sybille Krämer zurück, die ihn für den Bereich der (instrumentellen) Verwendung von Schriften, Karten und Diagrammen entwickelt hat. Sybille Krämer: Operative Bildlichkeit. Von der ‚Grammatologie' zu einer ‚Diagrammatologie'? Reflexionen über erkennendes ‚Sehen'. In: Martina Heßler, Dieter Mersch (Hg.): Logik des Bildlichen. Zur Kritik der ikonischen Vernunft, Bielefeld 2009, S. 94–122. Eine Auseinandersetzung und Weiterentwicklung ihrer Position findet sich in Sabine Ammon: Einige Überlegungen zur generativen und instrumentellen Operativität von technischen Bildern. In: Hanno Depner (Hg.): Visuelle Philosophie, Würzburg 2015, S. 167–181; Sabine Ammon: Epistemische Bildstrategien in der Modellierung. Entwerfen von Architektur nach der digitalen Wende. In: Ammon, Hinterwaldner (s. Anm. 1), im Druck.

in der Bildentstehung liegen. Durch die Bildentwicklung und den Einsatz gezielter Bildtechniken können Erkenntnisse über das zukünftige Artefakt erarbeitet werden. Wie die Skizze aus dem Entwurfsprozess des späteren Austin Seven, einem Kleinwagenmodell der britischen Austin Motor Company, zeigt, ⊅ **Abb. 2** schlägt sich der individuelle Reflexionsvorgang unmittelbar in zeichnerischen Suchbewegungen nieder, wofür der Technikhistoriker Eugene Ferguson den Begriff der „denkenden Skizze"[7] prägte. Davon abgegrenzt werden muss die „vorschreibende Skizze",[8] die als konkrete Handlungsanweisung der *instrumentellen* Bildlichkeit zuzurechnen ist.[9] Bei der instrumentellen Bildlichkeit stehen Handlungen im Vordergrund, in denen das Bild als Zwischen- oder Endprodukt eingesetzt wird und die einen Großteil der bekannten (und archivierten) technischen Zeichnungen ausmacht. Auf diese Weise können sie Kommunikationszwecken dienen (wie die technische Illustration des perspektivischen Schnitts), ⊅ **Abb. 3** um einen bestimmten Erkenntnisstand zu vermitteln, um einen Nachweis zu erbringen oder als Bauanleitung die praktische Umsetzung zu führen (wie die Blaupause einer Limousine in An- und Aufsicht). ⊅ **Abb. 4**

 Bei der Frage, ob *image guidance* in den Entwurfsdisziplinen eine Rolle spielt, scheiden von vornherein jene Bildhandlungen aus, die sich auf Konzeption und Planung beschränken. Die Operationen sind hier auf die Bildproduktion begrenzt, sie dienen zu diesem Zeitpunkt nicht dazu, die Ausführung des Artefaktes anzuleiten. Aufgabe dieser Form der generativen Bildlichkeit ist es vielmehr, ein Wissen über den Entwurfsgegenstand zu erarbeiten, das die spätere, gelingende Umsetzung und Benutzung erlaubt. Anders sieht es bei Bildhandlungen aus, die mit den Endprodukten der Planung in Verbindung stehen und die Fertigung des eigentlichen Artefakts anleiten. Konstruktions- und Werkpläne als Ergebnisse des Planungsprozesses werden nun instrumentell wirksam und leiten die Herstellung auf der Baustelle, in Werkstätten und Fabriken an. Wichtig für diese Unterscheidung ist, dass die unterschiedlichen Bildfunktionen in der Regel nicht mit unterschiedlichen Bildformen verknüpft sind,

7 Eugene S. Ferguson: Engineering and the Mind's Eye, Cambridge, MA, 1992, S. 96–97. In der deutschen Übersetzung (Eugene S. Ferguson: Das innere Auge. Von der Kunst des Ingenieurs, Basel u. a. 1993, S. 99) wird die Trias denkende, vorschreibenden und sprechende Skizze („thinking, prescriptive and talking sketch") leider sinnentstellend als Denkskizze, Vorentwurf und sprechende Skizze eingeführt.

8 Ferguson (s. Anm. 7), S. 96–97.

9 Mit dem dritten Skizzentyp, der sogenannten „sprechenden Skizze", begründet Ferguson keine neue Funktion, sondern verweist nur auf die Umstände ihres Einsatzes, nämlich im Dialog. Je nachdem kann dann die generative Funktion im Vordergrund stehen, wenn die Skizze Teil eines Teamgesprächs ist und zwei Ingenieure im zeichnenden Dialog die Entwurfsidee weiter entwickeln, oder die kommunikative Funktion, wenn die Skizze zur Verdeutlichung im Kundengespräch eingesetzt wird. Vgl. Ferguson (s. Anm. 7), S. 97, 101, Abb. 4.20.

sondern es sich um dieselben Produkte handeln kann. Wenn über viele Wochen, Monate oder Jahre hinweg ein Werkplan entwickelt wird, stehen die Bildhandlungen mit einer generativen Bildlichkeit im Zusammenhang. Erst wenn sich die in seiner Bearbeitung gewonnenen Erkenntnisse stabilisiert und als tragfähig erwiesen haben, wird der Werkplan dazu eingesetzt, den tatsächlichen Bauprozess anzuleiten: Die Funktion des Plans liegt nun in der instrumentellen Bildlichkeit.

Wenn Werk- oder Konstruktionszeichnung in dieser Weise instrumentell wirksam werden, liegen damit auch genuine Fälle von *image guidance* vor? Wer den Begriff sehr weit fassen möchte, wird diese Frage bejahen. Allerdings wären dann alle Formen der bildlichen Anleitung Fälle von Bildführung, von der Bauanleitung der Lego-Eisenbahn über die Montagevorschriften des Ikea-Regals bis zur Gebrauchsanweisung des Fotoapparats. Zu beantworten wäre bei einer derartigen Deutung, welcher Mehrwert in der synonymen Verwendung von „Bildführung" und „bildlicher Anleitung" liegen sollte. Sehr viel sinnvoller scheint es, mit dem Begriff der *image guidance* auf eine Sonderform der bildlichen Anleitung zu verweisen. Spezifika des Prozesses liegen zweifelsohne in der Rückkopplung des tatsächlichen Befundes mit dem geplanten Operationsverlauf, wie es in der Medizintechnik der Fall ist. Der Realabgleich löst iterative Schleifen mit entsprechender Nachjustierung aus.

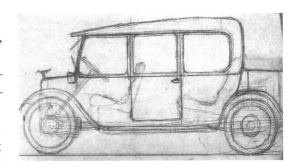

2: Entwurfsskizze des Austin Seven als individueller Reflexionsvorgang.

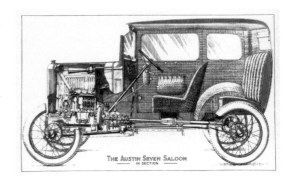

3: Perspektivischer Schnitt des Austin Seven als technische Illustration.

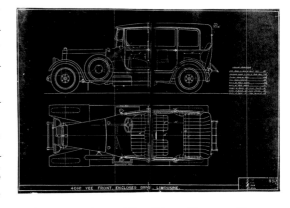

4: Blaupause im Automobilbau (Messrs Hooper and Sons, 1924).

Charakteristisch ist ein reflexives Moment, das durch intraoperative Bildgebung in Gang gesetzt wird. In der Neubewertung wird das Antizipierte operativ überlagert und eröffnet neue Handlungsoptionen. In dieser Anordnung sind generative und instrumentelle Bildfunktionen untrennbar miteinander verwoben, denn die Bildhandlung selbst verschmilzt Anleitungscharakter und erkenntnisgenerierende Bildbearbeitung zu einem Operationsraum.

Vor diesem Hintergrund wird deutlich, warum der Einsatz traditioneller Baupläne und Konstruktionszeichnungen in der Fertigung gerade nicht zu den Formen der *image guidance* zählt, sondern warum Letztere lediglich bildliche Anleitungen darstellen. Denn hier werden die Bilder ausschließlich instrumentell wirksam; eine bildbasierte iterative Rückkopplung und reflexive Revision findet im vorgelagerten Entwurfsprozess statt, nicht jedoch durch einen in die Operation integrierten Abgleich mit den materiellen Bedingungen vor Ort. Sollten Änderungen in der Ausführung notwendig werden, leiten sie zwar eine Überarbeitung des Planmaterials ein. Doch bleiben in dieser Form der iterativen Rückkopplung instrumentelle und generative Bildhandlungen voneinander zeitlich getrennt; die überarbeiteten Pläne leiten dann eine neue Phase der bildlichen Anleitung ein.

Die digitale Wende in der Fertigung

Doch wie stellt sich die Lage unter den veränderten digitalen Rahmenbedingungen dar, die Entwurf und Fertigung in Architektur und Produktentwicklung zunehmend miteinander verschmelzen lassen? Schlagworte wie „file-to-factory"[10] bringen den fließenden Übergang von der Planzeichnung zum Produktionsablauf ausschließlich über eine digitale Datenkette auf den Punkt. Entwurf und Konstruktion werden durch Visualisierungsschnittstellen des *computer-aided design* (CAD) am Bildschirm erarbeitet, um auf der Basis aufbereiteter Daten mit Hilfe des *computer-aided manufacturing* (CAM) direkt in die Fertigung überzugehen.

In der computergestützten Fertigung lassen sich derzeit zwei Hauptzweige unterscheiden. Das klassische CAM fertigt Artefakte durch das Abtragen von Material mittels Fräsen, Bohren, Drehen oder Schleifen und wird daher auch als subtraktive Fertigung bezeichnet. Dazu werden die CAD-Daten in CAM-Programmen aufbereitet, also um Produktionsanweisungen ergänzt, um schließlich in einem CNC-gesteuerten Bearbeitungszentrum das fertige Produkt zu erstellen. Die Screenshots in ↗ **Abb. 5** zeigen an einem Lehrbeispiel den prototypischen Ablauf für die Entwicklung und Her-

10 Fabian Scheurer: File-to-Factory. In: Detail. Zeitschrift für Architektur + Baudetail, 2010, Bd. 5, http://www.detail.de/artikel/file-to-factory-712/ (Stand: 01/2016).

stellung eines Artefakts aus dem Maschinenbau: Die technische CAD-Zeichnung des entworfenen Drehbegrenzers (a) wird in eine materialabhängige Fertigungsplanung in der CAM-Software durch Festlegung von Werkzeugen, Bearbeitungstechniken und zeitlicher Produktionsabfolge überführt (b). Es folgt ein Testdurchlauf der Fertigung durch Simulation am Bildschirm (c), dem sich die Aufbereitung der Daten für die CNC-Fertigungsmaschine anschließt (WOP oder werkstattorientierte Programmierung) (d). Vollständig automatisiert kann auf dieser Grundlage das fertige Produkt gefräst werden (e).

Die neuere *additive* Fertigung, die zum Teil auch unter den Begriffen „Rapid Prototyping", „3D-Druck" oder *generative* Fertigung geführt wird, erzeugt Artefakte durch einen schichtweisen Aufbau mittels verkleben, schmelzen oder sintern.[11] Verfahren der additiven Fertigung werden insbesondere für die Herstellung von Prototypen, Modellen und Einzelprodukten eingesetzt; eine industrielle Massenfertigung ist, anders als in der subtraktiven Fertigung, derzeit weder technisch möglich noch ökonomisch sinnvoll. Bei Extrusionsverfahren wird ein Kunststofffaden punktgenau Schicht für Schicht aufgeschmolzen; pulverbasierte Techniken tragen zunächst den Werkstoff dünn auf, um ihn dann durch einen Laserstrahl punktgenau zu verschmelzen (Metalle) oder zu sintern (Kunststoffe). Auch der eigentliche 3D-Druck arbeitet auf der Grundlage eines pulverbasierten Schichtaufbaus, der in diesem Fall durch verkleben mittels Bindemitteln (Harzen) stattfindet und dadurch vielfältige Basismaterialien zulässt. Auf diese Weise lassen sich auch geometrisch äußerst anspruchsvolle Produkte aus Freiformflächen, mit Hinterschneidungen oder Hohlräumen herstellen. Analog

5a-e: Lehrbeispiel eines prototypischen Ablaufs: a) technische CAD-Zeichnung, b) Fertigungsplanung durch CAM-Software, c) Simulation des Fräsvorgangs, d) Programmierung der CNC-Fertigungsmaschine (WOP), e) gefräster Drehzahlbegrenzer.

11 Vgl. VDI Statusreport „Additive Fertigungsverfahren", September 2014, https://www.vdi.de/ fileadmin/vdi_de/redakteur_dateien/gpl_dateien/VDI_Statusreport_AM_2014_WEB.pdf (Stand: 12/2015); Moritz Hauschild, Rüdiger Karzel: Digitale Prozesse. Planung, Gestaltung, Fertigung, München 2010, S. 44–69.

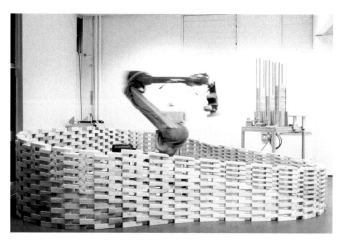

6: Maschinelle Fertigung einer Wand aus Holzelementen unterschiedlicher Dimensionen durch einen Roboter (Projekt Stratifications, Gramazio Kohler Research, ETH Zürich, 2011).

zu den subtraktiven Verfahren müssen die CAD-Daten aufbereitet werden, um Inkonsistenzen zu beseitigen und sie für die Maschinenhandhabung zu übersetzen. Auch hier steuert der fertige Code wiederum ein Ausgabegerät, welches das gewünschte Artefakt automatisch produziert.

Damit deutet sich an, warum auch in der automatisierten, digitalen Fertigung *image guidance* keine Rolle spielt. In der digitalen Fertigung werden die aufbereiteten Daten an die umsetzende Maschine geschickt, um das Produkt unmittelbar herzustellen. Iterative Rückkopplungen sind hier gerade nicht gewollt und wären ein Zeichen von Fehlern oder mangelnder Reife der Technologie (wie es zum Teil noch in der additiven Fertigung der Fall ist). Dadurch steigen die Anforderungen an die Planung in Hinblick auf Fehlerfreiheit und reibungslosen Ablauf erheblich. Anders als der traditionelle Konstruktionsplan, der die handwerkliche Ausführung anleitete und Nachbesserungen noch im Produktionsprozess erlaubte, kennt der abgeschlossene Maschinencode keine Fehlertoleranz: Was geschrieben steht, wird unmittelbar produziert (das erklärt, nebenbei bemerkt, die große Bedeutung von computerbasierten Simulationen des Prozesses im Vorfeld). ↗ Abb. 5c Der für die *image guidance* charakteristische Realabgleich in Verbindung mit iterativen Rückkopplungsschleifen findet hier gerade nicht statt. Darüber hinaus verliert die bildliche Dimension ihre Relevanz in der Fertigung. Die aufbereiteten Daten werden in maschinenlesbare Codes überführt und ersetzen dadurch die grafische Aufbereitung, die für die menschliche Interaktion notwendig wäre. Wenn Wände, wie in Projekten von Gramazio Kohler Research an der ETH Zürich, additiv und robotergesteuert aus Elementen hergestellt werden, ↗ Abb. 6 dann braucht es nur noch einen Programmcode als Grundlage der Fertigung. Damit verlieren Konstruktions- oder Werkpläne im Vergleich zu den herkömmlichen Verfahren ihre Bedeutung als bildliche Anleitung.

7: Stereoskopische Visualisierung einer Treppe auf der Baustelle (in Falschfarben).

Warum *image guidance* in den Entwurfsdisziplinen (noch) keine Rolle spielt

Weder der traditionelle Einsatz von Konstruktions- und Werkplänen noch die neueren, automatisierten Fertigungstechniken in Architektur und Produktentwicklung lassen sich sinnvoll als Formen der *image guidance* fassen. Während die herkömmlichen Herstellungsverfahren Pläne als bildliche Anleitungen einsetzen, wird diese Funktion mit computerbasierten additiven und subtraktiven Produktionsweisen obsolet. Visuelle Schnittstellen sind wichtig für menschliche Akteure; dort wo automatisierte Maschinenprozesse die Herstellung neuer Artefakte übernehmen, verlieren sie ihre Bedeutung. *Image guidance* stellt sich damit als ein Verfahren dar, das dann zum Einsatz kommt, wenn es einer menschlichen Intervention und eines individuellen Eingriffs bedarf. Die Bildführung erlaubt es, Planungsprozesse unmittelbar in der Bildhandlung mit realen Bedingungen abzugleichen und notwendige Veränderungen in den Prozess iterativ zurück einzuspeisen.

Warum aber in der computergestützten Fertigung in Architektur und Produktentwicklung gerade diese Rückkopplung nicht notwendig ist, liegt an einem wichtigen ontologischen Unterschied. Die moderne Medizintechnik arbeitet mit dem Gegebenen, die digitale Fertigung der „Wissenschaften vom Künstlichen" stellt das Gegebene durch ihre Verfahren erst her. Die Bearbeitung des Existierenden steht der Herstellung des Neuen gegenüber; während im ersten Fall Formen der *image guidance* zum wertvollen Werkzeug werden, erweisen sie sich im zweiten Fall als irrelevant.

Noch lassen Gramazio und Kohler ihre Bauteile durch Roboter in der Werkhalle vorfertigen, um sie auf der Baustelle zu montieren. Aber es sind durchaus Szenarien denkbar, in denen der direkte Bildzugriff auch in den Entwurfsdisziplinen eine Rolle spielen kann. Sollten die Fertigungstechniken des *rapid manufacturing* irgendwann technisch so ausgereift sein, dass sich mit ihrer Hilfe bauliche Veränderungen unmittelbar im Bestand vornehmen lassen, bedarf es auch Formen der *image guidance*. Wenn der Roboter die Steine erst auf der Baustelle verklebt, um in ein bestehendes Gebäude einzugreifen, muss auf unvorhergesehene Befunde reagiert werden. Vergleichbar einem

8: Überlagerung des 3D-Planungsmodells mit einer Aufnahme der Baustelle, um Verzögerungen im Bauablauf zu überwachen und dadurch die Prozesssteuerung zu optimieren (rot: verspätet, hellgrün: in der Zeit, dunkelgrün: zeitlich voraus).

chirurgischen Eingriff, könnten dann spezifische Formen der Bildoperation helfen, die Planung vor Ort anzupassen.

Für Architektur und Produktentwicklung liegt die Zukunft der *image guidance* gerade nicht in den vollautomatisierten Fertigungsprozessen der Massenproduktion, sondern dort, wo handwerkliche, individuelle Eingriffe notwendig werden. Schwerpunkte, die sich in der jüngsten Forschung abzeichnen, könnten beispielsweise in der Begleitung von Bauprozessen in der Architektur liegen. Durch Verfahren der *augmented reality* ließen sich Ausschnitte aus Entwurfsmodellen mit der gegebenen Situation überlagern, um vor Ort die Planung zu überprüfen und zu modifizieren; ↗ **Abb. 7** automatisierte Bilderkennung erlaubte die Dokumentation des Baufortschritts und eine unmittelbare Kopplung an die Terminplanung, um Abläufe in der Ausführung zu überwachen und zu optimieren. ↗ **Abb. 8** Doch noch sind Überlegungen dieser Art Zukunftsmusik; wie sinnvoll sie sich in der Praxis erweisen, muss die weitere Entwicklung entscheiden.

Die Arbeit an diesem Text wurde durch die Europäische Gemeinschaft im Rahmen eines Marie Skłodowska-Curie Fellowships ermöglicht (Grant Agreement Nr. 600209, Projekt IPODI).

Aud Sissel Hoel

Neurochirurgische Bildoperationen

In aktuellen neurochirurgischen Praktiken werden routinemäßig hochentwickelte Bildgebungs- und Visualisierungstechniken zur präzisen Lokalisierung, Orientierung und Steuerung verwendet. Bildgesteuerte Navigationssysteme unterstützen die Lokalisierung z. B. von Hirnläsionen und lebensnotwendigen Strukturen. Solche Neuronavigationssysteme geben die Positionen von chirurgischen Instrumenten relativ zu den dargestellten Pathologien an, zeigen die Ausdehnung von Läsionen und sollen so chirurgisch induzierte Schädigungen von kritischen Funktionsbereichen verhindern. In einigen Fällen bieten sie auch aktualisierte Informationen über etwaige Veränderungen der Hirnanatomie im Verlauf der Operation.

Bei Nutzung im Operationssaal übernehmen Bilder also eine leitende oder steuernde Rolle, die nach einer Begriffsklärung verlangt. Bildgesteuerte Systeme wie etwa solche, die in der Neurochirurgie verwendet werden, erinnern daran, dass Bildern eine Aktionsdimension innewohnt, die jenseits des Bereichs der etablierten bildtheoretischen Betrachtungen liegt, welche dazu tendieren, den formativen und transformativen Kräften von Bilder wenig Beachtung zu schenken. Die Auffassung einer Agentenschaft von Bildern setzt sich im aktuellen Diskurs jedoch allmählich durch.[1] In Bildgeschichte und Bildtheorie gewinnt zunehmend die Frage an Bedeutung, was Bilder tun – deren Aktivität und Leistung –, und der Status von Bildern wird in dynamischen Begriffen überdacht. Der vorliegende Aufsatz trägt zu aktuellen Bestrebungen bei, Bilder über ihre Darstellungsebene hinaus zu analysieren. Dafür wird der Status und die Funktion von Bildern untersucht, die für Navigationszwecke in neurochirurgischen Operationen verwendet werden. Bilder zeigen ihre Agentenschaft in Form ihrer aktiv handlungsanleitenden Rolle bei der Nutzung als chirurgische Werkzeuge auf zwei verschiedenen Ebenen, die nachfolgend untersucht werden.

Bildgesteuerte chirurgische Interventionen sind ein Beispiel für eine Kategorie von Bildern, die in der aktuellen Literatur als „operative Bilder" bezeichnet werden.[2] Operative Bilder sind mit den Worten des deutschen Künstlers Harun Farocki solche Bilder, die „kein Objekt repräsentieren, sondern eher Teil einer Operation

1 William J. T. Mitchell: What Do Pictures Want? The Lives and Loves of Images, Chicago 2004; Horst Bredekamp: Theorie des Bildakts. Frankfurter Adorno-Vorlesungen 2007, Berlin 2010; Gottfried Boehm: Ikonische Differenz. In: Rheinsprung 11. Zeitschrift für Bildkritik, 2011, Heft 1, S. 170–176.
2 Werner Kogge: Lev Manovich. Society of the Screen. In: David Lauer, Alice Lagaay (Hg.): Medientheorien. Eine philosophische Einführung, Frankfurt 2004, S. 297–315; Sybille Krämer: Operative Bildlichkeit. Von der Grammatologie zu einer „Diagrammatologie"? Reflexionen über erkennendes Sehen. In: Martina Heßler, Dieter Mersch (Hg.): Logik des Bildlichen. Zur Kritik der ikonischen Vernunft, Bielefeld 2009, S. 94–123.

sind".[3] Operative Bilder dienen typischerweise praktischen Zwecken, die untrennbar mit spezialisierten Aufgaben verbunden sind. Abgesehen von hier diskutierten chirurgischen Anwendungen, wären andere Beispiele von operativen Bildern interaktive Karten auf mobilen Geräten, ferngesteuerte Unterwasser- oder Luftfahrzeuge, Gepäck-Röntgenbilder bei der Flughafenkontrolle oder, wie bei Farocki diskutiert, jene Bilder, denen Fernsehzuschauer während des persischen Golfkriegs massiv ausgesetzt waren, nämlich Aufnahmen von *suicide cameras*, die auf den Köpfen von Projektilen montiert waren, die in irakische Ziele einschlugen.

In seiner Diskussion über die Bilder des Golfkriegs weist Farocki auf zwei Fähigkeiten von operativen Bildern hin, die in diesem Aufsatz weiter entwickelt werden. Die erste Fähigkeit betrifft die Art, wie operative Bilder es ermöglichen, die menschliche Wahrnehmung zu erweitern. Die auf automatisierten Gefechtsköpfen montierten Kameras lieferten eine „Phantomperspektive" der beobachteten Ereignisse, ähnlich der „Phantom Shots" des frühen Films, bei denen Aufnahmen aus Positionen gemacht wurden, die Menschen normalerweise nicht einnehmen (Farocki nennt als Beispiel eine Kamera, die unter einem Zug befestigt wurde).[4] Diese Auffassung von operativen Bildern, die Phantomansichten bieten, konnte weiter entwickelt werden, indem eingeschlossen wurde, was Walter Benjamin als das Optisch-Unbewusste bezeichnet: Die Fähigkeit der Kamera, die menschliche Wahrnehmung durch Aufzeichnen von Ereignissen zu bereichern, die zu klein, zu schnell oder zu zerstreut sind, um vom nicht technisch unterstützten visuellen System des Menschen wahrgenommen zu werden.[5] Diese Auffassung umfasst ebenfalls bildgebende Technologien, die nicht sichtbare Teile des elektromagnetischen Spektrums visualisieren und so Sachverhalte verdeutlichen, die außerhalb des Bereichs des menschlichen Empfindungsvermögens liegen. Die zweite Fähigkeit operativer Bilder betrifft die Art, wie solche Bilder eine steuernde Funktion einnehmen. In seiner Betrachtung von Farockis Arbeit merkt Thomas Elsaesser an, operative Bilder seien solche, „die handlungsanleitend wirken" – und nicht nur das. Die instruktive Funktion scheine heute vielmehr „die neue Standardeinstellung jeglicher Bilderzeugung" zu sein.[6] Dies ist eine nachdrückliche Erinnerung daran, dass operative Bilder alles andere als neutral sind. Sie fungieren als aktive Bedingungen für mensch-

3 „These are images that do not represent an object, but rather are part of an operation." Harun Farocki: Phantom Images. In: Public, 2004, Heft 29, S. 17.

4 Farocki (s. Anm. 3), S. 13.

5 Walter Benjamin: Kleine Geschichte der Photographie [Orig. 1931]. In: ders.: Gesammelte Schriften, Bd. 2, Frankfurt a. M. 1977, S. 368–385.

6 „One could go even further and say that operational images – images that function as instructions for action –are the new default value of all image-making […]." Thomas Elsaesser, Alexander Alberro: Farocki. A Frame for the No Longer Visible. Thomas Elsaesser in Conversation with Alexander Alberro.

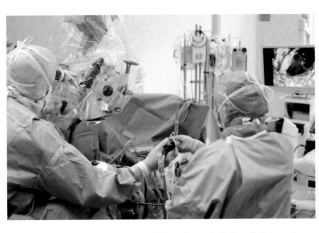

liches Wissen und Verhalten. Sie strukturieren die wahrnehmbaren Merkmale der physischen Welt gemäß ihrer eigenen Logik und kanalisieren unsere Aufmerksamkeit. Den operativen Bildern sind, anders ausgedrückt, Direktionalität und Normativität eigen, die in den Darstellungen selbst unerkannt bleiben.

1: Neurochirurgische Operation. Zu beachten sind die reflektierenden Kugeln auf dem chirurgischen Instrument in der Bildmitte, die eine Verfolgung der Position des Instruments erlauben. Live-Videobilder des chirurgischen Mikroskops sind auf dem Bildschirm rechts zu sehen.

Dieser Aufsatz soll die Bedeutung des „Operativ-Seins" eines Bildes erweitern, indem er sich auf die Nutzung von Bildern zur Steuerung und Kontrolle in Operationssälen konzentriert. Die Analyse basiert auf Feldforschungen an einem norwegischen Universitätskrankenhaus, wo eine neurochirurgische Tumorentfernung beobachtet wurde. ↗ Abb. 1

Der Phantomaspekt medizinischer Bildgebung

Die Agentenschaft von Bildern wird hier diskutiert, um damit zwei epistemologische Fallstricke zu vermeiden. Durch Anerkennen ihrer transformativen Kräfte vermeidet der Ansatz die bereits erwähnte Reduzierung von Bildern auf rein dienende Repräsentationen, zugleich kann sie dem Eindruck entgegenwirken, dass Bilder bloße Vehikel für menschliche Absichten und Zuschreibungen von Bedeutung wären. In dieser Beziehung klingen auch Überlegungen zur Rolle der Technik an, nach denen die Beziehung zwischen Menschen und ihren Werkzeugen wechselseitig angelegt ist,[7] sowie jene Überlegungen zur wissenschaftlichen Messung, welche die Reziprozität zwischen Messinstrument und gemessenem Phänomen betonen.[8]

In: e-flux, 2014, http://www.e-flux.com/journal/farocki-a-frame-for-the-no-longer-visible-thomas-elsaesser-in-conversation-with-alexander-alberro/ (Stand: 01/2016).

7 Ernst Cassirer: Form und Technik [Orig. 1930]. In: ders.: Gesammelte Werke, Hamburger Ausgabe, Bd. 17, Hamburg 2004, S. 139–183; Don Ihde: Technology and the Lifeworld. From Garden to Earth, Bloomington 1990, S. 1–226; Peter-Paul Verbeek: What Things Do. Philosophical Reflections on Technology, Agency, and Design, University Park, PA, 2005.

8 Edgar Wind: Das Experiment und die Metaphysik. Zur Auflösung der kosmologischen Antinomien [Orig. 1934], Frankfurt a. M. 2001; Karen Barad: Posthumanist Performativity. Toward an Understanding of How Matter Comes to Matter Signs. In: Signs. Journal of Women in Culture and Society, Jg. 28, 2003, Heft 3, S. 801–831; Hasok Chang: Is Water H_2O? Evidence, Realism and Pluralism, Dordrecht u. a. 2012.

Die Austauschbeziehung zwischen Apparat und dem untersuchten Phänomen zeigt sich auch in den Arbeitsweisen medizinischer Bildgebungstechnologien. Die Magnetresonanztomografie (MRT) erzeugt zum Beispiel Bilder durch Ausnutzen der magnetischen Eigenschaften von Wasserstoffatomen, die im menschlichen Körper in hoher Zahl vorhanden sind, vor allem im Wasser und im Fett. Da sich die molekulare Umgebung auf das Verhalten der wie kleine Magnete funktionierenden Wasserstoff-atome auswirkt, verhalten sich Protonen in verschiedenen Arten von Gewebe unter-schiedlich. Von besonderer Relevanz bei der medizinischen Verwendung der MRT ist, dass sich Protonen in pathologischem Gewebe anders verhalten als Protonen in gesundem Gewebe. Diese Unterschiede bilden die Grundlage des Kontrasts, der auf Graustufen-MRT-Aufnahmen zu sehen ist, die zur Kartierung von Gewebearten ver-wendet werden. Im natürlichen Zustand rotieren Protonen im Körper zufällig um ihre eigene Achse. Wird der Körper in das starke Magnetfeld eines MRT-Geräts geschoben, richtet sich diese, meist als Kernspin bezeichnete, Rotation des Protonen am Feld ent-lang der Mitte des Geräts aus und weist entweder zum Kopf oder zu den Füßen. Der Magnetismus der meisten Protonen relativiert sich gegenseitig, doch verbleibt ein klei-ner Teil ohne Gegenpol und ist so der Manipulation durch das MRT-System zugäng-lich. Nach der Ausrichtung der Protonenrotation innerhalb des Magnetfeldes, emittiert das MRT-Gerät einen Radiofrequenzpuls, der auf den interessierenden Körperbereich gerichtet ist, was eine Veränderung der Spinrichtung bei den ungepaarten Protonen verursacht. Gleichzeitig erzeugen drei Gradientenmagneten (einer für jede Richtung im kartesischen Raum) Variationen im Hauptmagnetfeld, was die Lokalisierung der dargestellten Bildschichten bestimmt. Wird die Radiofrequenz abgeschaltet, beginnen die Protonen zu *relaxieren* und erzeugen dabei Radiowellensignale und Energie, die entstehen, wenn sie ihre ursprüngliche Ausrichtung innerhalb des Hauptmagnetfelds wieder einnehmen. Diese Radiowellensignale werden durch die Empfängerspulen aufgenommen, und das MRT-System wandelt im weiteren Verlauf den Unterschied zwischen den Signalintensitäten in Graustufenintensitäten für jedes Pixel in einem Schnittbild um, das auf Computerbasis erzeugt wird.

Aus dieser Beschreibung der Arbeitsweise des MRT-Geräts wird deutlich, dass das in einer MRT-Aufnahme sichtbare Muster keine passive Reflexion eines Gegen-stands ist, welches einfach da bzw. bereits vorher gegeben und unabhängig vom Bild-gebungsprozess ist. Das Muster wird nicht einfach „gefunden" und es ist nicht lediglich eine Projektion des MRT-Geräts. Es ist das Ergebnis aktiver Manipulationen und Inter-ventionen durch den Apparat. Wenngleich besonders in der medizinischen Bildgebung ein reziproker Zusammenhang zwischen Apparat und Phänomen besteht, so ist für das Bildergebnis entscheidend, dass die Sensibilität des Apparats *direktional* angelegt ist:

Das in einer MRT-Aufnahme zu sehende Muster ist das Produkt von gezielten Anregungen von Geweben und Organen, die zu einer Resonanz entlang der durch die MRT-Aufnahmeparameter vorgegebenen Linien angeregt werden. Die Agentenschaft medizinischer Bilder hat gerade mit der Art zu tun, wie der bildgebende Apparat das Phänomen gemäß seiner eigenen Logik strukturiert. Mit den Worten von Karen Barad spezifiziert jedes Bildgebungsverfahren einen „agentiellen Schnitt, der eine örtliche Auflösung *innerhalb* des Phänomens bewirkt".[9] Jedes Bildgebungsverfahren impliziert eine je eigene Methode der Umschreibung von Realität, was zu einer charakteristischen Verteilung von Merkmalen führt, die durch ein anderes Verfahren nicht auf die gleiche Weise nachweisbar sind. Jedes medizinische Bildgebungsverfahren ist auf einen hochselektiven Bereich gerichtet und erfasst spezifische anatomische oder funktionelle Merkmale.

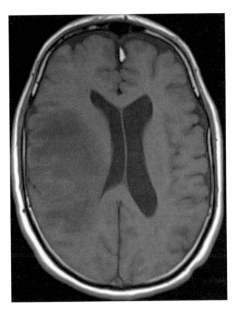

2a: T1-gewichtete MRT-Aufnahme.

Um diesen engen Fokus und die daraus folgenden, charakteristischen blinden Flecke zu kompensieren, existieren häufig Varianten von Bildgebungsmodalitäten mit je eigenen Vor- und Nachteilen. Ein Beispiel hierfür ist die Verwendung der MRT bei der Diagnose von Hirntumoren. Je nach Wahl der Aufnahmeparameter stellen die MRT-Aufnahmen unterschiedliche Gewebeeigenschaften prominenter dar. Die beiden am häufigsten bei klinischen Aufnahmen verwendeten Grundtypen werden als T1 und T2 bezeichnet. Mit T1- und T2-gewichteten Aufnahmen lassen sich Fett und Wasser differenzieren, beide Aufnahmevarianten stellen diese Differenzierung jedoch

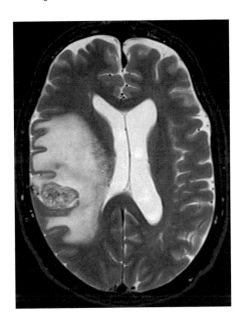

2b: T2-gewichtete MRT-Aufnahme.

9 „That is, the agential cut enacts a *local* resolution *within* the phenomenon […]." Karen Barad: Posthumanist Performativity. Toward an Understanding of How Matter Comes to Matter Signs. In: Signs. Journal of Women in Culture and Society, Jg. 28, 2003, Heft 3, S. 815 [Hervorh. i. O.].

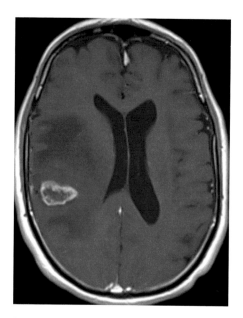

2c: T1-gewichtete MRT-Aufnahme mit Kontrastmittel.

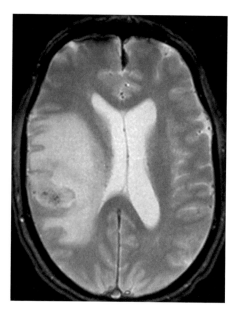

2d: T2-FLAIR MRT-Aufnahme. Ein Bildgebungsmodus, der Effekte von Flüssigkeitsansammlungen im Gehirn weniger prominent darstellt.

unterschiedlich dar. Während T1-gewichtete Aufnahmen (die Fett hervorheben) Hirntumore dunkler als oder mit der gleichen Intensität wie gesunde Hirngewebe wiedergeben, zeigen T2-gewichtete Aufnahmen (die Wasser hervorheben) Tumore heller als Hirngewebe. Das bedeutet, dass Hirntumore, die typischerweise mit einer Ansammlung von Flüssigkeit einhergehen, auf T2-gewichteten Aufnahmen deutlicher hervortreten. ↗ **Abb. 2a+b** Die Verteilung bzw. bildliche Darstellung von Merkmalen kann weiter durch die Verabreichung von Kontrastmitteln und anderen Maßnahmen modifiziert werden. ↗ **Abb. 2c+d**

Was mit diesen Beispielen verdeutlicht werden soll, geht über die Erklärung der selektiven Natur von Bildgebungsverfahren hinaus. Der Zweck ist vielmehr, die reziproke Beziehung zwischen dem Apparat und dem Phänomen zu betonen und damit die antizipatorische Agentenschaft, die sich in der Art zeigt, wie die medizinischen Bilddaten erzeugt werden. Diese Agentenschaft ist eng mit dem Phantomaspekt der medizinischen Bildgebung verbunden. Medizinische Bilddaten basieren grundlegend auf gezielten Interventionen des bildgebenden Apparats im Stadium der Datenerzeugung. Dies impliziert erstens, dass jedes Bildgebungsverfahren sein eigenes Untersuchungsgebiet konstituiert, und zweitens, dass jedes Verfahren erst die menschliche Wahrnehmung von bislang unzugänglichen Körpergebieten bzw. -dimensionen ermöglicht. Es sind diese apparativen Fähigkeiten der Entdeckung und Umschreibung bestimmter Phänomene, die in der bildgesteuerten Neurochirurgie genutzt werden.

Medizinische Bilder als Anleitungen für Aktion

Verbunden mit dem Phantomaspekt medizinischer Bilder ist deren Agentenschaft, die sich ebenfalls im Operationsmodus des bildgebenden Apparats zeigt. Da die untersuchten Phänomene nur über die intervenierenden Maschinen wahrnehmbar gemacht werden können, wird diesen eine erzeugende Funktion in Bezug auf die Bilddaten zuteil. Bildgebende Verfahren sind keineswegs reproduktive Technologien, sondern strukturieren Aspekte des fraglichen Phänomens im Prozess seiner Entdeckung. So steuern medizinische Bilder Sehen und Handeln bereits bevor sie für Navigationszwecke im Operationssaal eingesetzt werden. Das bedeutet auch, dass jedes Bildgebungsverfahren seinen eigenen epistemischen Raum festlegt, der nicht direkt in den epistemischen Raum eines anderen Verfahrens übersetzt werden kann. Im chirurgischen Kontext werfen diese verschiedenen Sichten, die von unterschiedlichen bildgebenden Modalitäten bereitgestellt werden, Fragen in Bezug auf die Abstimmung der unterschiedlichen Räume auf. Diese obliegt den Chirurginnen und Chirurgen, die verschiedenartige Bilddaten mit bisweilen widersprüchlichen Informationen in den Operationsprozess integrieren und mit ihrem Handeln an Patientinnen und Patienten abstimmen müssen. Während der Fokus bisher auf der isoliert betrachteten Agentenschaft des Bildgebungsapparats lag, soll nun die intraoperative Kooperation von menschlichen und maschinellen Akteuren nachvollzogen werden, insbesondere hinsichtlich der Frage, wie bildgesteuerte, chirurgische Navigationssysteme Chirurgen *Phantomsehen* gestatten.

Der Begriff „Neuronavigation" beschreibt die Verwendung von rechnergestützten und bildgesteuerten Technologien beim Planen und Ausführen von neurochirurgischen Operationen. Die Einführung dieser Technologien in die neurochirurgische Praxis hat die Lokalisierung von signifikanten anatomischen Strukturen erleichtert und das neurochirurgische Personal dabei unterstützt, sicherer durch die filigrane Landschaft des Hirns zu navigieren. Das Neuronavigationssystem definiert ein physisches Koordinatensystem des Patientenkörpers, das den Abgleich von präoperativ gewonnen Bilddaten mit dem Patienten auf dem Operationstisch erlaubt.[10] Bei dem beobachteten Eingriff einer Tumorentfernung umfasste das System die folgenden Komponenten: präoperatives MRT, Live-Videobilder des chirurgischen Mikroskops, intraoperative Ultraschallbilder und optisches Verfolgen des Patientenreferenzrahmens und der chirurgischen Instrumente. ↗ **Abb. 3+4**

10 Kristian Aquilina, Philip Edwards, Anthony Strong: Principles and Practice of Image-guided Neurosurgery. In: Anne J. Moore, David W. Newell (Hg.): Tumor Neurosurgery. Principles and Practice, London 2006, S. 123f.

3: Bildschirmanordnung im Operationssaal. Im Hintergrund: Navigationsbildschirm sowie Positionierungssystem mit Kameras, die das Verfolgen der Position des Referenzrahmens des Patienten und der chirurgischen Instrumente ermöglichen.

Um die präoperativen MRT-Bilder mit dem Referenzraum des Patientenkörpers abzugleichen, wurden am Kopf des Patienten Lokalisierungsmarker angebracht, bevor dieser in das MRT-Gerät geschoben wurde. In einem zweiten Schritt wurde der Kopf des Patienten auf dem Operationstisch fixiert; die Marker wurden nun als Orientierungshilfen verwendet, um einen Zusammenhang zwischen dem MRT-Bildraum und dem physischen Raum des Patienten herzustellen.

Eine erhebliche Herausforderung stellt die im Laufe der Operation eintretende Verschiebung der Gehirnmasse dar, die üblicherweise als *brain shift* bezeichnet wird. Die Positionsveränderungen der Gehirnanatomie, die eine Folge zahlreicher Faktoren ist (neben der Schwerkraft der Verlust von Zerebrospinalflüssigkeit und der Umfang der Resektion), verursacht eine räumliche Fehlpassung zwischen präoperativen Bildern und der intraoperativ eintretenden Lageveränderung. Bei dem hier beobachteten Eingriff wurde intraoperativer Ultraschall verwendet, um die Wirkungen dieser Lageveränderung zu kompensieren. In kritischen Momenten, insbesondere in direktem Zusammenhang mit der Entfernung des Tumorgewebes, wurde Ultraschall genutzt, um eine aktualisierte Darstellung der Patientenanatomie zu erzeugen. ↗ Abb. 5 Der Handlungsraum des Chirurgen wurde durch optisches Verfolgen wichtiger Instrumente, einschließlich der Ultraschallsonden und der Biopsiezange, mit dem Referenzraum abgeglichen. Die Bild- und Verfolgungsinformationen wurden auf einer multimodalen Anzeigeeinheit gezeigt, die dem Chirurgen zugewandt war, und zwar entweder als korrespondierende Ansichten in getrennten Anzeigefenstern oder als integrierte Navigationsszenen, in denen Merkmale aus verschiedenen bildgebenden Modalitäten vermischt wurden. Außerdem wurde der Operationssaal mit zusätzlichen Bildschirmen bestückt, welche die Live-Videobilder aus dem chirurgischen Mikroskop sowie die Vitalparameter des Patienten während der Narkose anzeigten.

Tumore desjenigen Typs, wie er während des beobachteten Eingriffs entfernt wurde (ein anaplastisches Astrozytom), stellen eine besondere Herausforderung dar, insofern sie über keine klare Abgrenzung verfügen und dazu neigen, in das umgebende Gewebe überzugehen. Der Chirurg und seine Assistenzärztin haben daher an einem

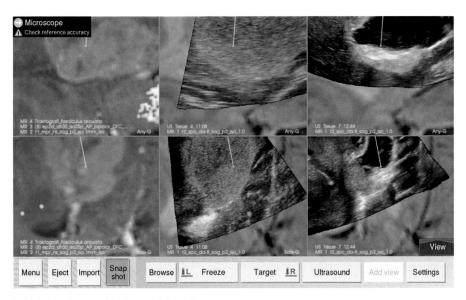

4: Nahaufnahme des Navigationsbildschirms.

bestimmten Punkt während der Operation die Tumorgrenzen diskutiert, wobei sie zwischen verschiedenen Modi der Bildgebung und Bildanzeige hin und her schalteten. Um die Entscheidung weiter abzusichern und die Gewebe zu differenzieren, führte der Chirurg mehrere Biopsien durch.

Wie er im Anschluss an den Eingriff in einem Interview bestätigte, ist die Möglichkeit des Wechselns zwischen bildgebenden Modalitäten entscheidend, um Gewebequalitäten zu bestimmen, da präoperative Bilder eine andere Ansicht bieten als das freigelegte Gewebe unter dem Mikroskop. In Fällen, in denen sich die Unterscheidung zwischen Tumor- und gesundem Gewebe mithilfe des Mikroskops nur schwer treffen lässt, kann die Verwendung von intraoperativem Ultraschall dazu dienen, die Gewebe klarer voneinander zu unterscheiden.

Auch wenn die intraoperative Bildgebung, wie etwa mit Ultraschall, zum Erlangen von aktualisierten Informationen über die Anatomie einer Person und das Ausmaß der Resektion von Nutzen sind, gibt es verglichen mit präoperativen Bildern doch einige Einschränkungen. Vor allem fehlen Informationen über funktionale Bereiche, eloquente Areale oder wichtige Leitungsbahnen der weißen Substanz, die präoperativ mittels verschiedener Verfahren gewonnen wurden (funktionales MRT, transkranielle Magnetstimulation, Diffusionstensor-Bildgebung, usw.). Um dieses Problem zu lösen, experimentieren Forschende, die sich mit medizinischen Bildgebungsverfahren beschäftigen, derzeit mit Methoden, um präoperative Bilder im Verlauf der Operation zu aktualisieren. Eine Gruppe norwegischer Forschender erprobt zum Beispiel ein Verfahren zur Aktualisierung präoperativer MRT-Bilder mittels intraoperativen

5: Intraoperativer Ultraschall.

Ultraschalls. Da die Bildeigenschaften der beiden Modi sehr unterschiedlich sind, ist eine direkte Registrierung, d. h. räumliche und dynamische Abstimmung, zwischen ihnen schwierig. Nutzt man hingegen eine MR-Angiografie und einen Doppler-basierten Hochleistungsultraschall, die beide zur Beschreibung des Gefäßbaums des Hirns geeignet sind, findet sich ein erfolgversprechendes Verfahren der Registrierung. Indem Blutgefäße als Orientierungshilfen für den Registrierungsalgorithmus genutzt werden, lässt sich die präoperativ festgestellte Position von dargestellten Merkmalen verschieben, wodurch den Operierenden aktualisierte Informationen zur Verfügung gestellt werden.[11] Doch selbst wenn in diesem Fall die Verschiebung der Position der MRT-Merkmale mittels der intraoperativ gewonnenen Ultraschallbilder kontrolliert wird, bedeutet dies nicht, dass die beiden Arten von Bilddaten ineinander übersetzt werden könnten. Auch wenn die Merkmale mithilfe der beiden Verfahren abgeglichen werden können, bleiben die gelieferten Informationen disparat, was zu einem epistemischen Hybridraum führt.

Verbreitung von Phantomsichten

Aus dem Versuch, die Fähigkeiten von operativen Bildern durch einen Blick auf die Agentenschaft medizinischer Bildgebung zu spezifizieren, hat sich die Frage ergeben, in welcher Beziehung operative Funktionen der Bildgebungsgeräte und menschliche Sehweisen zueinander stehen. Es ist zu vermuten, dass weitere Analysen in diesem Bereich es zunehmend erschweren werden, die Vorstellung aufrechtzuerhalten, die in der Definition Harun Farockis impliziert ist, wonach operative Bilder als separate

11 Ingerid Reinertsen et al.: Intra-operative correction of brain-shift. In: Acta Neurochirurgica, Jg. 156, 2014, Heft 7, S. 1301–1310.

Bildkategorie neben einer weiteren Kategorie von Bildern bestehen, deren vermeintliche Hauptfunktion die der Repräsentation ist. Ein Hinweis hierzu findet sich in dem bereits erwähnten Kommentar von Thomas Elsaesser, der vermutet, dass die lenkende Funktion von Bildern jetzt „die neue Standardeinstellung jeglicher Bilderzeugung" sei. Vielleicht ließe sich noch weiter gehen und behaupten, dass alle Bilder einen operationalen Aspekt aufweisen, da sie „Phantomsichten" liefern, indem sie gleichsam bisher nicht wahrnehmbare Bereiche erschließen und neue Möglichkeiten des Handelns eröffnen.

Dieser Text wurde aus dem Englischen übersetzt.

Die Arbeit an diesem Text wurde durch die Europäische Gemeinschaft im Rahmen eines Marie Skłodowska-Curie Fellowships ermöglicht (Grant Agreement Nr. 661526, Projekt IMAGUS).

Interview

Wie Bilder bildführend (gemacht) werden: ein Gespräch mit der Medizininformatikerin Tina Kapur

Bildwelten: Im Laufe der letzten dreißig Jahre wurden durch neue Technologien im Bereich medizinischer Bildproduktion und -verarbeitung neue Formen computergestützter Operation möglich. Heutzutage werden medizinische Bildgebungstypen wie Magnetresonanztomografie [MRT], Computertomografie [CT], Röntgen und Ultraschall durchgehend von der Diagnose bis in die Therapie eingesetzt. Bilder werden beispielsweise zur Planung benutzt, zu Navigationszwecken registriert, miteinander fusioniert, um zusätzliche Informationen zu erhalten, und mit intraoperativen Daten aktualisiert. Was sind die wichtigsten Konsequenzen dieser neuen Anwendungsbereiche für die Bilder und Bildgebung selbst?

Tina Kapur: Die Bedeutung für die Bildgebung lässt sich gut anhand der AMIGO-[*Advanced Multimodal Image-Guided Operating*] Suite hier am Brigham and Women's Hospital in Boston skizzieren, ein Beispiel für einen bildzentrierten Operationssaal auf dem aktuellsten Stand der Technik. Dort werden in großem Umfang Bilder genutzt, die präoperativ, also im Vorfeld des Eingriffs, gemacht wurden. Zugleich sind die drei sterilen Behandlungsräume der Suite jeweils auf eine wichtige Bildgebungsmodalität in ihrem Zentrum hin ausgerichtet. Damit musste gerade die intraoperative Bildgebung gezielter, schneller und kosteneffizienter werden. In AMIGO haben wir eine deutlich engere Kooperation zwischen Fachleuten für Bildgebung innerhalb des radiologischen Bereichs. Mittlerweile wird radiologisches Fachpersonal in den OP-Saal gerufen, um Bilder während eines Eingriffs in Echtzeit zu interpretieren. Entsprechend hat sich die Situation nicht nur für die diagnostische Bildproduktion verändert, sondern auch für die Bildproduzierenden.

Bildwelten: Technisch gesprochen, welche Voraussetzungen müssen Bilder inzwischen erfüllen, um in bildgeführten Eingriffen eingesetzt zu werden?

Tina Kapur: Die kurze Antwort auf diese Frage wäre: Bilder, die typischerweise präoperativ gemacht werden, um in ein Navigationssystem eingespielt zu werden, müssen die anatomischen Landmarken enthalten, die zur Registrierung mit dem Patientenkörper notwendig sind, in einem Standardformat (wie DICOM [*digital imaging and communication in medicine*]) vorliegen und eine ausreichend geringe Schichtdicke besitzen. Bei intraoperativ erstellten

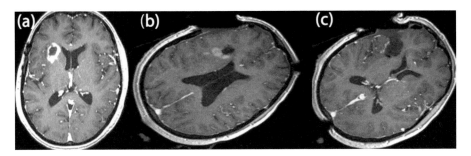

1: Bildführung in einer Hirntumoroperation: (a) präoperatives (diagnostisches) MRT-Bild, (b), (c) intraoperative Scans zur Verlaufskontrolle mit (b) und ohne (c) Tumorrest.

Bildern wird zu dieser Frage noch intensiv geforscht. Die Bilder müssen erstens den Chirurginnen und Chirurgen etwas zeigen, das deren intraoperative Entscheidungsfindung stützen kann, zweitens nicht von hoher diagnostischer Qualität sein, da die diagnostische Bildgebung ihren Zweck bereits erfüllt hat, und sollten drittens mit neuen, aktualisierten Informationen für die Navigation aufwarten, die über das hinausgehen, was die Operierenden bereits wissen. Wer heute einen Blick in unser PACS [*picture archiving and communication system*, das klinische Bildverwaltungsprogramm] und auf die Bilder wirft, die uns 2011 für die allerersten Patientinnen und Patienten in AMIGO zur Verfügung standen, sieht noch große Unterschiede zu heutigen Sehgewohnheiten. Die grundsätzliche Frage ist stets, welche Bildsequenzen einen echten informativen Mehrwert darstellen; daran orientiert haben wir unter anderem ein Standardprotokoll für Hirntumoroperationen entwickelt, das aus spezifischen MRT-Sequenzen besteht. Das diagnostische Bild zeigt den Ausgangszustand, also die genaue Lokalisation, Ausdehnung und Kontrastmittelanreicherung eines Tumors. Die intraoperativen Scans geben Auskunft über einen möglichen Tumorrest und bestätigen dessen erfolgreiche Entfernung bei Operationsende. ↗ **Abb. 1** Während wir anfangs hochauflösende Bilder im OP-Saal angestrebt haben, sind wir mit zunehmender Erfahrung dazu übergegangen, niedriger auflösende – und weniger – Bilder zu nutzen, um das Mindestmaß an Bildgebung zu bestimmen, das für intraoperative Entscheidungsfindung benötigt wird. Grundsätzlich unterscheiden sich die bildgebenden Verfahren im Saal jedoch nicht von denen in der radiologischen Abteilung.

Bildwelten: Kann man also sagen, dass sich die Bildproduktion für den oder im Operationssaal immer an etablierten diagnostischen Standards orientiert?

Tina Kapur: Absolut. Abgesehen von der Massenspektrometrie, die hochgradig invasiv ist, gibt es nichts in AMIGO – auf Bilder bezogen –, das nicht auch in der

Radiologie des Krankenhauses gemacht werden könnte. Natürlich gibt es intraoperative Anforderungen, die in Betracht gezogen werden müssen. Im OP-Saal sucht man nicht nach großer Detailschärfe im gesamten Bild. Hochdetaillierte Bilder der Patientenanatomie werden im Vorfeld produziert, diese sind entsprechend die wichtigen visuellen Instrumente für die Therapieentscheidung. Trotzdem kann selbst eine eher grobe Bildgebung während eines Eingriffs Vorteile mit sich bringen und Details offenbaren, die wir nur auf dem Bild und nicht im offenen Körper sehen. Zum Teil liegt dies an der jeweiligen Lagerung des Körpers, zum Teil an den unübersichtlichen Bedingungen während der Operation durch Blut und Gewebe, das die Sicht versperrt. Vor allem Blut verschlechtert die chirurgische Sicht erheblich.

Bildwelten: „Bildqualität" heißt also in erster Linie Auflösung, Gewebekontrast, Schichtdicke, Schnittebenen, Spezialsequenzen und gegebenenfalls Kontrastmittel, die besonders relevante Strukturen hervorheben?

Tina Kapur: Bildqualität bedeutet in unserer Arbeit eingriffsspezifische Information. In der chirurgischen Onkologie bedeutet Bildqualität die möglichst genaue Ortung des Tumorrandes. Optische Bildgebungsverfahren wie Mikroskope und Endoskope bieten dem Chirurgen eine Sicht auf eine offene Oberfläche und alles, was sich darauf befindet, und zwar bei einer höheren Auflösung als mit dem bloßen Auge. Während die Chirurgie grundsätzlich auf Oberflächen operiert, und zwar Schicht für Schicht, geben nicht-optische Verfahren wie MRT, CT, Röntgen und Ultraschall Informationen darüber, was sich unterhalb des freigelegten Gewebes befindet, darunter gelegentlich auch sehr präzise Details. Manche Tumoren präsentieren sich optisch exakt wie gesundes Gewebe, während sie im MRT vollkommen anders aussehen. Ein anderer Vorteil gegenüber dem bloßen Auge ist die multimodale Bildfusion, die Verbindung verschiedener Bildgebungsverfahren. Unabhängig davon, welche Bildmodalität während des Eingriffes eingesetzt wird, zum Beispiel die CT in einer Wirbelsäulenoperation zur Darstellung von Knochenstrukturen für die Navigation, können auf diese Weise detaillierte präoperative visuelle Informationen über die Weichteilverhältnisse hinzugezogen werden, wie sie die MRT zu bieten vermag. ↗ Abb. 2 Die Verfahren und ihre jeweiligen Stärken werden am Patienten „zusammengesehen".

Bildwelten: Warum sich nicht darauf konzentrieren, eine einzelne Bildmodalität zu perfektionieren, anstatt in der Operation mehrere zu kombinieren?

Tina Kapur: Diesen Ansatz haben wir eine Zeitlang verfolgt. Als wir mit AMIGO begonnen haben, hatten wir umfangreiche Vorerfahrungen mit intraope-

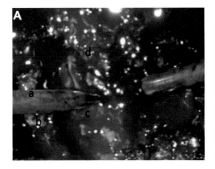

2: Multimodale Bildführung bei einem Wirbelsäuleneingriff: (A) Mikroskopansicht mit Instrumentenposition, (B) korrespondierende Navigationsbilder während der Operation (obere Reihe CT, untere Reihe MRT).

rativer MRT und konnten auf einer vorhandenen Lernkurve aufbauen. Dies ist der Grund, warum der Einsatz von MRT in AMIGO deutlich ausgereifter ist als der anderer Bildgebungsmodalitäten. Aussagekräftige morphologische Daten, wie sie von der anatomischen Schnittbildgebung zur Verfügung gestellt werden, stehen in unserem Kontext im Fokus, weil die meisten bildgeführten Verfahren genau daraufhin entwickelt werden. Das technische Potenzial aus der Kombination von Verfahren für bildgeführte Eingriffe ist jedoch beträchtlich, weil auf diese Art verschiedene zusätzliche Bildinformationen in die anatomischen Koordinaten integriert werden können.

Bildwelten: Gibt es künftige Anwendungsbereiche der bildgeführten Therapie, die momentan aufgrund der aktuellen Bildqualität nur eingeschränkt oder überhaupt nicht umsetzbar sind?

Tina Kapur: Beschränkungen, die sich primär aus der Bildqualität ergeben, sehen wir zum Beispiel in der Bildgebung peripherer Nerven, etwa in der Schilddrüsenchirurgie. Optimalerweise würden die Kehlkopfnerven im Bild aufleuchten, so dass sie nicht versehentlich während des Eingriffes als Kollateralschaden durchtrennt werden. Bei der Entfernung von Lymphknoten in der Allgemeinchirurgie fragen die Operierenden wiederum nach einer Möglichkeit, die Wächterlymphknoten bei Tumorpatienten gezielt hervorzuheben. Diese beiden Beispiele sind Versionen derselben Grundidee, nämlich die Identifizierung und Anvisierung von Gewebearealen, die entweder erhalten oder entfernt werden müssen. Bildgebung in dieser Hinsicht zu erweitern ist eine Perspektive für zukünftige Anwendungen im Bereich bildgeführter Therapien. Eine andere Perspektive liegt darin, komplexe Bildgebung in neueste Robotikanwendungen zu integrieren. Einiges von der innovativsten und

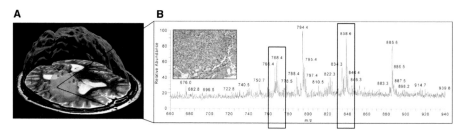

3: Positionsgenaue molekulare Gewebeanalyse bei einem Hirntumor: (A) Biopsiepunkte auf dem MRT-Bild, (B) differenzierte Gewebeanalyse für einen ausgewählten Punkt.

kommerziell erfolgreichsten Technologie hat es über den minimalinvasiven Da-Vinci-Operationsroboter in den OP-Saal geschafft. Da-Vinci-Instrumente erlauben mehr Bewegungsfreiheit als die eigentliche Hand, während die Chirurgin auf Bilder angewiesen ist, um diese Instrumente überhaupt nutzen zu können. Firmen haben bereits Bildgebungsinstrumente wie optische Kameras und Ultraschallwandler entworfen, die mit Da-Vinci-Operationen kompatibel sind. Und doch verlassen sich viele Chirurginnen und Chirurgen während einer Operation nach wie vor auf haptisches Feedback, und Bildgebung vermag hierzu noch nicht allzu viel beizutragen.

Bildwelten: Diese Einschränkungen zu überwinden würde also nicht nur bedeuten, dass vorhandene Bildgebungsmodalitäten verbessert werden müssen?

Tina Kapur: Sondern auch die Erfindung neuer Bildgebungsformen erfordern? Ja, gut möglich. Auch wenn wir die MRT momentan in gewisser Weise für die „perfekte" Bildmodalität für die meisten bildgeführten Eingriffe im Weichteilbereich halten, gibt es noch sehr viele Entwicklungen, die sich klinisch beweisen müssen. Durch die Kombination von Neuronavigation und Massenspektrometrie in der Hirntumorchirurgie zum Beispiel können meine Kollegin Nathalie Agar und ihr Team molekulare Analysen von resezierten Tumoren vornehmen, die exakt dem Punkt zugeordnet werden können, von dem die Gewebeproben entnommen worden sind. Das wurde dadurch möglich, dass wir die einzelnen Punkte auf dem intraoperativen MRT-Bild genau bestimmen können. ↗ **Abb. 3** Wir sind dadurch imstande, sehr viel mehr über die Biologie der Tumoren im Verhältnis zu ihrer bildräumlichen Darstellung in der morphologischen Diagnostik zu lernen.

Bildwelten: Liegt darin die Zukunft? In einer neuartigen Kombination von anatomisch-basierter Bildführung und molekularer Bildinformation?

Tina Kapur: Sehr wahrscheinlich. Über die Navigation kommt im OP-Saal alles zusammen. Das ist die Grundvoraussetzung für Multimodalität. Wenn wir navi-

gieren können, können wir alle vorhandenen Technologien zusammenbrin-
gen. Operateurinnen und Operateure sollten die einzelnen Informationen
nicht in ihrem Kopf zusammenführen müssen. Natürlich sind sie dazu in
der Lage, aber wenn ihnen diese Arbeit abgenommen wird und sie sich nur
um die Steuerung oder die Feinkontrolle kümmern müssen, dann werden
ihre kognitiven Kapazitäten nicht durch die mentale Koordination und
Übersetzung verbraucht.

Bildwelten: Werden Bilder so in ihrer Rolle aktiver oder „operativer" als früher?

Tina Kapur: Ich denke schon. Ein Beispiel aus der US-amerikanischen Neurochirurgie:
Vor zwanzig Jahren wollten sich viele nicht mit Ultraschall aufeinander-
setzten, weil ihnen die Bildqualität – und damit der verwertbare visuelle
Informationsgehalt – zu schlecht war. Stattdessen haben sie sich ganz auf
das Mikroskop verlassen. Inzwischen haben sich Ultraschallbilder deutlich
weiterentwickelt und die Beteiligten werden besser ausgebildet, diese Bilder
zu interpretieren. Mit einem Mal ist Ultraschall die wohl unkomplizierteste
intraoperative Bildgebung, die man hier derzeit finden kann. Bilder sind
schon zu Zeiten meines Studiums in chirurgischen Kontexten benutzt wor-
den. Es gab Leuchtkästen und ausgedruckte MRT-Bilder auf Film. Aber es
gab keine Möglichkeit, diese Bilder in das Koordinatensystem der Patien-
tinnen und Patienten zu bringen. Darin liegt die Vermittlungsleistung der
Navigationssysteme. Anstatt ein Bild anzuschauen und dann in unserem
Kopf auf einen Körper zu übertragen, ermöglichen sie es uns, auf diesen
Körper zu schauen, auf einen Punkt zu zeigen und auf dem Bild genau zu
sehen, wo sich dieser Punkt befindet.

Bildwelten: Befürchten Sie nicht, dass diese chirurgische Fähigkeit zur Übertragung,
zur mentalen Vorwegnahme dessen, was an welcher Stelle im Patienten-
körper passiert, verloren gehen wird?

Tina Kapur: Als wir die ersten Navigationssysteme gebaut haben, wurden diese Systeme
gerade erst klinisch getestet und es gab zunächst keinen Beweis für uns,
dass sie wirklich wichtig sein könnten. Erst als die klinischen Testreihen
schon sehr weit fortgeschritten waren, eines Tages unser Demosystem aus
irgendeinem Grund nicht funktionierte und der fragliche Chirurg die Ope-
ration deswegen absagte, wurde uns klar, dass sich die Lage geändert hatte.
Wenn man heutzutage einen beliebigen neurochirurgischen Operationssaal
betritt, findet man dort zuverlässig ein Navigationssystem. Einige nutzen
es nach wie vor nicht – jede Technologie hat ihre Adoptionskurve. Ich
denke jedoch, dass das medizinische Personal insgesamt besser im Multi-
tasking wird. Sie mögen einige konventionelle Fähigkeiten einbüßen, dafür

gewinnen sie neue hinzu. Der Nutzen des Neuronavigationssystems ist zu Beginn eines Eingriffes am größten. Dadurch entfällt die umständliche Abschätzung, wie der optimale chirurgische Zugang gewählt werden sollte. Darin liegt der größte Gewinn des Verfahrens.

Bildwelten: Anschließend greifen sie wieder auf ihr eigenes anatomisches und funktionelles Wissen zurück.

Tina Kapur: Richtig. Und an dieser Stelle könnten in Zukunft verschiedene ergänzende Verfahren ins Spiel kommen, die relevante Bereiche optisch hervorheben und einerseits den besten Zugang sowie andererseits das exakte chirurgische Zielgebiet vorgeben können. Eine effektive Form der visuellen Anleitung, was entfernt und was belassen werden muss.

Bildwelten: Ist eine derartige „Führungsfunktion" inzwischen ein unverzichtbares Kriterium, um den Wert von Bildern zu bemessen?

Tina Kapur: Nein. Die meiste Bildgebung ist nach wie vor rein diagnostisch, und nur ein geringer Prozentsatz – ich würde schätzen, etwa fünf Prozent – entfällt auf *image guidance* im Rahmen von Eingriffen. Ein präoperatives Bild, unabhängig von der Bildmodalität, kann einen Eingriff führen, solange es nicht zu starke anatomische Verschiebungen im Körper gibt. Viele Firmen bauen Navigationsprodukte, die sich auf präoperative Bilder stützen. Der Gedanke dahinter ist vergleichbar mit allen anderen Formen der Navigation: Man fährt mit seinem Auto auf einer Karte, die im Vorfeld erstellt wurde, und bekommt währenddessen eine Vorschau auf das Ziel präsentiert, auf das man hinsteuert. Die nächste Frage wäre, wie aktuell dieses Bild genau ist. Schaue ich auf eine Karte vom Vortag oder von vor zwei Tagen? Im Vergleich mit einem Eingriff ohne Karte sind diese Bilder sehr wertvoll. Für viele grundsätzliche Aspekte ist die Navigation auf Basis von vorher erstellten Bildern vollkommen ausreichend, Details, die nicht so sehr von der Zeit beeinflusst werden, zum Beispiel die Tumorlokalisation. Historisch gesehen, ist die älteste Form bildgeführter Behandlung die Strahlentherapie – dort werden im Vorfeld Hunderte von Scans gemacht und für die Umsetzung des Bestrahlungsplans genutzt.

Bildwelten: Macht es einen Unterschied für die Bildherstellung, ob diese Bilder eine Maschine oder einen Menschen bei der Durchführung der Therapie anleiten? In der Strahlentherapie gibt es viele automatisierte Prozesse und komplexe Kontrollverhältnisse zwischen Mensch und Maschine.

Tina Kapur: Eine Maschine zu haben, die die Behandlung durchführt, ist immer die größere Herausforderung. Wir akzeptieren den Umstand, dass eine Fach-

kraft den Behandlungsplan vorgibt und die Maschine anschließend das Skalpell führt. In der Radiochirurgie wurde diese Kunst perfektioniert. Trotzdem möchten wir im Verlauf der Behandlung die wichtigen Organstrukturen und die Tumorlage kontrollieren, deshalb werden in solchen Fällen röntgenbasierte Bilder zur Positionskontrolle gemacht.

Bildwelten: *Image guidance* impliziert eigentlich immer, dass Messdaten für ein menschliches Auge visualisiert werden – eine Maschine braucht schließlich keine Datenvisualisierung. In Ihrer Arbeit an bildgeführten Therapieformen entscheiden Sie regelmäßig darüber, welche Funktionen „bildlich" werden und welche nicht. Wie sehr beeinflusst es die Präsentation von eingriffsrelevanten Informationen, ob sie am Ende von einem Menschen oder einer Maschine genutzt werden?

Tina Kapur: Visuelle Information muss sich danach richten, was die Chirurgin wahrnehmen kann, sowohl in der Quantität als auch im Detailgrad. Hier in unserem Labor, dem Surgical Planning Laboratory, richten sich die meisten Tools an menschliche Endnutzerinnen und Endnutzer. Ein für uns interessanter Anwendungsfall war Ultraschall. Die Bilder, die wir sehen, sind zweidimensionale Bilder, die aus einer großen Menge zugrundeliegender Daten erstellt werden. Diese geben Aufschluss über die akustischen Eigenschaften des Gewebes. Die Bilder sind für ein menschliches Auge gemacht, aber ein Großteil der Informationen dahinter geht im Prozess der Bildwerdung verloren. Forschende haben damit begonnen, diese Rohdaten in die Bildverarbeitung mit einzubeziehen, um mehr über die elastischen Eigenschaften der Gewebe zu erfahren. Sie gehen entsprechend in einem größeren Maßstab mit Bilddaten um, nicht nur mit dem, was das menschliche Auge verarbeiten kann.

Bildwelten: Wird die Bildführung Ihrer Meinung nach zuverlässiger, je dichter man an tatsächliche Echtzeit-Bildgebung herankommt, zum Beispiel durch die Nutzung von Bildupdates aus Endoskopie und Ultraschall?

Tina Kapur: Lässt man den Kostenfaktor einmal beiseite, würde ich sagen, jeder Eingriff sollte es den Operierenden erlauben, die Veränderungen der Anatomie, an der operiert wird, gleichzeitig visuell zu verfolgen. Da wir in der gegenwärtigen Bildgebung nicht sehr viele Beispiele für Echtzeit-Funktionalität haben, ist das derzeit nicht praktikabel. Allerdings gibt es selbst in der Bestrahlungsplanung seit etwa zehn Jahren einen Ansatz dazu, nämlich die adaptive Strahlentherapie. Die Idee dahinter ist, dass zwischen jeder Behandlung ein neues Bild – entweder ein MRT- oder ein CT-Scan – gemacht und bei Bedarf eine Anpassung des Behandlungsplans an die

veränderte Patientenanatomie ermöglicht wird. ↗ **Abb. 4** In der Neurochirurgie wiederum weiß man inzwischen, dass die Operationsergebnisse um etwa 30 Prozent besser sind, wenn vor Operationsende ein MRT-Bild gemacht wird. Kontinuierliches Feedback und fortlaufende Bildführung findet man im Moment eher in der interventionellen Radiologie. Bewegt man einen Katheter während Live-Röntgenaufnahmen, sieht man genau, wo er sich befindet. Natürlich geht fortlaufende Bildgebung auf Basis von Röntgenstrahlung mit all den Risiken einher, die Strahlenexposition mit sich bringt. Heutzutage haben wir in der Neurochirurgie keine Bildlösung, die es erlauben würde, Handlungen unter Live-Updates der Bilder durchzuführen. Etwas Derartiges wäre phänomenal.

Bildwelten: Wie schätzen Sie den Umstand ein, dass alle diese Bilder eine zusätzliche Ebene zwischen Ärztin und Patientin einschalten? Bilder vermitteln, sie bilden einen Zwischenraum, anders als in offenen Operationen, wo es direkten, scheinbar unvermittelten Sichtkontakt mit dem Körper gibt.

Tina Kapur: In der laparoskopischen Chirurgie funktioniert es ausschließlich auf diese Weise – indirekt. Die Bildgebung und das Wissen, das sie zur Verfügung stellt, können diese Indirektheit hinlänglich kompensieren. Bilder schalten sich in allen möglichen Eingriffsformen ein, dabei müssen sie sehr anpassungsfähig bleiben, empfänglich für die jeweils vorrangige Anforderung. Es ist wie bei der Navigation mit GPS: Wenn ich mein Smartphone nicht benutze, lerne ich die Gegend sehr viel besser kennen. Allerdings kann ich mich auch verirren oder entscheidende Dinge verpassen. Einige Fahrten würde ich gar nicht erst unternehmen.

Bildwelten: Verbessert sich mit der technischen Erweiterung chirurgischer Sehbedingungen auch das Verständnis chirurgischen Sehens?

Tina Kapur: Ich denke ja. Neueste Technologie, selbst Prototypen, kommt inzwischen sehr früh in die Krankenhäuser und Testumgebungen wie AMIGO, und man muss sich damit aktiv auseinandersetzen. In unserem Programm für bildgeführte Therapien trainieren wir chirurgisches Personal sehr ausgiebig in der Bildnutzung, als Vorbereitung darauf. Natürlich lassen sich diagnostische Bildinterpretation und therapeutische Bildnutzung nicht wirklich voneinander trennen. Radioonkologen etwa sind sehr versiert in der Interpretation von dreidimensionalen Bildern, weil sie täglich damit arbeiten. Sie bereiten die Bestrahlung vor, aber sie analysieren auch Bilder. Dieser Zusammenhang ist entscheidend.

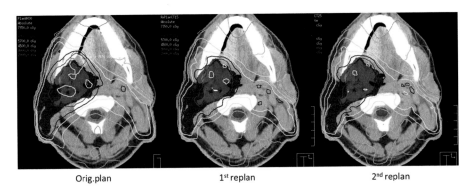

Orig.plan 1st replan 2nd replan

4: Adaptive Strahlentherapie bei Kopf-Hals-Tumoren.

Bildwelten: Ziehen Sie aus diesen Entwicklungen spezielle Konsequenzen für die medizinische Aus- und Weiterbildung?

Tina Kapur: Wir betonen in erster Linie, wie wichtig das Verständnis der zugrundeliegenden Technologien ist. Wenn unsere Trainees uns wieder verlassen, wissen sie um den schnellen Wandel und die Mängel der Technik. Wir fördern ein tiefgehendes Interesse für all diese Fragen, denn wenn die Praktizierenden an der Entwicklung von Verfahren nicht beteiligt sind, wird die Technologie auch nicht genutzt werden. Viele hochgradig innovative Produkte verstauben ungenutzt, weil sie Lösungen ohne genaue Kenntnis der praktischen Probleme anbieten. Während des Medizinstudiums wird dem chirurgischen Nachwuchs nicht genug Raum für Bildarbeit gegeben, da hierfür traditionell die Fachleute aus der Radiologie in der Verantwortung gesehen werden. Bei intraoperativer Bildgebung und -führung funktioniert diese Praxis jedoch nicht mehr. Es geht nicht darum, jemanden „offline" eine Diagnose stellen zu lassen. Es geht darum, genug Bildinterpretation zu beherrschen, um im Zweifelsfall eine Radiologin in den OP-Saal zu rufen. Es geht darum, die Zusammenarbeit zwischen Chirurgie und Bildproduktion zu intensivieren. Im Bereich der Bildführung warten noch viele Herausforderungen auf uns. Je mehr Bildgebung von einer diagnostischen zu einer perioperativen Angelegenheit wird, desto wichtiger werden multidisziplinäre Teams.

Das Gespräch führte Anna Roethe am 3. März 2016 in Boston.

Bildbesprechung

Janet Vertesi

Kollektive Arbeit.
Bilder und Interaktionen auf dem Mars

Die Bilder, die die Rover *Spirit* und *Opportunity* bei ihren Marsexplorationen aufgenommen haben, kursieren als spektakuläre Visionen der Weltraumerkundung in der Öffentlichkeit. Hinter den Kulissen sind sie jedoch in erster Linie Arbeitsmaterial und durchlaufen fortwährende Verhandlungs-, Interpretations- und Interaktionsprozesse. Im Mittelpunkt dieser Arbeit steht nicht ein einzelner Mensch, der als kognitiv Verständiger für die Interpretation und Intervention verantwortlich ist. Wie bei vielen Bildern, die im Mittelpunkt von Handlungen stehen, ist die Auswertung vielmehr ein Teamprozess.

Dies manifestiert sich zuallererst in der Planung mit Bildern, zu denen das abgebildete gehört.[1] ↗ **Abb. 1** Roboter bewegen sich nicht von alleine und nehmen auch nicht selbsttätig Bilder auf. Stattdessen ist ein Team von etwa 150 Experten aus wissenschaftlichen und technischen Fachgebieten auf der Erde für jede Minute und Sekunde verantwortlich, die der Roboter auf dem Mars verbringt. Diese Gruppe überprüft die Bilder und Daten, die der Roboter in der Nacht vor Beginn der geplanten Schicht gesendet hat. In stundenlangen Telefonkonferenzen stellen die Teammitglieder eine Gruppe von Vertretungen aus jedem einzelnen ihrer wissenschaftlichen und technischen Fachgebiete zusammen, um eine einheitliche Interpretation der Position des Roboters, der auffälligsten und wissenschaftlich interessantesten Ziele um ihn herum und dessen weitere Interaktionen auf dem Mars zu besprechen und zu planen. Jedes Bild muss kollektiv gestaltet werden, um sowohl wissenschaftlichen Zielen gerecht zu werden als auch in die täglichen Kontingente an Bits, Energie und des Daten-Downloads zu passen.

Selbst diese täglichen Planungssessions werden in längere Zyklen interpretativer Arbeit eingebunden. Die Forschenden sind fortwährend damit beschäftigt, Daten zu verarbeiten, die die Instrumente des Marsroboters, insbesondere dessen Multispektralkameras, liefern. Diese Kameras verknüpfen eine Vielzahl an Einzelbildern zu Bildmosaiken, um das den Roboter umgebende Terrain besser zu erkennen. Bei wöchentlich stattfindenden Besprechungen werden vorläufige Forschungsergebnisse ausgetauscht, wissenschaftliche Fragen aufgeworfen und Prioritäten für die nächsten Bewegungen des Roboters festgelegt. Aus individuellen Visionen werden gemeinsame Visionen vom Mars und den zukünftigen Tätigkeiten des Roboters. Diese langfristigen Prioritäten werden unter Berücksichtigung der Notwendigkeit von unmittelbaren, taktischen Entscheidungen auf dem Mars mit strategischen Zielen der Mission in den täglichen Planungszyklen abgewogen und *vice versa*. Im hier gezeigten Bildmosaik sind die Fahrspuren des Rovers eine Spur dieser kollektiven Arbeit.

Die Interpretation der Bilder, die der Rover sendet, ist alles andere als einfach. Jedes Bild vom Mars wird durch die Kameraaugen eines etwa 1,5 Meter großen Erkundungsroboters gesehen, die über eine Lichtempfindlichkeit verfügen, die dem menschlichen Auge überlegen ist. Die Roboter durchqueren das Gebiet und können etwa durch Steine zum Umkippen gebracht werden oder in Sanddünen stecken bleiben. Um die Bilder zu verstehen und die nächste Folge von Aktivitäten planen zu können, entwickeln wissenschaftliche und technische Experten eine eigene körperliche Sensibilität für die potenziellen Aktionen und Interaktionen des Roboters auf dem Mars. Sie stecken ihre Arme aus wie Solarpaneele, machen eigenartige Verrenkungen mit ihren Ellenbogen, um die Bewegungsfreiheit des Roboterarms einschätzen zu können, und legen ihre Hände an beide Seiten ihres Kopfes an, um so ein Gefühl für die Positionierung der Kameras zu bekommen, die nicht wie menschliche Augen direkt nebeneinander, sondern in einem Abstand von 30 Zentimeter zueinander angebracht sind. Sie ahmen den Roboter und dessen Fähigkeiten mit dem eigenen Körper nach, um auf diese

1: D-Star Panorama des Rovers *Opportunity*, Testmosaik, Falschfarbenbild. Mit freundlicher Genehmigung durch NASA/JPL-Caltech/Cornell University.

Weise bestimmen zu können, was als nächstes zu tun ist.

Eine solche Herangehensweise ist besonders wichtig, da die Fähigkeiten des Roboters häufigen Änderungen unterliegen. So klemmte das Rad von *Spirit* zu Beginn des 700. Missionstages, während das Armgelenk von *Opportunity* eigenartig zufror. Staubstürme beeinflussen die Fähigkeit der Roboter, Solarenergie aufzunehmen, wobei andererseits Wind die Solarpaneele reinigt. Softwareaktualisierungen schaffen neue Möglichkeiten für Automatisierungen und verbessern die Intelligenz des Roboters. Das gezeigte Bildschirmfoto einer Mosaikdarstellung wurde zur Beurteilung eines solchen Upgrades aufgezeichnet, durch das die Fähigkeit des Roboters verbessert wurde, Hindernisse mithilfe von durch ihn selbst verarbeiteten Fotografien des Marsterrains zu erkennen, und somit seine Reichweite zu vergrößern.

All diese Dinge – tägliche Pläne, wissenschaftliche Interpretation und Verkörperung – könnten für sich allein stehen. Doch sie sind in einen organisatorischen Rahmen eigebettet. An sich ist dies nicht unüblich: Alle Teams, die sich mit Weltraumfahrzeugen befassen, sind dafür verantwortlich, auch Zeit für Forschungstätigkeiten ihrer Mitglieder einzuplanen. Allerdings ist das für den Rover verantwortliche Team relativ klein und in einer flachen Hierarchie

strukturiert. Zwar laufen alle Instrumente und Forschende bei einem einzelnen Forschungsleiter zusammen, jedoch wird erwartet, dass sämtliche zur Verfügung stehenden Maßnahmen zur Lösung von gemeinsamen Problemen eingesetzt werden. Entscheidungen über die Tätigkeiten des Rovers auf dem Mars spiegeln nicht das wider, was einzelne sondern alle Beteiligte tun möchten. Dementsprechend arbeitet das Team wie ein Kollektiv im Rahmen eines unilateralen Konsensmodells. Selbst am Ende von Planungsbesprechungen fragen sie sich gegenseitig: „Bist du zufrieden damit?", bevor sie den Plan freigeben. Wenn die Antwort von allen Anwesenden lautet: „Ich bin zufrieden damit", gehen sie zum nächsten Schritt über.

Dies erfordert ein außerordentliches Maß an sozialer Arbeit. Darüber hinaus sind dafür auch andere Bilder notwendig. Bilder, die Menschen gemeinsam den Körper des Roboters nachempfinden lassen, um aus dieser Position heraus kollektive Entscheidungen treffen zu können. Solche Bilder werden normalerweise durch den Roboter oder eine höher positionierte Sonde aufgezeichnet und darin Elemente gekennzeichnet, die sich in der Umgebung des Rovers befinden. Dabei kann es sich – wie bei der abgebildeten Aufnahme – um ein Falschfarbenbild handeln, das Anmerkungen enthält, mithilfe derer die Aufmerksamkeit auf örtliche Gegebenheiten

und spezifische Elemente gerichtet werden soll. Mit Bezug zu Wittgensteins Begriff der theoriegetriebenen Beobachtung, können solcherart Praktiken unter dem Begriff „Zeichnen-als" gefasst werden. Sie fordern andere Beteiligte auf, die gleichen Sachverhalte zu sehen und ein einheitliches Bild von einer Aktion des Roboter und einer wissenschaftlichen Interpretation zu zeichnen. Diese unter Ausschluss der Öffentlichkeit stattfindenden Praktiken sind von größter Bedeutung für die Herstellung eines Konsenses und dessen Ergebnis – den Aktionen des Roboters.

Die Erkundung des Planeten Mars erfordert eine vielschichtige Interpretation und fortlaufende Re-Repräsentationen. Wissenschaftliche und technische Teams müssen gemeinsame Entscheidungen treffen: in diesem Fall auf einer kollektiven Grundlage. Es bedarf einiger visueller Arbeit, kollektive Visionen von der Marsoberfläche zu erzeugen und zu einer konsensuellen Perspektive zu finden. Es erfordert ein hohes Maß an zwischen den Teams geteiltem Verkörperungsvermögen, durch das der Rover in den Körpern der Teammitglieder zum Leben erweckt wird. Zusammen ergeben diese Elemente einen iterativen Zyklus von Teamwork, Interpretation und Roboteraktionen. Wenn Bilder Handlungen erforderlich machen, eröffnen oder auf eine andere Art und Weise bestimmen, dann aufgrund der aktiven Interpellation von organisatorischer und interpretativer Arbeit hinter den Kulissen, durch die solche Handlungen zunächst entworfen werden.

Dieser Text wurde aus dem Englischen übersetzt.

1 Zum technischen Entstehungsprozess solcher Mosaikdarstellungen vgl. auch Janet Vertesi: Seeing Like a Rover: How Robots, Teams, and Images Craft Knowledge of Mars, Chicago 2015, S. 224–231.

Helena Mentis

Intraoperative Interaktion gestalten.
Die Sichtbarmachung des chirurgischen Bildes

Die historische Bestimmung der Chirurgie liegt darin, das Körperinnere freizulegen, um anatomische Strukturen zu korrigieren oder zu entfernen. In diesen Fällen bezieht und beschränkt sich der Bedarf an medizinischen Bildern (wie etwa Röntgenaufnahmen) auf die prä- und postoperativen Phasen der Behandlung. Mit den zunehmenden Anwendungsmöglichkeiten minimalinvasiver Operation hat sich hier jedoch ein neues visuelles Regime entwickelt, das sowohl die Art der Darstellung als auch die Art der intraoperativen Interaktion mit digitalen Bildern verändert.

Diese Bilddarstellungen und -interaktionen umfassen die Verwendung von Bildern als exklusive Sicht auf das Operationsgebiet wie in der laparoskopischen Chirurgie, sie ermöglichen einen Echtzeit-Abgleich zwischen Voraufnahmen und anatomischen Gegebenheiten auf präoperativen CT-Aufnahmen durch Infrarotsonden oder sie erlauben die Hinzunahme von Videoübertragungen des chirurgischen Orts für chirurgisches Telementoring und Telekonsultation. Derartige technologische Innovationen bieten jedoch nicht nur erweiterte Möglichkeiten, um den Körper zu betrachten. Ihre weitreichende Bedeutung ergibt sich vielmehr durch die Interaktion mit ihnen sowie durch die damit veränderte Interpretation im Rahmen sich ständig verändernder chirurgischer Bedürfnisse.[1]

So scheint es naheliegend, dass neue Technologien in der Chirurgie die Möglichkeiten und Einschränkungen der visuellen und operativen Erschließung des Patientenkörpers bestimmen. Studien über wissenschaftliches Arbeiten haben die wechselseitige Definition von Wissen durch die Einschränkungen und Erfordernisse des wissenschaftlichen Apparats gezeigt[2] sowie auf die Konsequenzen für wissenschaftliche Ergebnisse durch die Handlungsmacht des Objekts selbst hingewiesen, das mithin kein neutraler Apparat ist, der ohne Weiteres verwendet werden kann. Innerhalb der Chirurgie haben vor allem Koschmanns Arbeiten[3] auf die Bedeutung der interpretativen Natur des Sehens in der Chirurgie und dessen Wirkung auf Handlungen hingewiesen.

1 Morana Alac: Working with Brain Scans. Digital Images and Gestural Interaction in fMRI Laboratory. In: Social Studies of Science, 38, 2008, 4, S. 483–508; Kelly Joyce: Appealing Images. Magnetic Resonance Imaging and the Production of Authoritative Knowledge. In: Social Studies of Science, 35, 2005, 3, S. 437–462; Amit Prasad: Making Images/Making Bodies.Visibilizing and Disciplining through Magnetic Resonance Imaging (MRI). In: Science, Technology & Human Values, 30, 2005, 2, S. 291–316; Prentice: Bodies in Formation. An Ethnography of Anatomy and Surgery Education, Rachel Durham 2012.

2 Karin Knorr Cetina: Epistemic Cultures: How the Sciences Make Knowledge, Cambridge/London/ Massachusetts 2009; Andrew Pickering: The Mangle of Practice. Time, Agency, and Science, Chicago 1995.

3 Timothy Koschmann, Curtis LeBaron, Charles Goodwin, Paul Feltovich: Can you see the cystic artery yet? A simple matter of trust. In: Journal of Pragmatics, 43, 2011, 2, S. 521–541; Timothy Koschmann, Curtis LeBaron, Charles Goodwin, Alan Zemel, Gary Dunnington: Formulating the Triangle of Doom.

Ebenso wegweisend war die Studie von Rachel Prentice, welche den Verkörperungs-grad von Praktiken aufgezeigt hat, die zum Erwerb von bildspezifischem Fachwissen bei chirurgischen Assistenzärztinnen und -ärzten führen.[4]

Bis heute wird die Entwicklung von computergestützten Werkzeugen für die Chirurgie durch das Bedürfnis angetrieben, eine möglichst genaue und realistische Darstellung zu erlangen. Die Frage, wie die Interaktion mit Bildern ein handlungsbe-zogenes Wissen im Hinblick auf die Zielsetzung des Eingriffs hervorbringt, wird dabei allerdings zumeist ausgeklammert. So zielen die meisten technischen Entwicklungen darauf ab, möglichst hochaufgelöste Bildschirmdarstellungen zu erreichen. Interaktionale Ansätze zur Verflechtung von Bildern mit Wissens- und Handlungsoptionen bleiben dabei nachrangig. Um darzulegen, wie bildgebende Interaktion im Rahmen eines bildgebenden Systemdesigns besser verstanden und eingesetzt werden könnte, sollen im Folgenden daher drei Themenbereiche von „verkörperter" Bildinterakti-on in der Chirurgie vorgestellt werden, hier zusammengefasst unter den Begriffen „Emergenz des Sehens", „Offenlegung der Anatomie" und „Herstellung von Sicht-barkeit". Insbesondere durch Freilegung der Mechanismen und Motivationen, die den bildgeleiteten Verfahren zugrundeliegen, können Aufbau und Einsatzort bildbasierter Interaktionssysteme besser identifiziert werden.

Emergenz des Sehens

Die vielfältigen Darstellungen des Körpers, heute zur Verfügung stehen, sind eng mit den Möglichkeiten einer physischen Manipulation verflochten und der Einblick in den Körper, den sie ermöglichen, ist auf eine entsprechende Handhabung ausgerichtet. Die hochgradig konstruierte Sicht wird insbesondere durch das fortwährende Beziehungs-geflecht von Händen, Instrumenten und Bildern erreicht. Erst eine Abfolge von Fühlen, Sehen und Sprechen führt dazu, dass die Bilder ihr Wissen tatsächlich preisgeben.

So steht zum Beispiel während der Entfernung eines Spinaltumors über einen endonasalen Zugang die manuelle Bewegung der neurochirurgischen Werkzeuge in direkter Beziehung zur Ansicht des Körpers, die von den intraoperativen Bildern geboten wird.[5] Das Navigationssystem Treon der Firma Medtronic, das mit der soge-nannten *StealthStation* des Herstellers ausgeliefert wird (im Folgenden als *StealthCam* bezeichnet), vermittelt die Lage einer Sonde auf präoperativen CT-Aufnahmen, wäh-

 In: Gesture, 7, 2007, 1, S. 97–118. Michael Lynch: Discipline and the Material Form of Images. An Ana-lysis of Scientific Visibility. In: Social Studies of Science, 15, 1985, 1, S. 37–66.

4 Prentice (s. Anm. 1).

5 Helena Mentis, A. S. Taylor: Imaging the body. In: Proceedings of the SIGCHI Conference on Human Factors in Computing Systems – CHI '13, New York, 2013, S. 14–79.

1: Emergentes Sehen des Körpers durch eine Kombination von Darstellungen und physischen Manipulationen. Der StealthCam-Bildschirm ist links, der Endoskop-Bildschirm ist rechts im Bild.

rend das Endoskop eine Videoansicht der Handlung zeigt. In diesem Zusammenhang richtet das chirurgische Personal kontinuierlich seine Aufmerksamkeit abwechselnd auf die endoskopische Anzeige rechts und die StealthCam-Anzeige links. ↗ **Abb. 1** Diese Darstellungen erhalten ihre Bedeutung wiederum durch gleichzeitige Interventionen wie Bohren, Abklopfen und Druckanwendung auf die Gewebe und den Knochen. Entscheidend ist hier, dass das endoskopische Video und die StealthCam in Koordination mit den Handlungen der Operierenden verwendet werden. Die visuellen Darstellungen sind nur in Kombination mit der physischen Erkundung des Körpers und der zeitlich-räumlichen Bewegung durch ihn hindurch sinnvoll. Entscheidend für den Eingriff ist nicht nur die gleichzeitige Wahrnehmung verschiedener Bildformen, sondern auch die parallele Tastempfindung, vermittelt durch Instrumente, Finger und Hände.

So wird deutlich, wie das „Sehen" des Körpers durch eine Abfolge von Aktionen und Interaktionen erreicht wird und daraus allmählich emergiert. Aktionen und Interaktionen, sowohl mit dem Körper als auch mit den Bildern, stiften gemeinsam ein Verständnis dafür, was als Nächstes zu tun ist. Ohne dergestalt koordinierte Aktionen blieben die Bilder bedeutungslos. Die Verschränkung von Bild und Handlung wiederum erfordert eine unmittelbare Nähe von Bildschirmmedien zum OP-Tisch, um zwischen dem Operationsgebiet auf den Darstellungen und der Lokalisierung des Dargestellten innerhalb des Körpers eine Beziehung herzustellen.

Im Falle der StealthCam wird der wechselseitige und nahtlose Verweis zwischen Körper und präoperativen CT-Aufnahmen durch eine sterile Sonde erreicht, mit der das Operationsgebiet visuell markiert wird (Telestration). Jedoch wird die Beziehung zwischen den beiden Darstellungen – CT-Aufnahme und Endoskopie – nur durch mentale Mitwirkung erbracht, da die beiden Modi miteinander synchronisieren müssen. Die Möglichkeit, den eigenen Blickwinkel der endoskopischen Kamera auf die CT-Aufnahme zu übertragen, könnte ein erster Schritt sein, die beiden verschiedenen Darstellungen miteinander zu verbinden.

Offenlegung der Anatomie

Während der chirurgischen Aus- und Weiterbildung werden Ärztinnen und Ärzte in zunehmendem Maße bei der Identifizierung und Darstellung anatomischer Gegebenheiten bildlich unterstützt und angeleitet. Der Einsatz optischer und bildbasierter Methoden ist längst Teil des visuellen Erlernens der menschlichen Anatomie, das in der chirurgischen Ausbildung durchlaufen werden muss, um den Körper in seinen Bestandteilen wahrzunehmen, die vom Körper als Ganzem getrennt werden können.[6] In einer Studie mit ärztlichem Nachwuchs, der das minimalinvasive Verfahren einer laparoskopischen Cholezystektomie (d. h. der Entfernung der Gallenblase) erlernte, hielten die chirurgisch Erfahrenen den Nachwuchs an, den Körper durch die Verwendung der laparoskopischen Instrumente, Sprache und des Laparoskops selbst erfolgreich darzustellen.[7] Im Verlauf des chirurgischen Eingriffs ließ dieser Prozess des Erklärens, deiktischen Verweisens und Präparierens die Anatomie allmählich aus dem durcheinander von Gewebstrukturen und Bildeindrücken hervortreten. Während sich die Ansicht selbst im Verlauf der Operation häufig kaum verändert, besteht die anatomische „Enthüllung" gerade darin, dass die visuelle Information eine neue, anwendungsbezogene Bedeutung gewinnt.

Zum Beispiel sondiert ein behandelnder Chirurg Bindegewebe über anatomischen Zielstrukturen und lässt dabei seine eigene Sehpraxis einfließen, durch die die Anatomie für ihn sichtbar wird:

> *„If this is the common bile duct …"* [verfolgt den Gallengang langsam mit der Spitze der Sonde.] *„… that means the window goes this way."* [Greift sanft mit dem Dissektor in die Stelle, wo seinen Angaben nach das Fenster sein sollte, und es entsteht eine Öffnung.] *„And this might be the artery."* [Verwendet den Dissektor, um ein Stück eines länglichen Gewebes zu ergreifen und hochzuhalten.] ↗ **Abb. 2**

Durch die chirurgischen Erklärungen und Anleitungen legt der chirurgische Oberarzt der Assistenzärztin gegenüber schrittweise offen, was sie vorher nicht wahrgenommen hatte. Chirurgische Oberärztinnen und -ärzte tun dies in der Regel durch Verwendung der zur Verfügung stehenden Instrumente und durch Zeigegesten an einem Videobildschirm, der strategisch hinter ihnen und in Reichweite platziert ist.

6 Stefan Hirschauer: The Manufacture of Bodies in Surgery. In: Social Studies of Science, 21, 1991, 2, S. 279–319.

7 Helena Mentis, Amine Chellali, Steven Schwaitzberg: Learning to See the Body. Supporting Instructional Practices in Laparoscopic Surgical Procedures. In: Proceedings of the 32nd annual ACM conference on Human factors in computing systems, 2014, S. 2113–2122.

Derartige Praktiken der Bild-
interaktion und des Bildlernens sind
durchweg aus der Chirurgie selbst
und ihrem Repertoire an Werkzeu-
gen hervorgegangen. Bildgebungs-
systeme unterstützen diese intra-
operativen Bildinteraktionen in der
Ausbildung nicht standardmäßig.
Untersuchungen belegen, dass die
Praxis der Telestration auf Laparos-
kopievideos vor allem durch Gesten
oder Mechanismen des Blickrich-

2: Erfahrener Chirurg, der eine Anatomie durch Dissektion darstellt. Die chirurgische Assistenzärztin verbessert dadurch ihr visuelles Verständnis.

tungs-Trackings untestützt wird. Dies ermöglicht es erfahrenen Operierenden, spezi-
fisch auf die sie interessierende Anatomie hinzuweisen oder diese zu markieren. Die
Bereitstellung eines Telestrationssystems befreit den chirurgischen Oberarzt davon,
sich vom OP-Tisch abwenden zu müssen oder sich sogar kontinuierlich auf die Bilder
zurückbeziehen zu müssen. Stattdessen kann die Telestration auf einem Nebenbild-
schirm zur kontinuierlichen Anleitung durch in Ausbildung Befindliche dienen. Auf
diese Weise wird eine kontinuierliche Offenlegung der Anatomie ermöglicht.

Herstellung von Sichtbarkeit

Ebenso wie in Ausbildungssituationen sind an den meisten Operationen mehrere aus-
führende Chirurginnen und Chirurgen beteiligt. Um das Sehen der zusammenarbei-
tenden Beteiligten in Einklang zu bringen, muss die Ansicht des Körpers so gestaltet
werden, dass sie die Aufmerksamkeit und Diskussion unterstützt. Innerhalb der chir-
urgischen Telemedizin ist diese gemeinsame Sicht jedoch der einzige Aspekt gemein-
samer Arbeit zwischen den Operierenden. Hierbei werden über Telekommunikation
nicht vor Ort befindliche chirurgische Experten zur Beratung oder zum Mentoring
in den Operationssaal gebracht. Eine Audioverbindung ist Standard, während eine
Videoverbindung durch eine Videokamera hergestellt werden kann, die über dem
OP-Tisch installiert wird oder von im Operationssaal befindlichem Personal auf dem
Kopf getragen wird. Dabei ist unbedingt zu beachten, dass nicht vor Ort befindliches
Personal in der Telemedizin nicht mit dem Körper oder den Bildern interagieren kann
– zugeschaltete Fachleute etwa sind auf die Sicht angewiesen, die ihnen durch das über-
mittelnde Personal bereitgestellt wird. Dies erfordert wiederum eine besondere Leis-
tung des übermittelnden Personals, um Bilder für beide Parteien zu erzeugen, damit

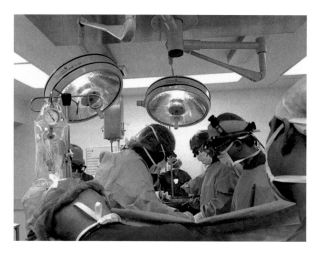

3: Chirurg (links) zeichnet ein Video der Organvitalität mit einer am Kopf befestigten Videokamera (rote Brille) auf.

diese ihr Wissen zusammenführen und gemeinsam eine Entscheidung fällen können.

Um genauer zu untersuchen, wie eine bildbasierte Wissenszusammenführung zustandekommt, wurde im Rahmen einer Beobachtungsstudie ein am Kopf befestigtes Audio-Video-System verwendet, das während eines Eingriffs zur Entnahme eines Transplantatorgans dessen Funktionen überwacht. ↗ **Abb. 3** Der Vorteil des am Kopf befestigten Videorekorders gegenüber einer über dem Kopf installierten oder von Begleitpersonal gehaltenen Kamera liegt darin, dass damit „berührungslos" interagiert werden kann. Der aufzeichnende Chirurg kann durch Bewegung seines Kopfes und Körpers entscheiden, worauf die Kamera fokussiert wird und wie viel er von seinem Sichtfeld einfangen will. Da der Chirurg somit auch freie Hand hat, ist es ihm auch möglich, während des Filmens gleichzeitig an den Organen zu manipulieren.

Die Aufzeichnungen belegen, dass Chirurginnen und Chirurgen nicht einfach Bilder übermitteln. Sie gestalten sie vielmehr auf ein gemeinsames Ziel hin.[8] Unter „gestalten" soll hier die bewusste Ausführung dessen verstanden werden, was aufzuzeichnen wäre und wie dies geschieht. Auf diese Weise wird eine bestimmte, gemeinsame Sicht auf den Körper und die Handlungen am Körper aufgerufen. Wie die Verwendung eines Videos zeigt, das mit dem am Kopf befestigten Videoaufzeichnungsgerät hergestellt wurde und von anderen Beteiligten live verfolgt werden kann, ist die „Sicht" meist auf eine ergänzende Handlungsschilderung angelegt:

> „Now what we're gonna do is maybe trying to just sort of take that uh nick pad out …
> ↗ **Abb. 4a** and then with your left hand sort of push down on the diaphragm towards the liver." [Assistenzarzt führt seine Hand ein, drückt dabei auf das Zwerchfell und Herz/Lungen heben sich] … „Yeah … That shows the anterior wall." [Bewegt sich näher heran und bewirkt so eine gezoomte Ansicht.] ↗ **Abb. 4b**

8 Helena Mentis, Ahmed Rahim, Pierre Theodore: Crafting the Image in Surgical Telemedicine. In: Conference on Human Factors in Computing Systems, 2016.

4a+b: Veränderungen des Bildes durch aktive Sichtgestaltung, a) Ansicht vorher, b) erzeugte Sicht mit Zoomwirkung.

Diese typische Szene zeigt, wie eine gemeinsame Sicht gestaltet wird: zunächst durch das gezielte Dirigieren der Hand des Assistenzarztes und dann auch seiner übrigen Körperbewegungen für eine herangezoomte Organsicht. Der Chirurg, der das Organ entnimmt, nutzt außerdem die verbale Beschreibung, um seine Aufzeichnung zu erläutern. Der Blick des Chirurgen, der das Organ einsetzt und der zu einem nicht vor Ort befindlichen Team gehört, wird so auf eine Information gelenkt, die zum Treffen einer Entscheidung maßgeblich ist. Die daraus resultierende Blickveränderung wird auch in der näheren Ansicht deutlich. In diesem Augenblick gestaltet der organentnehmende Chirurg das Bild, indem er nur aufzeichnet, was er zeigen möchte, und dieses dann schildert. Insgesamt impliziert der Ablauf, dass die Intervention vom Sender festgelegt wird, und zwar sowohl im Hinblick auf Zeitpunkt und Detailreichtum der Aufzeichnung als auch im Hinblick auf die Art der Präsentation (beispielsweise wird das Organ hochgehalten, herangezoomt). An diesem Punkt könnten Werkzeuge bereitgestellt werden, die es beiden beteiligten Seiten erlauben, ein gemeinsames Verständnis des Gesehenen zu gestalten. Dies kann etwa dadurch erreicht werden, dass beiden Seiten eine Telestration der Bilder oder das gegenseitige Aufzeichnen und Anzeigen von kommentierten Bildern ermöglicht wird.

Der Übergang zu einer bildgebenden Interaktion im OP

Intraoperative Bildgebungssysteme für minimal invasive chirurgische Eingriffe verändern das professionelle Sehen. Die Untersuchung dieser neuen Praxis zeigt, dass das „Sehen" von Bildern ein verkörperter Prozess ist, der durch eine Koordination von visuellen Informationen über den Körper und die Instrumente sowie über explorative Aktionen mit Instrumenten an und im Körper erreicht wird. Es sollte damit deutlich werden, dass zwischen der Manipulation von Bildern und der Interaktion mit dem Körper eine enge Verbindung besteht. Bilder werden nicht einfach nur angeschaut,

sondern entstehen erst durch diese Verknüpfung, im Prozess einer professionell gesteuerten Wahrnehmung.

Damit könnte zugleich das Fundament für die Einführung neuer interaktiver Mechanismen für die intraoperative Bildverwendung gelegt sein: Wenn Handlungen an und mit Bildern – und damit auch das chirurgische Eingreifen – allein durch die Kontrollelemente strukturiert werden, definieren die verfügbaren Interaktionsmechanismen die Art und Weise des Sehens und Handelns mit visuellen Informationen. Das Wissen über diese darstellende und integrative Verwendung von Bildern in der chirurgischen Praxis sollte in intraoperativen Bildgebungssystemen mit einem höheren Grad an Interaktionsmöglichkeiten münden, die das Gebiet der Bildgebungsinformatik weiter vorantreiben. Wie außerdem deutlich werden sollte, können diese bedeutungsgenerierenden Praktiken unterstützt werden, indem die Fähigkeit zur Verknüpfung zwischen den multiplen Repräsentationen des Körpers und dem Körper selbst gefördert wird. Dies würde eine kollaborative Form des „Sehens" durch die Annotation ermöglichen und eine berührungslose Form der Manipulation erlauben und außerdem die Interaktion mit Bildern in verteilten Anordnungen ermöglichen. Dies sind machbare und kostengünstige Lösungen, welche letztlich die chirurgischen Fähigkeit verbessern, um Informationen einsatzsynchron für eine bessere Entscheidungsfindung und idealerweise für bessere Patientenergebnisse zu nutzen.

Dieser Text wurde aus dem Englischen übersetzt.

Bildessay

Christina Lammer

Pulsierendes Leben.
Bildgeführt in den Blutfluss eingreifen

Prolog Ein kreisrund grün gerahmtes, haut-farbenes, undefinierbares Feld eröffnet die Szene. In der Mitte eine Art von Anschluss. Ein schwarzes Kabel reicht bis zum Bildrand in der rechten oberen Ecke. Eine Operation. Grüne Faltenwürfe. Hände, die mit einer Sprit-ze hantieren, die zuvor an diese Verkabelung angeschlossen wurde. Das Bild wirkt porös. Ein pastoser Farbeindruck herrscht vor. Nichts von der sterilen Glattheit und Schärfe digitaler Aufnahmen.

Der dreiminütige, in der Kamera geschnit-tene Super-8-Film[1] entstand im Eingriffsraum der Kardiovaskulären und Interventionellen

1 Online: http://www.corporealities.org/matters-of-the-heart-herzensangelegenheiten/ (Stand: 09/2015).

Radiologie am Allgemeinen Krankenhaus (AKH) in Wien, ein medizinischer Bereich, in dem bildgeführt die Blutgefäße behandelt wer-den. Ich arbeitete bereits vor fünfzehn Jahren in dieser radiologischen Abteilung und kehrte vor wenigen Wochen für meine aktuelle künst-lerische Forschung über *Chirurgische Gesten* (2015–2018) zurück, um weitere Beobachtun-gen mit der Kamera zu machen und Eindrücke zu sammeln. In meinem zwischen den Erfah-rungen – im Sinne eines ästhetischen Erlebens – wechselnden und sich in einem eigenen Rhyth-mus durch die Zeit asynchron entwickelnden Textgewebe vermische ich Beobachtungen und spinne assoziativ inhaltliche Fäden, die auf den ersten Blick vielleicht kaum etwas miteinander zu tun haben, aber für mich dennoch zusam-menhängen. Meine eigene Bildpraxis mit der Kamera – mein spezifisches Eindringen in die Wirklichkeit durch Nahaufnahmen – steht den Operationen in der Klinik gegenüber. Eine Geschichte über Intimität und Einfühlen wird erzählt.

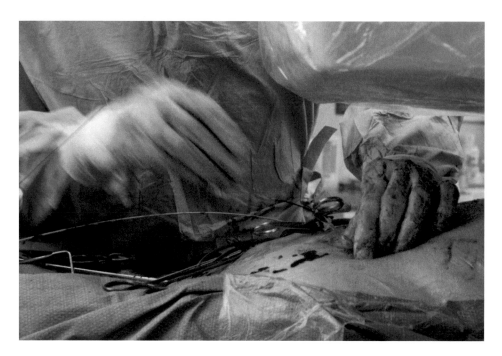

Spüren Den Puls und das lebendige Fließen des
Blutes im Körperinneren ertasten. Eine Vielfalt
von Eingriffen in diesem radiologischen Fach
beginnt mit einer Form von taktiler Einfüh-
lung. Der Arzt oder die Ärztin nimmt einen
ersten Kontakt auf, erspürt den Blutfluss, bevor
er oder sie ein Gefäß punktiert. Diesbezüglich
erzählte mir Oberarzt Florian Wolf, stellvertre-
tender Leiter der Abteilung für Kardiovaskuläre
und Interventionelle Radiologie, während wir
gemeinsam Videomaterial ansahen, das ich von
einem komplexen Stentgrafteingriff im August
2015 aufgenommen hatte:

*„Ich muss und will einfach hundertprozentig
den Puls und das Gefäß spüren. Je besser ich den
Verlauf unter meinen Fingern spüre, desto leichter
komme ich mit der Nadel hinein und steche genau
dorthin, wo darunter das Gefäß ist. Das dauert
oft lange, bis man das in den Fingern spürt. Dann
spürt man vielleicht noch seinen eigenen Puls. Man
muss einfach den Puls vom Patienten spüren und
manchmal wirklich auch das Gefäß – unter seinen
Fingern.“*

Meine eigene körperliche und emotionale Ver-
fasstheit verbindet sich mit einer subjektiven
Beobachtungshaltung aus künstlerischer Pers-
pektive. Ich beschreibe sensible Handlungen –
chirurgische Operationen – als intime Arbeits-
prozesse am und im verletzlichen Körper einer
anderen Person und entwickle eine eigene
Sprache, die jener, die ich in den Gesprächen
mit radiologischem und chirurgischem Perso-
nal wahrnehme, möglichst nahekommt, um
sensorische Phänomene auszudrücken und die
beobachteten und gefilmten Vorgänge begreif-
bar zu machen. In *Das giftige Herz der Dinge*
(2012), einem Gespräch, das Claude Bonnefoy
mit Michel Foucault geführt hatte, bezeichnete
der Philosoph sein Schreiben als etwas „Sam-
tiges" und zugleich als „trocken und beißend".
Als Sohn eines Chirurgen „liegt in meinem
Federhalter" vermutlich „die alte Erbschaft des
Skalpells".[2] Schreiben und meine Filmarbeit als
ein Schneiden.

2 Michel Foucault: Das giftige Herz der Dinge.
 Gespräch mit Claude Bonnefoy, Zürich 2012, S. 39.

Sehen Kürzlich befand ich mich selbst in der Situation als Patientin. Gebettet am Operationstisch. Am Rücken liegend. Die Arme ausgebreitet. Kurz vorm Einschlafen. Mein nackter Körper. Von einem warmen, grünen Operationstuch umhüllt. Ich lausche der Stimme der Anästhesistin und schlafe ein. Erwache erst nach der Operation im Aufwachraum. Wenige Tage danach, beim Abendakt an der Akademie der bildenden Künste in Wien, bat ich eines der Modelle diese Position einzunehmen. Ich skizzierte sie, ertastete ihre Lage, ihre Konturen und ihre Formen. „In dieser Haltung fällt das Einschlafen leicht. Durch die ausgebreiteten Arme wird die Bewegungsfreiheit eingeschränkt", berichtete sie mir danach. Eine keineswegs neutrale Pose, die sie nie zuvor ausprobiert hatte. Im Operationssaal wird der Körper durchaus häufig auf diese Art gelagert. Jeweils davon abhängig, an welcher Stelle chirurgisch eingegriffen wird. Bei einer offenen Herzoperation liegt der Patient oder die Patientin etwa am Rücken; bei einer laparoskopischen Bauchoperation ebenso, allerdings sind die Beine dabei gespreizt, um für den Chirurgen oder die Chirurgin ausreichend Platz zu schaffen; Thoraxoperationen werden üblicherweise in Seitenlage der betroffenen Personen durchgeführt. Abhängig sind die unterschiedlichen Formen der Lagerung vom jeweiligen Zugangsweg. Ein genau definierter Operationsbereich – die Positionierung des Körpers – erlaubt dem eingreifenden Blick, möglichst tief in den physischen Raum einzudringen.

Zeichnen Aufwendige chirurgische Behand-
lungen von Bauchaortenaneurysmen werden
häufig für die Patientinnen und Patienten aufge-
zeichnet. Das Zeichnen für eine andere Person
dient der Vermittlung von Wissen und zugleich
als Vertrauen schaffende Geste. Um diesen Pro-
zess des Zeichnens für und mit zu operierenden
Personen besser zu verstehen, bat ich den frü-
heren Leiter der Abteilung für Kardiovasku-
läre und Interventionelle Radiologie, Johannes
Lammer,[3] für mich eine solche Operation zu
zeichnen und mir den Eingriff zu erklären.[4]

„I will show you the endovascular therapy of
your aortic aneurysm. This would be your aorta.
That's the main artery, which is coming from
the heart. These are the renal arteries, which are
supplying your kidneys and then comes your aor-
tic aneurysm. [...] Now you have this prosthesis,
which looks like trousers. Here and here down and
here up. So the blood is now going down through
the aneurysm into your both limbs that they are
very well perfused but the blood cannot go anymo-
re into the aneurysm. Therefore this will undergo
spontaneous thrombosis and there is no more pres-
sure and the risk of rupture is gone. That's it."[5]

Während er zeichnet, bezieht sich der Radio-
loge auf die Person. Er stellt eine Beziehung
zwischen seinem Fachwissen und den entspre-
chenden Vorstellungen und dem individuellen
Körper des oder der Kranken her. Der Arzt
skizziert ein persönliches Krankheitsbild und
dessen Behandlung. Das gemeinsame Vorstellen
oder Imaginieren, was während des Eingriffes
passieren wird, und das Durchspielen der kon-
kreten Abläufe dient einem Kennenlernen und
schafft ein Gespür füreinander.

3 Univ.-Prof. Dr. Johannes Lammer und die Auto-
 rin sind nicht miteinander verwandt.
4 Ich bat Prof. Lammer, Englisch zu sprechen,
 um das Videomaterial mit Originalton bei einer
 Tagung in der Whitechapel Gallery in London
 zu präsentieren. Die Konferenz fand 2011 statt.
5 Christina Lammer, Artur Zmijewski (Hg.): Ana-
 tomiestunden, Wien 2013, S. 284.

Eingreifen Die Entwicklung der Bildtechnologien steht in unmittelbarem Zusammenhang mit den Möglichkeiten, aufwendigere und schwerwiegendere Eingriffe vorzunehmen. Operationen, die gegenwärtig durchgeführt werden, wären früher bildtechnisch gar nicht möglich gewesen.

Florian Wolf: „Ich habe das Gott sei Dank nie mehr erlebt, aber es hat ja auch die Plattfilmangiografie gegeben, wo wirklich bei einer Angiografie die Filme mit Hilfe einer Maschine durchgezogen wurden. Dann wurde jedes Bild einzeln entwickelt. Die RTA [radiologisch technische Assistentin] ist dann mit diesem Packerl mit Filmen in die Dunkelkammer gelaufen. Dort wurde das entwickelt und man konnte das anschauen.“

Auf großen Monitoren wählt er oder sie Perspektiven auf zu behandelnde Blutgefäße. Anhand der bewegten Aufnahmen in Echtzeit navigieren die Hände Führungsdrähte, Schleusen, Katheter, Ballons, Stents und andere Materialien genau an jene Stellen in den Adern, wo sie gebraucht werden.

Christina Lammer: „Die Bildschirme waren auch viel kleiner.“

Florian Wolf: „Genau. Die Bildschirme sind größer. Ich sehe viel kleinere Strukturen viel besser und genauer. Dazu noch mit einer viel, viel geringeren Strahlenbelastung. Das ist radikal nach unten gegangen.“

Die Patientinnen und Patienten sind bei den Eingriffen in dieser radiologisch chirurgischen Disziplin häufig bei vollem Bewusstsein. Größere Operationen, etwa die Behandlung von Bauchaortenaneurysmen, werden im Team mit gefäßchirurgischem und anästhesistischem Personal durchgeführt. Davor spielen die Operierenden die Abläufe gerne durch. Dies geschieht nicht ausschließlich anhand diagnostischer Bilder, sondern zudem mit geschlossenen Augen. Auf einer inneren Leinwand läuft die Operation wie ein Film ab. Florian Wolf erzählte mir, dass er manchmal sogar davon träumt.

Schlafen Wurden in der Vergangenheit in der Abteilung Operationen mit einem Anästhesieteam an einem Tag in der Woche durchgeführt,[6] werden gegenwärtig an vier Tagen pro Woche Patientinnen und Patienten unter Vollnarkose operiert. Das Aufnahmegerät, der sogenannte C-Bogen, wird über eine Fernbedienung zu jenem Areal des Körpers des Patienten oder der Patientin bewegt, das operiert werden soll. Einem Greifarm ähnlich, umfängt die Apparatur die in Vollnarkose schlafende Person, von der kaum etwas erkennbar ist.

Florian Wolf: „Diese ganzen superselektiven Embolisationen in kleinen Stromgebieten. Das wäre nicht möglich. Oder auch die Schlaganfallthrombektomie wäre nicht möglich gewesen.“

Christina Lammer: „Was ist das genau?“

Florian Wolf: „Wenn man beim akuten Schlaganfall den Thrombus aus dem Gehirn herausholt. Oder auch diese komplexen Stentgrafteingriffe. Das wäre auch nicht möglich gewesen.“

Für das bildgeführte Platzieren der individuell maßgeschneiderten und manchmal sogar handgenähten Prothesen im Körperinneren des oder der tief Schlafenden kommt dem Tastsinn große Bedeutung zu. Seine fragmentarischen Eigenschaften – Strukturen und Widerstand in den Blutgefäßen zu erspüren – werden während dieser aufwendigen endovaskulären Operationen als sensibler Akt der Erkenntnis und zugleich des Einfühlens deutlich.

6 Gespräch (s. Anm. 4).

Zeigen Auf den bewegten Durchleuchtungs-
bildern der Angiografie – der Darstellung
von Blutgefäßen – sind äußerst abstrakte und
kontrastreiche Landschaften unter der Haut
zu sehen. Der rote Fluss im Inneren erscheint
auf Bildschirmen als dunkle Schattierung oder
Verästelung. Spiralförmige Strukturen, die sich
füllen und leeren. Im Team werden die weite-
ren Schritte des Eingriffes anhand der Echtzeit-
bilder diskutiert. Der Gestus des Zeigens wird
prägend für die komplexen Kommunikations-
prozesse, die während solcher schwerwiegenden
Eingriffe stattfinden. Eine Verständigung dar-
über erfolgt, was die an der Operation Beteilig-
ten auf den zahlreichen Bildschirmen im Raum
sehen und welche Schlüsse sie für das weitere
Vorgehen daraus ziehen. Ein ganzkörperliches
Einfühlen. Ein gemeinsames Reflektieren der
bewegten Durchleuchtungsaufnahmen.

*Florian Wolf: „Vieles geht schon noch auf alten
Geräten. Ich kenne eigentlich kein Privatspital, wo
man ein Overlay hat. Da malt man das dann am
Bildschirm an. Man macht eine Serie und malt mit
einem Edding die Konturen der Aorta nach, die
Nierenarterien und dann die Beckengefäße. Auf-
grund dieses gemalten Bildes setzt man den Stent-
graft ein. Das funktioniert sehr gut. [...] Wenn ich's
nicht mehr brauche, nehme ich Alkohol und wische
das Bild wieder weg. Dann male ich mein nächstes.“*

Die Bilder erweitern die Kapazität des ope-
rierenden Körpers. Sie verbinden sich mit den
tastenden Augen und sehenden Händen. Den-
noch bleibt der Vorgang ein Operieren, ohne zu
sehen. Die Augen sind auf etwas anderes gerich-
tet. Sie blicken anderswohin. Orientieren sich an
Markierungen in einer technisch hergestellten,
zweidimensional dargestellten Landschaft vom
Inneren auf Monitoren.

Orchestrieren Das chirurgische Eingreifen in den Körper einer anderen Person setzt ein umfassendes Interagieren voraus. Ein im Dialogischen eingebettetes Handeln, in das die Aufmerksamkeit aller Beteiligten einbezogen wird. Die Handlungen sind präzise und behutsam zugleich. Material und Instrumente werden wortlos gereicht. Ruhig und konzentriert wird gearbeitet. Gemeinsam im Team werden Entscheidungen getroffen. Ein kollegialer Austausch von Wissen, der auf Erfahrung basiert.

Christina Lammer: „Welche anderen Eingriffe werden mit Hilfe der derzeit verfügbaren Bildtechnologien gemacht?"

Florian Wolf: „Viel feiner, viel periphärer, viel in kleineren Regionen – und die Zahl der Eingriffe ist massiv nach oben gegangen, weil die Indikationen in alle Richtungen und fast in allen Fachgebieten immer mehr geworden sind."

Das Fließen und Pulsieren im Körperinneren zeigt sich auf den Durchleuchtungsbildern und im lebendigen Agieren der Operierenden. Wenngleich ihr Aktionsradius mitunter räumlich beengt sein mag. Der Kopf des Radiologen dreht sich in Richtung der Bildschirme, während seine Hände weiteroperieren. Sein gesamter Körper fügt sich in diese räumliche Ordnung ein. Die mehrere Kilo schwere Bleiweste und die sterile Operationskleidung darüber erfordern Stehvermögen. Operieren benötigt vollsten körperlichen Einsatz. In Abstimmung aufeinander. Ähnlich einem Orchester wirken alle Beteiligten mit, nehmen ihre Plätze ein und spielen ihre Instrumente.

Epilog Dieses orchestrierte Miteinander in der Chirurgie unter dem Aspekt der Einfühlung und als intimes Hineinspüren in eine andere Person zu untersuchen, als berührende Handlungen und Prozesse der gemeinsamen Entscheidungsfindung, als bildunterstützte zwischenmenschliche Operation, erfordert in der Tat die Entwicklung einer eigenen Diagnostik. Samtig, trocken oder beißend, in jedem Fall legen meine Beobachtungen mit der Kamera – das Filmen als ein weiterer Akt des Schneidens und Rhythmisierens, um in die Wirklichkeiten des Gegebenen einzudringen – nahe, dass sich die Eigenschaften des Fragmentarischen, die dem Tastsinn zugeschrieben werden, nur allzu leicht auf das chirurgische Handeln übertragen lassen. Selbst die operierenden Hände, die nicht unmittelbar in den Körper hineingreifen, sondern durch Drähte, Katheter, andere Materialien und über diagnostische Bilder mit dem Inneren verbunden sind, berühren das lebendige Pulsieren und regulieren jene Flüsse, die aus den Ufern zu treten drohen. Ein Tasten auf Distanz? Im intimen Kontakt. Nahaufnahmen. Um das Taktile dieser Gesten zu erfassen.

Ich bedanke mich bei den Patientinnen und Patienten für ihre Teilnahme. Univ.-Prof. Dr. Christian Loewe, Leiter der Abteilung für Kardiovaskuläre und Interventionelle Radiologie, danke ich für seine Bereitschaft, meine künstlerische Forschung als Kooperationspartner zu unterstützen. Univ.-Prof. Dr. Florian Wolf, Stellvertretender Leiter der Klinischen Abteilung für Kardiovaskuläre und Interventionelle Radiologie, danke ich für sein Vertrauen und dafür, dass ich bei zahlreichen Eingriffen, die er durchführte, mit der Kamera dabei sein und mitfilmen durfte sowie für die ausführlichen Gespräche. Bei Oberarzt Dr. Wolfgang Matzek, Klinische Abteilung für Kardiovaskuläre und Interventionelle Radiologie, bedanke ich mich für sein Feedback und dafür, dass ich ihm mit einer Super-8-Kamera auf die Finger schauen durfte. Allen Mitarbeiterinnen und Mitarbeitern der genannten Klinikabteilung, die ich kennenlernen durfte und die meine Forschung tatkräftig unterstützten, möchte ich herzlich danken.

Pasi Väliaho

Verkörperter Bildkasten.
Projektive Bildschirme und visuelle Imperien um 1700

Am 19. Dezember 1694 präsentierte Robert Hooke der Royal Society of London eine Arbeit über „An Instrument of Use to take the Draught, or Picture of any Thing".[1] Hookes Erfindung war im Wesentlichen eine tragbare Camera obscura. ↗ **Abb. 1** Der Naturphilosoph hatte darin ausgeführt, wie man einen kleinen „dunklen Raum" aus Holz über Kopf und Schultern des Betrachters positionieren könnte, um so das Zeichnen der in die Vorrichtung projizierten Ansicht zu erleichtern. Der Kasten sollte sich wie eine halbwegs natürliche – wenn auch zweifellos unkomfortable – Verlängerung des Körpers oder (in den zeitgenössischen Worten des jesuitischen Astronomen Christoph Scheiner) wie „ein künstliches, totes Auge" mit dem Betrachter drehen und bewegen.[2]

Hooke gab selbst zu, dass seine Erfindung keine völlige Neuheit sei. Das 1685 erschienene Buch *Oculus artificialis* von Johann Zahn, einem Chorherrn des Prämonstratenserordens, hatte zum Beispiel mehrere Darstellungen von tragbaren Camerae obscurae präsentiert, ↗ **Abb.** 2 auch wenn deren Konstruktion genau genommen nicht dazu gedacht war, direkt mit den Körperbewegungen des Betrachters gekoppelt zu werden, wie dies offenbar bei Hookes Modell der Fall war. Dessen Vorrichtung, die tragbar, genaugenommen sogar anziehbar („wearable") sein sollte, richtete sich insbesondere an wissbegierige Reisende („curious Navigators and Travelers"), denen damit ein Instrument an die Hand gegeben sei, um Dinge wiederzugeben, wie sie tatsächlich seien.[3] Die Camera zeige damit

> „[…] *true Forms and Shapes* […] *not only of the Prospects of Countries, and Coasts,*
> *as they appear at Sea from several Distances, and several Positions; but of divers*
> *In-land Prospects of Countries, Hills, Towns, Houses, Castles, and the like; as also*
> *of any Kind of Trees, Plants, Animals, whether Birds, Beasts, Fishes, Insects; nay,*
> *of Men, Habits, Fashions, Behaviours; as also, of all Variety of Artificial Things, as,*
> *Utensils, Instruments, Engines, Ships, Boats, Carriages, Weapons of War, and any*
> *Other Thing of which accurate Representation, and Explanation, is desirable".*[4]

1 Robert Hooke: Philosophical Experiments and Observations, London 1726, S. 292–296.
2 Christoph Scheiner: Rosa Ursina sive Sol, Bracciani: apud Andream Phaeum, 162630, S. 106; zitiert und übersetzt nach Michael John Gorman: Projecting Nature in Early-Modern Europe. In: Wolfgang Lefèvre (Hg.): Inside the Camera Obscura Optics and Art under the Spell of the Projected Image, Preprint des Max-Planck-Instituts für Wissenschaftsgeschichte, Berlin 2007, S. 31–50, S. 38.
3 Hooke: Philosophical Experiments (s. Anm. 1), S. 292f.
4 Hooke: Philosophical Experiments (s. Anm. 1), S. 292f.

Die hölzerne *Picture Box*, wie
Hooke sie nannte, würde es prin-
zipiell auch künstlerischen Laien
ermöglichen, ihre Umwelt auf eine
wirklichkeitsgetreue Weise wie-
derzugeben. Außerdem sollte der
Kasten als ein Beobachtungs- und
Aufzeichnungsinstrument dienen
können, ähnlich dem zusammen-
gesetzten Mikroskop, mit dessen
Hilfe Hooke die kleinsten Details
der Natur ausgeforscht und als
Illustrationen in seinem Bestseller
Micrographia 1665 einer breiten
Öffentlichkeit zugänglich gemacht
hatte, etwa durch die zeichnerische
Darstellung eines Flohs.[5] ↗ **Abb. 3**
Der Zeichnungskasten arbeitete
zwar nach den gleichen Gesetzen
der Optik und Projektionsgeome-
trie wie das Mikroskop, jedoch

1: Tragbare Camera obscura. Holzschnitt von Robert Hooke:
Philosophical Experiments and Observations, London 1726.

schien eine reine Wiedergabe von Dingen nicht ihr Hauptzweck zu sein. Vielmehr
lassen Hookes Beschreibungen erkennen, dass der Kasten eher zur Erstellung von
Vorlagen gedacht war, für ein Nachzeichnen von Profilen und ein Herausarbeiten
von Umrissen mit dem Stift, die später mit Licht- und Schattenwerten oder Farbe
vervollständigt werden konnten.[6] Damit schien der Bildkasten eher eine Antwort auf
andere epistemische und pragmatische Anliegen zu geben als auf ästhetische Kriterien
der Plausibilität.

Denn vor allem sollte die Vorrichtung die Abstraktion der Welt auf ihre Umris-
se erleichtern. Sie diente der Übersetzung von komplexen Formen – Landschaften
von entfernten Orten, Küstenlinien, ja praktisch jeglicher sichtbaren Erscheinung
auf der Erde – in eine Reihe von Linien und Zonen. Anders als die wunderlichen
Zeichnungen und Geschichten von See- und Kaufleuten oder anderen Reisenden über

5 Robert Hooke: Micrographia. Or Some Physiological Descriptions of Minute Bodies Made by Magnify-
 ing Glasses with Observations and Inquiries thereupon, London 1665, Preface.
6 Hooke: Philosophical Experiments (s. Anm. 1), S. 295.

2: Tragbare Camerae obscurae. Aus: Johann Zahn: Oculus artificialis sive Telescopicum, London 1685, Abb. XXI.

ihre Exkursionen, in denen Hügel im Allgemeinen in „extravagant heights" gehoben wurden,[7] wie Hooke behauptete, sollte der Bildkasten eine Erzeugung von visuellen Informationen entsprechend den richtigen Proportionen und Perspektiven erlauben.

Dabei darf man nicht vergessen, dass der Ausgangspunkt für solche Darstellungen der Welt ein projektiver Bildschirm und nicht die Realität selbst war, die sich der sogenannten natürlichen Wahrnehmung öffnet. Der Bildschirm der Camera obscura wirkte als entscheidender Vermittler zwischen Umwelt und Betrachtung. Zeitgenössischen Künstlerinnen und Künstlern war sehr wohl bewusst, dass die Vorrichtung nicht nur die Herstellung von hybriden Bildern erlaubte, in der sich Lichtprojektionen mit handgefertigten Zeichnungen vermischten, sondern dass sie auch neue Möglichkeiten des Ausdrucks und Sehens eröffnete.[8] Jedoch waren Hookes Anliegen in dieser Hinsicht weit vom Künstlerischen entfernt. Sein Schwerpunkt lag auf Disziplin und Regulierung der Fantasie und weniger auf dem Experimentieren mit ihren Möglichkeiten. Seine Vision war das Einfangen von „prospects of countries and coasts", nicht in der Art eines emporstrebenden Landschaftsmalers, sondern wie jemand, der über Bilder in operationalen Begriffen nachsinnt – operational im Sinne des Fungierens als integrales Element in einem wissenschaftlichen, technischen, militärischen oder ökonomischen Vorgang.

Man kann erahnen, wie Hooke präzise Visualisierungen, die mithilfe seines Bildkastens erzeugt wurden, als „Überwachungsdaten" wie auch als praktische Orientierung für kommende Handlungen verstand, sei es für wirtschaftliche, wissenschaftliche, politische oder militärische Zwecke. „Explanations" von fernen und fremden Dingen in Form von Projektionen und Skizzen wurden insbesondere für die kolonialen Bestrebungen des Königreichs England benötigt, in die Hooke zusammen mit seinen Kollegen der Royal Society stark involviert war. Ausgehend von dieser grundlegenden Bestimmung der Camera obscura als Orientierungsmittel, soll das Folgende die Stellung dieser Erfindung – insbesondere ihres projektiven Bildschirms – innerhalb des kolonialen Projekts des Britischen Empire untersuchen, wobei der Schwerpunkt darauf liegen wird, wie das Gerät Bilder, Wissen und Eigentum (oder Besitz) in zukunftsträchtiger Form miteinander verbunden haben könnte. Hookes Bildkasten soll so in der „Tiefenzeit" von visuellen Medien und Wissenschaft und der Implementierung und Orchestrierung von Macht in der Moderne betrachtet werden.

7 Hooke: Philosophical Experiments (s. Anm. 1), S. 294.
8 Vgl. Carsten Wirth: The Camera Obscura as a Model for a New Concept of Mimesis in Seventeenth-Century Painting. In: Lefèvre (s. Anm. 2), S. 152.

Projektion und Imperium

Wie das „optische Experiment" mit den Projektionen der Camera obscura, das Hooke in den späten 1660er-Jahren arrangierte, muss der tragbare dunkle Raum eine erbauliche („delightful") Erfahrung gewesen sein.[9] Ein Betrachter schritt herum und drehte seinen Oberkörper, während er in dem Holzkasten steckte, und wurde dabei Zeuge, ↗ **Abb. 1** wie die Welt auf einer Glasoberfläche zu ihrem eigenen Bild wurde. Wie in jeder Camera obscura, wurden auch in Hookes Apparat die Bilder aus Licht und Schatten gestaltet, die durch Linsen gelangten, von Spiegeln (sofern vorhanden) reflektiert und auf konischen Pfaden verkleinert oder vergrößert wurden, schrumpften oder expandierten. Die Bilder waren nicht statisch, sondern dynamisch und *lebten*; sie bestanden aus „Motions, Changes, and Actions".[10] Damit die diversen Erscheinungen und Verflüchtigungen („various Apparitions and Disappearances") sichtbar werden konnten, war eine dunkle Umgebung nötig.[11] Der Apparat erforderte eine strikte Trennung zwischen dem System und der Umgebung bezüglich des Verhältnisses von Umgebungslicht und Dunkelheit. Das wichtigste Element des Bildkastens war der projektive Bildschirm, den er zwischen die Beobachtenden und die Umwelt schob: ein wahrnehmender und kognitiver Hilfsmechanismus, durch den die Welt umrissen und vermessen werden konnte. Der Bildschirm (oder die *tabula*, wie er im 17. Jahrhundert genannt wurde[12]), verwandelte die Welt in eine flache, zweidimensionale Ebene. Er gab sie als projiziertes Bild wieder, welches das Äußere als eine virtuelle Realität innerhalb der Maschine verkörperte – „virtuell", insofern die Bilder ihrer physikalischen Existenz beraubt wurden, aber ihre Erscheinung volle Farben, Formen und Bewegung besaß.

In begrifflicher Hinsicht steht Hookes Apparatur für ein erkenntnistheoretisches Problem, das als Schlüssel zur Philosophie der Frühmoderne verstanden worden ist, nämlich die Vorstellung, dass die sichtbare Welt nur mentale Projektion sei.[13] Während Hooke den Mechanismus der Camera obscura mit der Physiologie des Auges und der Bildung von Bildern auf der Netzhaut verglich[14] und damit der in dieser Zeit üblichen Sicht folgte, verlängerten andere die Analogie von der menschlichen Physiologie zur Arbeitsweise des Geistes. Hookes Zeitgenosse und Kollege in der Royal Society, John

9 Vgl. Robert Hooke: A Contrivance to Make the Picture of Any Thing Appear on a Wall, Cub-Board, or within a Picture-Frame. In: Philosophical Transactions, 38, 1668, Heft 3, S. 741–743.
10 Hooke: A Contrivance (s. Anm. 9), S. 742.
11 Hooke: A Contrivance (s. Anm. 9), S. 742.
12 Vgl. Gorman. In: Lefèvre (s. Anm. 2), S. 36.
13 Wie etwa konstatiert von Jonathan Crary: Techniques of the Observer. On Vision and Modernity in the Nineteenth Century, Cambridge, MA, 1990; vgl. auch Friedrich Kittler: Optische Medien: Berlin-Vorlesung, Berlin 1999, S. 89–90.
14 Vgl. Robert Hooke: The Posthumous Works of Dr. Robert Hooke, London 1705, S. 126–127.

Schem XXXIV

3: Zeichnung eines Flohs. Aus: Robert Hooke: Micrographia: Or Some Physiological Descriptions of Minute Bodies Made by Magnifying Glasses with Observations and Inquiries thereupon, London 1665, Platte 34.

Locke, zog einen entsprechenden Vergleich zwischen Camera obscura und Verstandeskraft:

> „[…] *denn mir scheint der Verstand einer gegen das Licht ganz verschlossenen Kammer zu gleichen; nur eine kleine Oeffnung ist geblieben, um die äussern sichtbaren Bilder oder Vorstellungen von den Aussendingen einzulassen; blieben die in einen solchen Raum eindringenden Bilder darin, und zwar in einer Ordnung, dass sie sich leicht finden liessen, so würde er in hohem Maasse dem Verstande des Menschen rücksichtlich aller sichtbaren Gegenstände und deren Vorstellungen gleichen“.*[15]

15 John Locke: Versuch über den menschlichen Verstand. In vier Büchern, London 1872, Bd. 51, Buch II, Kap. XI, §17.

Locke verband so den dunklen Raum der Camera obscura mit einem inneren Raum des Denkens und die projizierten Bilder mit den Ideen des Geistes – die Camera obscura war damit auch imstande, das Verhältnis auch eines inneren Auges zu einer äußeren Welt zu bestimmen, wie Jonathan Crary gefolgert hat.[16]

Hookes Bildkasten schnitt die Betrachtung von ihrer Umgebung ab, aber er tat auch noch etwas anderes und ebenso Wesentliches: Er umschloss nicht nur das Selbst, wie Locke implizierte, sondern auch die äußere Umgebung in seiner visuellen Anordnung. Der von Hooke vorgestellte Holzschnitt illustriert, ↗ **Abb. 1** wie der von der Camera obscura internalisierte Betrachter sofort zu einer Art Besitzer wird. Eingeschlossen im Kasten und anscheinend unbeeinflusst, scheint der Betrachter die fremde Landschaft – exotische Bäume, Schlösser und Hügel – zu dominieren und zu besitzen, indem er sie durch Projizieren, Betrachten und Zeichnen visuell einfängt und umschreibt. Der Kasten verschmilzt so Sehen, Vorführen und Bilderstellung mit der Eroberung von Territorium und dem Aufzwingen (wirtschaftlicher und politischer) Autorität. Dies ist exakt die Funktion des Projektionsbildschirms: Die Welt zu bewohnen, indem sie in virtuellen Bilder eingefangen wird – was, wie Hooke es im Vorwort zu *Micrographia* formuliert, „Operative and Mechanick Knowledge" und visuelle Herrschaft gewährt.[17]

In dieser Hinsicht erinnert uns Hookes tragbare Camera obscura daran, dass keine Macht der Moderne (im Sinne sowohl eines Wissenssystems als auch eines Interventionsfeldes) ohne Bildschirme funktioniert, welche die Welt zu einem Objekt der Analyse und Handlung machen. Macht beruht auf technischen Bildern als wahrnehmender und operativer Voraussetzung – auf Bildern, die als quasi unabhängige kognitive Akteure arbeiten und ein Heilmittel gegen die Gefahren im Prozess der menschlichen Vernunft bieten („These being the dangers in the process of humane Reason [...].").[18] In der frühen Moderne war das Erstellen von Karten (neben der Camera obscura eine andere wesentliche Projektionstechnik) zum Bereitstellen solcher Bilder entscheidend.[19] Tatsächlich war die Wiederbelebung der von Ptolemäus entwickelten kartografischen Projektionen in der Renaissance für die europäische Kolonialisierung der Welt entscheidend. Die Ausbreitung von Imperien nach Übersee war auf neue Navigationstechniken angewiesen, die auf der Projektion des kugelförmigen Volumens der Erde auf eine flache Oberfläche und der Einführung des geografischen Gradnet-

16 Crary: Techniques of the Observer (s. Anm. 13), S. 34.
17 Hooke: Micrographia (s. Anm. 5), Preface.
18 Hooke: Micrographia (s. Anm. 5), Preface.
19 Vgl. Christian Jacob: The Sovereign Map: Theoretical Approaches in Cartography throughout History, Chicago 2005.

zes basierten. Hookes tragbare Camera obscura deutet jedoch darauf hin, dass auch optische Projektionen, zusätzlich zu den kartografischen, eine zumindest wichtige konzeptionelle Rolle bei den europäischen Kolonialprojekten spielten, insbesondere bei den britischen Bestrebungen jenseits des Atlantiks.

Hookes Vorrichtung verband projektive Bildschirme, Gesten des Skizzierens, der Wissenserzeugung und der Inbesitznahme auf nie dagewesene Weise. Was die britische Kolonialmaschinerie auszeichnete, war die Weise, mit der sie die Theologie des Alten Testaments mit einem umfassenden Prozess des Besetzens und Privatisierens von fremdem Land verband. Mitglieder der Royal Society of London waren tief in diese frühe Form eines globalen Kapitalismus verstrickt. Eines ihrer Gründungsmitglieder, Robert Boyle, besaß zum Beispiel Anteile an der Hudson's Bay Company und arbeitete im Vorstand der English East India Company.[20] Wissenschaftsgeschichtlich betrachtet, nahmen die Gelehrten der Royal Society, zu denen Hooke gehörte, das Diktum ihres intellektuellen Vaters Francis Bacon auf, „[to] enlarge the bounds of humane empire to the effecting of all things possible".[21] Der intellektuelle Hintergrund für solch ein Unterfangen war nicht nur kommerziell, politisch oder rein wissenschaftlich, sondern auch religiös: Wissen über verschiedene Arten zu sammeln und zu verwenden, um die ursprüngliche Herrschaft über die Natur, die Adam im Garten Eden innehatte, wiederherzustellen. Die Werke der Vernunft waren die Befolgung von Gottes Befehl an Adam: „Die da herrschen [...] vber die gantzen Erde / vnd vber alles Gewürm das auff Erden kreucht."[22]

Das Ziel der Royal Society war es also, neben dem politischen und wirtschaftlichen ein „epistemic empire" zu errichten[23] – ein Imperium, das auf der empirischen Methode des Extrahierens von Wissen aus der Natur basierte, wie sie von Bacon und Newton begründet wurde, d. h. auf Beobachtung, induktiver Beweisführung und Experimenten mithilfe von Techniken. Es umfasste auch das Erfassen und Aufbewahren von „Daten" jener Teile der Welt, die noch vollständig erforscht werden mussten. Die Royal Society errichtete dazu ein Archiv mit Spezies, die von fernen Orten nach England geschickt wurden; dieses Archiv sollte, in den Worten Hookes (der 1663 zu dessen Kurator ernannt wurde), „as full and compleat a Collection of all varieties of Natural Bodies as could be obtained" werden.[24]

20 Vgl. Sarah Irving: Natural Science and the Origins of British Empire, London 2008, S. 1.

21 Francis Bacon: New Atlantis. In: Francis Bacon, B. Vickers (Hg.): The Major Works, Oxford 2002, S. 480, zitiert nach Irving (s. Anm. 20), S. 2.

22 Genesis 1:26 (Luther-Bibel, 1545). Vgl. auch Irving (s. Anm. 20), S. 2.

23 Dies ist das Hauptargument, das Sarah Irving in „Natural Science and the Origins of British Empire", entwickelt hat (s. Anm. 20); z. B. S. 22.

24 Robert Hooke, zitiert nach Irving (s. Anm. 20), S. 94. Siehe dort auch S. 17.

Für einige Zeitgenossen, wie John Locke, waren die Anliegen solcher empirischer Untersuchungen von natürlichen Erscheinungen sogar in erster Linie staatlicher und wirtschaftlicher Natur. Aus „rational and regular experiments", so Locke, „we may draw advantages of ease and health, and thereby increase our stock of conveniences for this life".[25] Wissen hatte für Locke den Zweck, die ursprüngliche Herrschaft der Menschheit über die Erdkugel wiederherzustellen sowie die Erde zu verbessern, um sie fruchtbar und lukrativ zu machen.[26] Prosaischer ausgedrückt, wurde empirisches Wissen für neue Eroberungszüge und zur Sicherung von Investitionen benötigt. Diese utilitaristische Auffassung von Wissen wurde durch Lockes Theorie des Besitztums ergänzt, die der Philosoph formulierte, während er bei den Besitzern der Carolina Company beschäftigt war und die Kolonialgeschäfte seines Förderers Lord Anthony Ashley Cooper führte.[27] „As much land as a man tills, plants, improves, cultivates, and can use the product of", notierte Locke, „so much is his property. He by his labour does, as it were, enclose it from the common."[28] Durch Arbeit wird Besitz verfestigt, Grenzen und Besitzrechte werden gezogen, die Früchte der Erde geerntet. Reichtum und Besitz lassen sich also auf „the labour of [man's] body, and the work of his hands" reduzieren, die „properly his" sind.[29]

Lockes Theorien von Wissen und Besitz entsprachen dem britischen Kolonialprojekt des Besetzens, Kultivierens und Privatisierens fremder Territorien – die beiden Amerikas, die Karibik, Teile von Afrika und so weiter –, die eingeschlossen und als Quellen des Profits verbessert werden mussten. In diesem Kontext tragen Lockes Überlegungen auch dazu bei, Hookes Bildkasten als Instrument der empirischen Argumentation zu verstehen, das entworfen wurde, um die britische Herrschaft über die Welt auszuweiten. Die hybriden Bilder des Apparats sollten, in einer solchen Perspektive, weit mehr als einfache Beschreibungen fremder Dinge und Geschöpfe sein. Sie sollten, wie man annehmen darf, in ihrem Impetus Gottes ursprünglichen Befehl von „füllet die Erden / vnd macht sie euch unterthan" als Akte der Umschließung dienen.[30] „[T]o find is not to see a thing with the eyes but to lay hold of it with the hands", wie Hugo Grotius in *The Free Sea* (1609) feststellte.[31] Die Voraussetzung dafür, etwas in die

25 John Locke: An Essay Concerning Human Understanding, London 1706, Buch IV, Kap. XII, §10.
26 Irving (s. Anm. 20), S. 117–119.
27 Vgl. Irving (s. Anm. 20), S. 113.
28 John Locke: Two Treatises of Government. In: The Works of John Locke in Nine Volumes, London 1824, Vol. 4, Buch II, Kap. V, §32.
29 Locke: Two Treatises of Government (s. Anm. 28), §27.
30 Genesis 1:27 (Luther-Bibel, 1545).
31 Hugo Grotius: The Free Sea, Indianapolis 2004, S. 13.

Hand nehmen zu können, ist zunächst ein System der Visualisierung und der Wissens-
erzeugung, das die Sphäre von Gegenständen sichert, auf die eingewirkt werden soll.

Zu diesem Zweck war die Projektion bzw. der Entwurf, wie Martin Heidegger
anmerkte, eine der grundlegenden Vorgehensweisen der modernen Wissenschaft und,
dies sei hinzugefügt, der Errichtung von epistemischen Imperien.[32] In Hookes Vorrich-
tung wurden Projektion und Zeichnung in Aktivitäten von (epistemischer) Herrschaft
umgewandelt. Das Bedienen des Apparats war eine Art der Umschreibung von Besitz:
Bezeichnen und Skizzieren von Dingen und Geschöpfen – Früchten, Bäumen, Hügeln,
Flüssen, Eingeborenen, was auch immer –, die dem eigenen Besitztum und der eigenen
Sorge zufallen sollten. Indem die Erde und ihre Kreaturen also in Projektionen von
Licht und Schatten umgewandelt wurden, war es möglich, dass sie vom Allgemeinen
abgeschlossen wurden („enclosed from the common").

Sehen bedeutet zu besitzen

Zusammenfassend ließe sich Projizieren und Zeichnen in Hookes Camera obscura als
Form der Besitzergreifung verstehen. Die Vorrichtung formte den Betrachter zu einem
„possessive individual", das die Welt abstrahiert, besetzt und sich aneignet.[33] Darüber
hinaus verwandelte die Vorrichtung Bilder – durch die Beschreibung und Umschlie-
ßung des eigenen Besitzes – in operationale Akteure. An dieser Stelle sei ein vielleicht
etwas kühner, anachronistischer Vergleich gestattet: Die projizierten Bilder aus Hookes
Bildkasten können auf aktuelle operationale Bildlichkeit bezogen werden, insbeson-
dere auf die Bildschirmdarstellungen von Drohnen und anderen Überwachungs- und
Tötungsmaschinen, mit denen die Mächte des Westens heute ihre Herrschaft über
die Erde auszuweiten und aufrechtzuerhalten suchen. Sicherlich heben die heutigen
Bildschirme die Sichtlinien der Erdoberfläche in den Himmel empor, während sie
gleichzeitig die Bilderzeugung mittels netzwerkbasierten Rechenanlagen automati-
sieren. Durch diese Bildschirme werden darüber hinaus die Handlungen von Sehen
und Überwachen mit der Möglichkeit der „Interaktion" kombiniert, das heißt, mit den
unmittelbaren Gesten des Abfeuerns einer Waffe und des Tötens. Das Skizzieren der
Landschaft mit der Hand und die Beanspruchung von Besitz in Hookes Bildkasten
wird damit zu einer Handhabung, die einen *joystick of death* betätigt. Was den Bild-
kasten des späten 17. Jahrhunderts und den Bildschirm der heutigen Drohen verbindet,

32 Martin Heidegger: Die Zeit des Weltbildes. In: ders.: Gesamtausgabe, hg. v. Vittorio Klostermann, Band
 5: Holzwege, Frankfurt a. M. 1977, S. 75–113.
33 Zum Aufkommen des „possessive individual" als neue Art des politischen Subjekts im England des 17.
 Jahrhunderts siehe Ed Cohen: A Body Worth Defending. Immunity, Biopolitics and the Apotheosis of
 the Modern Body, Durham 2009, S. 88.

ist die gemeinsame Form von Herrschaft und Inbesitznahme. Beide verwandeln die Erde und ihre Geschöpfe in Objekte der Intervention, Sicherung und Kultivierung und zwar durch Projektion. Daher ist es nicht völlig abwegig darüber nachzudenken, wie die operationalen Bilder aktueller militärischer Einsätze und die in Hookes Camera obscura projizierten Bilder Adams plünderndes Programm der Errichtung eines Imperiums „über alle Kriechtiere auf dem Land" fortsetzen und ausweiten.

Dieser Text wurde aus dem Englischen übersetzt.

Derek Gregory

Im Angesicht des Todes.
Drohnen und der spätmoderne Krieg

Der rechtschaffene Krieg

Moderne Militärs brüsten sich gern damit, dass ihre Art der Kriegsführung chirurgisch, sensibel und gewissenhaft geworden sei.[1] Die Entwicklung der Fähigkeit eines Präzisionsschlags, die kulturelle Wende zu einer Aufstandsbekämpfung, welche die lokale Bevölkerung in den Mittelpunkt der Operationen stellt, und die Vervollkommnung gesetzlichen Rahmenwerks, das bewaffnete Konflikte zu regeln vorgibt, tragen zur Feier dessen bei, was Der Derian einen „rechtschaffenen Krieg" genannt hat. Er vertritt die Ansicht, dass dessen Kern

> *„is the technical ability and ethical imperative to threaten and, if necessary, actualize violence from a distance with no or minimal casualties. Using networked information and virtual technologies to bring ‚there' here in near-real time and with near-verisimilitude, virtuous war exercises a comparative as well as strategic advantage for the digitally advanced. Along with time (as in the sense of tempo) as the fourth dimension, virtuality has become the ‚fifth dimension' of US global hegemony".[2]*

Im Mittelpunkt des Aufstiegs des Kriegs von einem virtuellen zu einem rechtschaffenen Krieg stehen die Drohnenkriege, welche die USA in den globalen Randgebieten führen. Eine „Drohne" ist ein populärer Begriff für das hier diskutierte Fluggerät. Die United States Air Force zieht jedoch die Bezeichnungen ferngesteuertes Luftfahrzeug (Remotely Piloted Aircraft, RPA) oder unbemanntes Luftfahrzeug (Unmanned Aerial Vehicle, UAV) vor. Sind diese Fluggeräte Teil eines integrierten Netzwerks – wie hier –, werden sie als unbemannte Luftsysteme (Unmanned Aerial System, UAS) bezeichnet. Die Beschreibung als „unbemannt" ist jedoch irreführend, da ein UAV zwar keinen Piloten an Bord hat, das System jedoch durch mehrere hundert Personen bedient und unterstützt wird. Der Schwerpunkt dieses Beitrags liegt auf dem *skopischen Regime*, das Drohnenoperationen zugrunde liegt. Christian Metz[3] hat diesen Begriff eingeführt, um die cinematische Art der Darstellung und Sichtweise der Welt von derjenigen des Theaters zu unterschieden. Seitdem hat sich der Begriff jedoch von jeglichen Formen, Darstellungen und Technologien gelöst, und bezeichnet vielmehr eine Art des visuellen Begreifens, das kulturell konstruiert und präskriptiv sowie sozial strukturiert und

1 Derek Gregory: War and Peace. Transactions of the Institute of British Geographers, 2010, Bd. 35, Heft 2, S. 154–86.
2 James Der Derian: Virtuous War. Mapping the Military-industrial-media-entertainment Network, New York (2. Aufl.) 2009, S. 21.
3 Christian Metz: The Imaginary Signifier. Psychoanalysis and the Signifier, Bloomington 1982, S. 61.

geteilt ist.[4] Wie der begleitende Begriff „Visualität", der kulturell oder technokulturell vermittelte Wege des Sehens bezeichnet, dient das Konzept als wesentliche Ergänzung der Vorstellung vom Sehen als rein biologischer Fähigkeit (der Ausdruck „Ergänzung" soll dabei anzeigen, dass die Verkörperung des Sehens mehr als eine nebensächliche Bedeutung besitzt). Skopische Regime sind historisch variabel, und innerhalb einer einzelnen kulturellen und sozialen Formation können verschiedene Regime koexistieren. Die größte Aufmerksamkeit richtete sich jedoch auf die Ligaturen zwischen Visualität und Moderne. Abgesehen von einer Handvoll Studien, deren bekannteste vermutlich *Krieg und Kino* von Virilio ist,[5] wurde der Art und Weise, wie die moderne Kriegsführung durch skopische Regime vermittelt und beeinflusst wird, vergleichsweise wenig Aufmerksamkeit geschenkt.

An dieser Stelle laufen vielleicht gerade sowohl die Luftkriege in Afghanistan und Pakistan als auch die Grenzen von Angriffs- und Verteidigungskrieg zusammen. Die Befürwortenden der Drohnenkriege beharren darauf, dass die beinahe in Echtzeit erfolgenden Videoübertragungen von Luftfahrzeugen einen nie dagewesenen Grad an Präzision und sorgfältig kalibrierter Reaktion erlauben, wodurch sich zivile Opfer minimieren lassen. Dieser Vorgehensweise gegenüber kritisch eingestellte Personen hegen die Befürchtung, dass Töten über eine solche Distanz zu einer Nebensache geworden ist und der spätmoderne Krieg damit zu einem Videospiel reduziert ist. Auch dies hat eine Vorgeschichte, auf die Rey Chow verweist:

> *„War can no longer be fought without the skills of playing video games. In the aerial bombings of Iraq the world was divided into an above and a below in accordance with the privilege of access to the virtual world. Up above in the sky, war was a matter of maneuvers across the video screen by US soldiers who had been accustomed as teenagers to playing video games at home; down below, war remained tied to the body, to manual labor, to the random disasters falling from the heavens."*[6]

Für viele Beobachtende hat die Entsendung von bewaffneten Drohnen durch die US Air Force (USAF) die optische Distanziertheit noch weiter perfektioniert. Obwohl diese UAV von Luftstützpunkten in Afghanistan und im Irak gestartet werden, erfolgt die Kontrolle ihrer Missionen in der Regel über eine Satellitenverbindung (im Ku-

4 Vgl. Martin Jay: Scopic Regimes of Modernity. In: Hal Foster (Hg.): Vision and Visuality, Seattle 1988, S. 3–23; Antonio Somaini: On the Scopic Regime. In: Leitmotiv, 2005, Bd. 5, S. 6.

5 Paul Virilio: Krieg und Kino. Logistik der Wahrnehmung. [franz. Orig. 1984], München 1986.

6 Rey Chow: The Age of the World Target. Atomic Bombs, Alterity, Area Studies. In: The Age of the World Target. Self-referentiality in War, Theory and Comparative Work, Durham 2006, S. 35.

1: Bodenkontrollstation, Creech AFB, Nevada.

Frequenzbereich, d. h. 12–18 GHz) durch Bedienpersonal in einer Bodenkontrollstation auf der Creech Air Force Base in Nevada.[7] ↗ **Abb. 1**

Als Kaplan den Luftstützpunkt besuchte, erzählte man ihm: „Inside that trailer is Iraq, inside the other, Afghanistan."[8] Diese mühelose Wahrnehmung einer Zeit-Raum-Verdichtung wird nur noch durch ihren beiläufigen Imperialismus übertroffen. Kritikische Stimmen beharren jedoch darauf, dass hier nur eine Tyrannei der Geografie durch eine andere ersetzt wird: Der Tod der Distanz ermöglicht einen Tod aus der Distanz und diese ferngesteuerten Missionen projizieren nicht nur Macht ohne Verwundbarkeit – wie die Air Force immer wieder betont –, sondern scheinbar auch ohne Schuldgefühle.[9] Offenbar führt Distanz zu einer neuen Form von Verzauberung.

7 Die Entfernung von 11.000 km führt zu einer 1,8-sekündigen Verzögerung der Steuerungseingaben, was dem aus der Ferne agierenden Bedienpersonal die Durchführung von Starts und Landungen unmöglich macht. Dies liegt in der Verantwortlichkeit von in größerer Nähe eingesetzten „Launch and Recovery"-Mannschaften, die eine sogenannte line-of-sight-Datenverbindung nutzen.

8 Robert Kaplan: Hunting the Taliban in Las Vegas. In: Atlantic Monthly, September 2006, S. 81.

9 Lambèr Royakkers, Rinie van Est: The Cubicle Warrior. The Marionette of Digitized Warfare. In: Ethics and Information Technology, 2010, Bd. 12, Heft 3, S. 289–296; Dave Webb, Loring Wirbel, Bill Sulzman: From Space, No One Can Watch You Die. In: Peace Review, 2010, Bd. 22, Heft 1, S. 31–39.

Während dies einerseits als Banalisierung eines Krieges wahrgenommen werden kann, dessen Beteiligte als „Kabinenkrieger" oder „Kampfpendler" verunglimpft werden, erhebt sich an anderer Stelle auch die scharfsichtigere Kritik, dass durch die Hellfire-Raketen der UAV eine beängstigende, quasi-himmlische Macht freigesetzt wird. „Sometimes I felt like a God hurling thunderbolts from afar",[10] gestand selbst ein beteiligter Pilot. Tom Engelhardt hat die Implikationen dieser Metapher genauer analysiert: „Those about whom we make life-or-death decisions, as they scurry below or carry on as best they can, have – like any beings faced with the gods – no recourse or appeal."[11]

Je mehr die von der USAF geflogenen Predator- und Reaper-Drohnen Teil der Aufstandsbekämpfung werden, desto komplexer wird jedoch dieses Bild. Die folgenden Darlegungen konzentrieren sich daher auf die sogenannte *Jäger-Killer-Funktion* von UAVs, also das Zusammenspiel aus Informationsgewinnung, Überwachung und Aufklärung (ISR) [engl. für *intelligence, surveillance, reconnaissance*] einerseits und der Waffenplattform andererseits, um damit aufzuzeigen, wie die neue Sichtbarkeit des Kampfgebiets und der militärischen Aktionen, die sie ermöglichen, den Zielführungsablauf beeinflussen.

Das zentrale Argument ist dabei, dass diese Sichtbarkeit notwendigerweise konditioniert ist – Räume aus konstruierter Sichtbarkeit sind stets auch Räume von konstruierter Unsichtbarkeit –, da sie keine technischen, sondern eher technokulturelle Errungenschaften sind. Im Gegensatz zu kritikischen Positionen, die behaupten, dass diese Operationen den Krieg auf ein Videospiel reduzieren, in dem der Tötungsraum abgelegen und entfernt erscheint, soll hier argumentiert werden, dass die neuen Sichtverhältnisse eine besondere Art der Intimität erzeugen, welche die Sicht des Jäger-Killers privilegiert, deren Implikationen weitaus tödlicher sind.

Die *killchain* und Aufstandsbekämpfung

Die US Air Force schätzt, dass die Aufstandsbekämpfung drei- bis viermal mehr ISR erfordert als große Kampfoperationen, da hier eine kaum definierbare Zielgruppe involviert ist. Daher erfordert die ISR wesentlich längere Verweilzeiten, was nur UAV bieten. Operatoren am Boden können am Ende einer Schicht ausgetauscht werden, während eine Drohne vor Ort in der Luft bleibt und die Videoübertragung nicht unterbrochen wird. Unter solchen Umständen muss ISR nicht nur ausdauernd, sondern auch allgegenwärtig sein: Am Ende erfordert dies „gathering intelligence on fast,

10 Matt J. Martin, Charles W. Sasser: Predator. The Remote-Control Air War over Iraq and Afghanistan. A Pilot's Story, Minneapolis 2010, S. 3.
11 Tom Engelhardt: War of the Worlds. In: TomDispatch, 8.10.2009.

fleeting, hidden and unpredictable adversaries [...] knowledge of everyone, everywhere, all the time".[12] Dafür ist ein technokulturelles Gerät notwendig, das ein militarisiertes Regime der *Hypersichtbarkeit* herstellen kann, das Avery Gordon beschrieben hat als „a kind of obscenity of accuracy that abolishes the distinctions between ‚permission and prohibition, presence and absence'".[13] Über die Genauigkeit der Informationsgewinnung, die aus den hochwertigen, hochaufgelösten Bildern der Drohnen abgeleitet wird, lässt sich streiten; aber fraglos hat die Bildproduktion diese Differenzierungen aufgelöst. Das multispektrale Zielfindungssystem in der Predator-Drohne liefert ein Echtzeit-Full-Motion-Video (FMV) mit 30 Frames pro Sekunde. Das Sichtfeld ist dabei jedoch begrenzt, und es wird beklagt, dass es sich beim Zoomen anfühle, als blicke man durch einen Strohhalm. Dies soll sich mit der Einführung des sogenannten Gorgon Stare ändern, das zwar Bilder mit niedrigerer Auflösung liefern wird (fünf Kameras, die jeweils zwei 16-Megapixel-Frames pro Sekunde schießen), aber mehr Bewegungsvideoeinspielungen von einer einzelnen Reaper-Drohne übertragen wird. Die Absicht ist, den Bilderstrom während des Flugs zu einem Kachelmosaik zusammenzusetzen und durch eine zugehörige Bodenstation an die vernetzten Nutzer im Einsatzgebiet weiterzuleiten, die die Sensoren kontrollieren und die Operationen mit der Flugcrew in Nevada koordinieren (die zum Fliegen des Luftfahrzeugs immer noch auf die Sensoren der Reaper-Drohne angewiesen sind). Eine noch großräumigere Überwachung wird durch die Einführung des ARGUS-IS-Systems erreicht, das hochaufgelöste Bilder über einen Multigigapixel-Sensor mit einer Aktualisierungsrate von 15 Frames pro Sekunde sendet.

Derartige Entwicklungen sollen die Verfolgung von Individuen und Bewegungen über multiple Netzwerke hinweg erlauben, um ein *pattern of life* zu etablieren, das mit einem neuen Vorbild der *activity-based intelligence* übereinstimmt, die den Schwerpunkt von Aufstandsbekämpfungsoperationen bildet.[14] Auch wenn die Innovationen erfolgreich sind, wird mit der Erzeugung eines Makrofelds von Mikrosehen nur ein Problem gelöst, indem dadurch ein neues erzeugt wird, und die Air Force ist sich der Gefahr schmerzlich bewusst in Sensoren zu schwimmen, aber in Daten zu ertrinken.[15] Eine

12 Pat Biltgen, Robert Tomes: Rebalancing ISR. In: Geospatial Intelligence Forum, 8, 2010, Nr. 6, S. 14–16.

13 Avery Gordon: Ghostly Matters. Haunting and the Sociological Imagination, Minneapolis 2008, S. 16.

14 Biltgen, Tomes (s. Anm. 12); William Matthews: One Sensor to do the Work of Many. In: Defense News, 1. 3.2010; Ellen Nakashima: Air Force's New Surveillance System for Aerial Drones not Working as Hoped. In: Washington Post, 24.1.2011; Richard Whittle: Gorgon Stare Broadens UAV Surveillance. In: Aviation Week, 3.11.2010.

15 Der Ausdruck wurde erstmals im Juli 2009 von Lt Gen David Deptula, damals stellvertretender Stabschef der ISR der Air Force, verwendet und entwickelte sich seitdem zu einem Leitmotiv in Diskussionen über ISR.

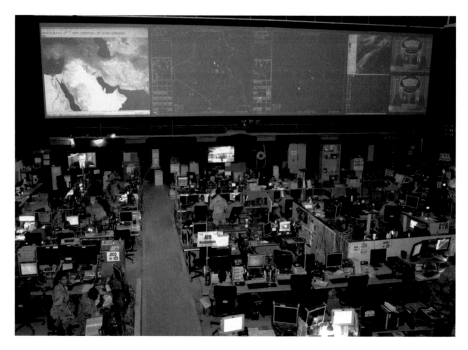

2: Combined Air Operations Center.

Standardvideokamera erfasst pro Stunde 100.000 Bildframes, und die USAF hat bereits 400.000 Stunden Videoaufzeichnung von ihren fliegenden Überwachungseinheiten archiviert. Die Zuwachsrate beschleunigt sich mit zunehmender ISR-Abdeckung. Um die Datenflut zu bewältigen, wurde der analytische Bereich erweitert. UAV-Operatoren in den Vereinigten Staate sind in ein umfassendes Netzwerk eingebettet, das nicht nur Truppen die *Joint Terminal Attack Controller,* die am Boden in Afghanistan das Sensor-System Rover (Remotels Operated Video Enhanced Receiver) verwenden, sondern auch Militärs im Offiziersrang, Missionsleitung und Militäranwaltschaft am Combined Air and Space Operations Center (CAOC) auf der Al Udeid Airbase in Katar ↗ **Abb. 2** sowie datenanalytisches und bildtechnisches Personal im Distributed Common Ground System (DCGS) der Langley Air Force Base in Virginia umfasst.[16] Dies ist ein dramatischer Wandel gegenüber den Erfahrungen der ersten Flugpioniere der 1920er-Jahre, die von Billy Mitchell mit den Worten: „In the first place they are alone. No man stands

16 Die USAF verfügt über fünf DCGS-Stationen, drei in den USA und je eine in Deutschland und Korea, die in einem als „Sentinel" bekannten System verbunden sind.

at their shoulder to support them" gefeiert wurden, und auch gegenüber den Erfahrungen, die die meisten anderen Kampfpilotinnen und -piloten heute machen, denn UAV-Operatoren arbeiten niemals ‚allein'.[17] Vielmehr werden derzeit 185 Personen benötigt, um eine Luftpatrouille mit Predator- oder Reaper-Drohnen zu ermöglichen.

Dieses Netzwerk hat zahlreiche unerlässliche Aufgaben. Zunächst werden archivierte Bilder gescannt, um *uneventful footage* herauszufiltern und um normale von abnormalen Aktivitäten zu unterscheiden. Idealerweise basiert diese forensische Überwachung – die eine Art von militarisierter Rhythmusanalyse oder sogar eine zur Waffe umgewandelte Zeit-Geografie ist – auf kulturellem Wissen.[18] Allerdings ist die Bilddatenbank so umfangreich, dass derzeit Experimente mit automatisierten Softwaresystemen zum *truthing* und zur Kommentierung von Videobildern laufen und es werden neue TV-Technologien erforscht, um Bilder mit Tags zu versehen und abzurufen.[19] Darüber hinaus werden Live-Videostreams gescannt, um zeitkritische Informationen an UAV-Crews und Bodentruppen weiterzuleiten, die auf neue Ereignisse reagieren. Diese Entwicklungen verstärken den *rush to the intimate*, der für „Aufstandsbekämpfungsoperationen" kennzeichnend ist, allerdings liegt die Betonung dabei gleichermaßen auf dem *rush* wie auf dem *intimate*.[20] Die Netzwerkhierarchien sind flach und fließend, die Räume sind komplex und zusammengesetzt, und die Missionen erfolgen am Bildschirm durch Videoübertragungen und Chatrooms (Bildschirme zeigen bis zu 30 verschiedene Chats gleichzeitig), die eine Reihe von Personen mit unterschiedlichen Fähigkeiten an unterschiedlichen Orten in der gleichen Zone zusammenbringen. Zeit

17 Houston Cantwell: Operators of Air Force Unmanned Systems. In: Air and Space Power Journal, 2009, Bd. 33, Heft 2, S. 75.

18 Die genauen Einzelheiten unterliegen der Geheimhaltung, es ist jedoch bekannt, dass das US-Militär GeoTime verwendet. Dies ist ein Programm, das räumliche, zeitliche und geheimdienstliche Daten aus verschiedenen Quellen zu einer dreidimensionalen Matrix vereinigt und visualisiert („combining the where, the when and the who"), die die vom schwedischen Geografen Torsten Hägerstrand in den 1960er- und 1970er-Jahren entwickelten Standardzeit-Geografie-Diagramme nachbildet. Das Programm umfasst „dedicated pattern-finding tools", die dem Nutzer erlauben, „to navigate the data in real time for rapid visual discovery of patterns of behavior"(siehe http://www.geotime.com).

19 Zur Videoanalyse und ihren Algorithmen siehe Jordan Crandall: The Geospatialization of Calculative Operations. Tracking, Sensing and Megacities. In: Theory, Culture & Society, 2010, Bd. 27, S. 68–90 (obwohl er die damit einhergehenden technischen und betrieblichen Schwierigkeiten herunterzuspielen scheint). Weiterhin: Julian Barnes: US Military Turns to TV for Surveillance Technology. In: Los Angeles Times, 7.6.2010; Biltgen, Tomes (s. Anm. 12); Grace Jean: Broadcast Television Tools to Help Intelligence Analysts Wade through Data, National Defense Magazine 03/2011, S. 32f.; Eli Lake: Drone Footage Overwhelms Analysts. In: Washington Times, 9.11.2010; Thom Shanker, Matt Richtel: In New Military, Data Overload Can Be Deadly. In: New York Times, 16.1.2011.

20 Derek Gregory: The Rush to the Intimate. Counterinsurgency and the Cultural Turn in Late Modern War. In: Radical Philosophy, 2008, Bd. 150, S. 8–23.

und Raum werden ineinandergeschoben, so dass, wie ein Offizier sich ausdrückte, „[w]e're mostly online with each other as we go".[21]

Das Netzwerk geht jedoch über ISR hinaus, denn es ist auch ein Waffensystem. UAV erfüllen auch die Jäger-Killer-Funktion, die schon in ihren abscheulichen Namen steckt. Bei aller Betonung einer kultur-zentrierten Kriegsführung dürfen wir nicht vergessen, dass die aktuelle Aufstandsbekämpfung nach wie vor Kriegsführung ist und sich keineswegs auf das Nichtkinetische beschränkt. Die durch das ausgedehnte Netzwerk erleichterte Informationsliquidität hat aus Cullathers *bombing at the speed of thought* noch keine Wirklichkeit gemacht, hat aber das, was die Air Force als *kill chain* bezeichnet, drastisch verkürzt.[22] Tatsächlich wurden, seit General Dan („Bomber") McNeil sein Kommando 2008 zurückgegeben hat, kinetische Operationen, einschließlich der Luftunterstützung, durch die *Rules of Engagement* geregelt, die Kollateralschäden minimieren sollten, und infolgedessen wird nun beklagt, dass „decisions move through the risk mitigation process like molasses"[23] und dass Anfragen zur Genehmigung eines Schlags „echelons of staffs sitting above me, like owls in trees"[24] durchlaufen.

Die *kill chain* kann als ein zerstreuter und verteilter Apparat gedacht werden, ein Konglomerat aus Agierenden, Objekten, Praktiken, Diskursen und Affekten, das Menschen vereinnahmt, und sie als eine besondere Art von Subjekten konstituiert.[25] Während des Zweiten Weltkriegs, des Kalten Kriegs und sogar darüber hinaus war die *kill chain* linear und aufeinanderfolgend und im Wesentlichen auf fixierte und vorgegebene Ziele gerichtet; die Zeit von der Identifizierung bis zur Ausführung erstreckte sich über Tage oder sogar Wochen. Nur wenige der daran beteiligten Personen konnten den Prozess in seiner Gesamtheit überblicken, was die Vermischung dessen erklärt, was Chad Harris „the mundane and the monstrously violent"[26] nennt. Der Apparat, mit dem das Ziel erzeugt und durch die Glieder der Kette geschickt wurde, machte das Geschäft der Zerstörung alltäglich: „extreme forms of violence and normal bureaucratic practices"

21 John Tirpak: Beyond Reachback. In: Air Force Magazine, 2009, 3; Vgl. auch: Christopher Drew: Military Taps into Social Networking Skills. In: New York Times, 7.6.2010.

22 Nick Cullather: Bombing at the Speed of Thought. Intelligence in the Coming Age of Cyberwar. In: Intelligence and National Security, 2003, Bd. 18, Heft 4, S. 141–154; Adam Herbert: Compressing the Kill Chain. In: Air Force Magazine, 2003, Bd. 86, Heft 3, S. 50–54.

23 Jonathan Vaccaro: The Next Surge. Counterbureaucracy. In: New York Times, 8.12.2009.

24 Bing West: The Wrong War. Grit, Strategy and the Way Out of Afghanistan, New York 2011, S. 89.

25 Der Begriff leitet sich von Foucault ab, aber Deleuzes Randbemerkung ist besonders passend: Vorrichtungen oder Geräte umfassen „curves of visibility and curves of enunciation", mit anderen Worten: „[T]hey are machines which make one see and speak". Gilles Deleuze: ,What Is a Dispositif?' In: Michel Foucault: Philosopher [Essays], New York 1992, S. 160.

26 Chad Harris: The Omniscient Eye. Satellite Imagery, Battlespace Awareness and the Structures of the Imperial Gaze. In: Surveillance & Society, 2006, Bd. 4, Heft 1, S. 102.

wurden „co-extensive" gemacht.[27] Die spätmoderne *kill chain* ist jedoch zunehmend auf mobile und neu entstehende Ziele gerichtet. Die „choreography of combat" (David Kaplow) erfordert eine schnelle Verarbeitung der Geheimdienstinformationen, wenn sogenannte „intelligente Waffen" nicht plötzlich sehr dumm erscheinen sollen.[28] Die Verdichtung von Raum und Zeit, die eine Folge davon ist, bringt alle Beteiligten im Netzwerk viel näher an den Raum des Tötens.[29] Herkömmliche Bomberpilotinnen und -piloten sähen ihre Ziele nicht, so Peter Singer, aber im Gegensatz zu Zygmunt Baumans Anspielung auf „pilots-turned-computer-operators",[30] die weit von ihren Zielen entfernt sind und „scurrying over those they hit too fast to witness the devastation they cause and the blood they spill", besteht er darauf, dass diejenigen, die eine UAV-Mission in Echtzeit beobachten, ihr Ziel aus nächster Nähe sähen und auch das Geschehen während und nach der Explosion mitbekämen. Sie befänden zwar in physischer Distanz, sähen aber umso mehr. Tatsächlich sagen die in Nevada arbeitenden Operatoren immer wieder, dass sie überhaupt nicht weiter weg sind, sondern nur „eighteen inches from the battlefield": Das ist der Abstand zwischen Auge und Bildschirm. Dieses Gefühl ist teilweise das Produkt der gewollten Prägung einer Kriegerkultur unter UAV-Steuerungspersonal, aber es ist zum Teil auch ein Produkt von Interpellation, der Vereinnahmung und Gefangennahme durch das Sichtfeld.[31]

Videospielkrieg?

Aus diesem Grund gehen Charakterisierungen der Drohnenmissionen als Augenblicke in einem *„video game war"*, der eine *„playstation mentality to killing"* hervorruft, womöglich weit am Ziel vorbei.[32] Kritische Stimmen verweisen oft auf Grossmans Untersuchungen des *learning to kill*, die Distanz als wirkungsvolles Mittel zur Überwindung

27 Harris (s. Anm. 26) S. 114.

28 David Koplow: Death by Moderation. The US Military's Quest for Usable Weapons, Cambridge 2010, S. 96.

29 Rebecca Grant: The All-seeing Air Force. In: Air Force Magazine, September 2008; Timothy Uecker: Full-motion Video. The New Dimension of Imagery. Research Report, Air Command and Staff College, Maxwell Air Force Base, 2005.

30 Zygmunt Bauman: Wars of the Globalization Era. In: European Journal of Social Theory, 2001, Bd. 4, S. 15.

31 Dieser Prozess verdient eine besondere Hervorhebung. Ein UAV-Pilot gestand, das er bei seinem ersten „kill" „[was] concentrating entirely on the shot and its technical aspects". In seiner Sicht war der Mensch „only a high-tech image on a computer screen". Allerdings erzeugten nachfolgende Missionen allmählich nicht nur ein Gefühl von Beteiligung, sondern auch von (bedingter) Verantwortlichkeit und sogar gelegentlich von Reue. Martin, Sasser (s. Anm. 10), S. 43–44, 52–55, 212.

32 Philip Alston: Report of the Special Rapporteur on extrajudicial, summary or arbitrary Executions, Genf 2010, S. 5.; Fellowship of Reconciliation: Convenient Killing. Armed Drones and the „Playstation" Mentality, Oxford 2010.

des Widerstands gegenüber dem Töten identifizieren. Seiner Ansicht nach wurden „pilots and bombardiers" des Zweiten Weltkriegs vom Anblick der Wirkung ihrer Bomben „protected by distance".[33] „From a distance I can deny your humanity, and from a distance I cannot hear you scream."[34] Obwohl Grossman seine Arbeit verfasste, bevor UAV bewaffnet wurden, und so die Drohnenkriege nicht direkt betrachten konnte, wies er doch auf Ego-Shooter-Videospiele als besonders wirkungsvolle Mittel zur Konditionierung hin, durch welche die Spielenden *hardwired,* zum Töten abgehärtet wurden. Seine Anatomie des Tötens führt nicht nur physikalische Distanz an, sondern auch emotionale Distanz, einschließlich sozialer, kultureller, moralischer und, was ganz wesentlich ist, *mechanischer* Distanz: nämlich durch den Bildschirm, der sie vom Spiel trennt.[35] Daraus abzuleiten, dass das Töten aus der Distanz über ein UAV diesen affektiven Schutz radikalisieren würde, scheint ein kleiner Schritt zu sein. Und doch inszenieren Videospiele Gewalt nicht als passives Spektakel. Sie sind zutiefst penetrant und ziehen Spielende in ihre virtuellen Welten hinein, weshalb das US-Militär sie in ihrem einsatzvorbereitenden Training nutzt.[36]

Die Videostreams aus den UAV scheinen die gleiche Realitätswirkung zu erzeugen. „You see a lot of detail", heißt es in den ersten Berichten über UAV vom Commander der Air Force, „we feel it, maybe not to the same degree [as] if we were actually there, but it affects us". Die Konsequenz des eigenen Handelns ist zudem unumkehrbar. „When you let a missile go", so führt er weiter aus, „you know that's real life – there's no reset button."[37] Ein Predator-Pilot beharrt darauf, dass der Schrecken, zwei kleine Jungen auf einem Fahrrad in den Rahmen radeln zu sehen, nur Sekunden bevor seine Rakete einschlug, nichts von ihrer Wucht verliere, nur weil dies eine Bildschirmansicht sei: „Death observed was still death".[38] Anekdoten können diese Frage selbstverständ-

33 Dave Grossman: On Killing. The Psychological Cost of Learning to Kill in War and Society, New York 1995, S. 78.

34 Grossmann (s. Anm. 33), S. 102; Derek Gregory: Doors into Nowhere. Dead Cities and the Natural History of Destruction. In: Michael Heffernan, Peter Meusburger, Edgar Wunder (Hg.): Cultural Memories, Heidelberg 2011, S. 249–283.

35 Grossmann (s. Anm. 33), S. 188f.

36 Das Militär verwendet sie auch zur Rekrutierung, was sehr viel problematischer ist, und auf ihrer Homepage inszeniert die Air Force die Jäger-Killer-Missionen tatsächlich als Videospiel-Unterhaltung, siehe „Fly the MQ-9 Reaper" auf http://www.airforce.com/games-and-extras. Allgemeiner ausgedrückt schätzt der spätmoderne Krieg Fähigkeiten wie rasche Hand-Augen-Koordination, Multi-Tasking und Sehschärfe, die durch das Spielen von Videospielen verbessert werden – insofern liegt Chow richtig –, jedoch reduziert dies den Krieg nicht automatisch auf ein Videospiel. Vgl. Chow (s. Anm. 6), S. 35.

37 Lara Logan: Drones. America's New Air Force. In: CBS News 60 Minutes, 14.8.2009; David Zucchino: Drone Pilots Have a Front-row Seat on War from Half a World Away. In: Los Angeles Times, 21.2.2010.

38 Martin, Sasser (s. Anm. 10), S. 212.

lich nicht klären, aber Berichte über Drohnencrews, die an posttraumatischem Stress leiden, der dadurch ausgelöst wird, dass sie sich dauerhaft hochaufgelösten Bildern von Echtzeittötungen und dem nach dem Angriff erfolgten Inventarisieren der Körperteile ausgesetzt sehen, sollten äußerst ernst genommen werden.[39]

Zudem existieren auffallende Unterschiede zwischen Videospielen und Videoübertragungen. Erstens erfolgt das Eintauchen in Videospiele diskontinuierlich – Levels werden neu gestartet, Situationen resettet, Spiele angehalten – und auch wenn es verschiedene Intensitäten der Beteiligung während einer UAV-Mission gibt und im Laufe einer Patrouille Schichten wechseln, ist das Eintauchen in Video-Liveübertragungen intrinsisch kontinuierlich.[40] Zweitens zeigen Videospiele, die in Simulakren von Afghanistan inszeniert sind, stilisierte Landschaften, durch die nur Aufständische oder Terroristen streichen, deren comichaftes Aussehen sie augenblicklich erkennbar macht. Der Neo-Orientalismus dieser Wiedergabe ist dabei noch eine andere betrübliche Angelegenheit.[41] Videoübertragungen von UAV zeigen eine viel komplexere bewohnte Landschaft, in der Unterscheidungen zwischen zivilen und gegnerischen Personen äußerst problematisch sind. Die Existenz so vieler Augen in diesem überfüllten Himmel – Militärs im Offiziersrang, steuernde und analysierende Fachkräfte und vor allem Militäranwaltschaft – ist eine (Vor-)Warnung, dass die Gegenwart von Zivilpersonen ständig möglich ist. Das Risiko von Kollateralschaden ist zu einem wesentlichen Kriterium während der gesamten *kill chain* geworden, was sowohl eine Folge der Protokolle des Völkerrechts als auch der Aussicht auf eine öffentliche Untersuchung ist. Dies markiert einen dritten wesentlichen Unterschied zu Videospielen, da, wie Grossman zugibt,[42] das Töten im Kampf durch Rechtsverordnungen und gesetzliche Sanktionen geregelt ist und Befürwortende der Drohnenmissionen routinemäßig Aufmerksamkeit auf die Gesetze zur Regulierung von bewaffneten Konflikten lenken, nämlich auf den Uniform Code of Military Justice und die Rules of Engagement. Ein informierter Kommentator führt an, dass die längeren Verweilzeiten und verbesserten Videostreams der Drohnen die Rolle von *Judge Advocates*, die Befehlshaber seit den späten 1980er-Jahren bei der Verfolgung von Zielen sachverständig beraten, erheblich erweitert haben.[43]

39 Scott Lindlaw: UAV Operators Suffer War Stress. In: Associated Press, 8.8.2012.
40 Ich verdanke diesen Vorschlag Ben Anderson.
41 Siehe Johan Höglund: Electronic Empire. Orientalism Revisited in the Military Shooter. In: Game Studies, 2008, Bd. 8, Heft 1, online abrufbar: http://gamestudies.org/0801/articles/hoeglund (Stand: 09/2011).
42 Grossman (s. Anm. 33), S. 314–316.
43 Jack Beard: Law and War in the Virtual Era. In: American Journal of International Law, 2009, Bd. 103, S. 422.

Kulturelle Gräben

Die USAF ihrerseits behauptet unter Berufung auf die *Revolution in Military Affairs* und nachfolgende Projekte, dass sie sich von einer Kriegsführung des *industrial age* zu einer Kriegsführung des *information age* weiterentwickelt habe. Seit dem Zweiten Weltkrieg hat die Zahl von Waffen (Luftfahrzeuge/Bomben), die am Angriff auf ein Ziel beteiligt waren, beträchtlich abgenommen, während die Zahl der daran beteiligten Sensoren sich beträchtlich erhöht hat. Bewaffnete UAV haben an diesem Übergang einen entscheidenden Anteil. Doch während die USAF dies als die Überwindung einer kulturellen Trennung von „Präzision" und „Information" wertet, sehen kritische Stimmen hier einen anderen Rubikon überschritten. So hat der Air Chief Marshall Großbritanniens, Sir Brian Burridge, die Jäger-Killer-Missionen weniger als Präzisionsschläge eines „virtuous war" begriffen als vielmehr einen „virtue-less war" in ihnen am Werk gesehen, der weder Heldentum noch Mut erfordere.[44] Dabei beruft er sich auf einen zentralen Grundsatz vieler ethischer Forderungen an bewaffnete Konflikte, nämlich auf das Recht auf Tötung des Gegners aus Notwehr und zur Selbstverteidigung. Im Gegensatz dazu erlauben die ferngesteuerten UAV-Operationen, was die USAF „the projection of power without vulnerability" nennt.[45] Dies trifft selbstverständlich nur in einem bestimmten Sinne zu: Flug- und Bedienpersonal auf der Creech Air Force Base ist offentsichtlich keiner Gefahr ausgesetzt – das an der Front eingesetzte Personal und die Bodentruppen hingegen sehr wohl. Dennoch zielt Burridges Punkt genau auf den zentralen Kern des spätmodernen Kriegs. So bezweifelt Frédéric Gros, dass man diesen tatsächlich als „Krieg" bezeichnen dürfe:

> *„New conflicts, in their hyper-technical version, marginalize or even completely evacuate that minimal equality in the face of death that constituted the identity of what, among the violence and the massacres, the clashes and the raiding, used to be distinguished as ‚war'."*[46]

Wenn diesen neuen Stadien von Gewalt jedoch etwas Raubtierhaftes innewohnt, so wurde diese „Gleichheit im Angesicht des Todes" – und damit die rohe Intimität des Tötungsraums – noch durch andere Technologien ausgelöscht als durch die Predator- oder Reaper-Drohnen: Man denke nur an die Marschflugkörper, die von Schiffen

44 Jane Mayer: The Predator War. In: New Yorker, 26.10.2009.

45 Die UAV selbst sind äußerst verletzlich. In Afghanistan (und andernorts) ist der Luftraum, in dem sie sich bewegen, unangefochten, aber in anderen Kriegsgebieten wäre ihre Lebensdauer in ihrer jetzigen Form weit kürzer.

46 Frédéric Gros: States of Violence. An Essay on the End of War, London 2010, S. 268.

abgefeuert wurden, die Hunderte von Kilometern von ihren Zielen entfernt sind. Was diese Jäger-Killer-Plattformen unterscheidet, ist die Zerstreuung und die Verteilung sowohl der „faceless enemies that wage war from afar", als auch der Gesichter ihrer menschlichen Ziele über ein Netzwerk, das eine seltsam neue Form von Intimität schafft, die gleichzeitig kollektiv und einseitig ist.[47] Denn wie gezeigt werden sollte, stellt die Verdichtung von Zeit und Raum der *kill chain* sicher, dass unabhängig davon, welcher kulturelle Graben mit *precision and information* überschritten wurde, ein anderer seither auffallend verbreitert ist: die technokulturelle Unterscheidung zwischen „ihrem" Raum und „unserem" Raum, zwischen dem Auge und dem Ziel.

Die beiden Ebenen des konventionellen Luftkriegs – die „Sicht von oben" und die „Sicht von unten" – verschmelzen in den hier beschriebenen Netzwerkoperationen, wie es auch ein Missionsleiter auf Creech ausdrückte: „You're watching what they see, eighteen inches from the battlefield."[48] Doch in dieser neuen militärischen Optik sind beide Sichtweisen stets „unsere".

Der vorliegende Beitrag ist eine gekürzte Übersetzung des in englischer Sprache erschienenen Texts von Derek Gregory: From a View to a Kill. Drones and Late Modern War. In: Theory Culture Society, 2011, Bd. 28, Heft 7–8, S. 188–215. Veröffentlichung mit Erlaubnis von Sage Publications, Ltd.

47 David Kilcullen, Andrew Exum: Death from Above, Outrage Down Below. In: New York Times, 16.5.2009.
48 Kelly Guernica: On the Frontlines. From 8,000 Miles Away. In: FOX News, 8. 4.2010.

Nicholas Whitfield

Serielle Fotografie als Vermittlungsstrategie endoskopischer Sehpraktiken

Als der deutsche Urologe Maximilian Nitze im späten 19. Jahrhundert ein Instrument entwickelte, um in die menschliche Harnblase zu schauen, eröffnete er damit ein Sehfeld, das in der langen Geschichte der anatomischen Forschung einzigartig ist. Nitzes Zystoskop war nicht die erste Vorrichtung, um das dunkle Innere des menschlichen Körpers zu erhellen. Jedoch boten seine Ideen zur Beleuchtung mit glühenden Platindrähten und Niederspannungsglühbirnen eine ganz neue Deutlichkeit und erlaubten eine fotografische Dokumentation. Während des 20. Jahrhunderts entwickelte sich die Endoskopie in vielen medizinischen Spezialgebieten zu einem Standardverfahren und wurde für exploratorische, diagnostische und später auch chirurgische Zwecke eingesetzt. Die fotografische Dokumentation war ein integraler Bestandteil dieser Geschichte. Technische Verbesserungen bei der Visualisierung führten zu neuen Geräten und Indikationen und damit breitete sich die Nutzung von Endoskopen in der zweiten Hälfte des Jahrhunderts von der Gynäkologie und der Gastroenterologie bis in die Allgemeinchirurgie aus. Da Fotografien dazu beitrugen, eine charakteristische Seherfahrung festzulegen, verschärften sie die für die endoskopische Sehweise zentralen interpretativen Dilemmata.

In den vergangenen zwei Jahrhunderten hat die Zahl von Endoskopiegeräten stark zugenommen – Instrumente, die dazu entworfen wurden, die verschiedenen inneren Oberflächen des menschlichen Körpers zugänglich zu machen und zu visualisieren.[1] Nitzes Vorrichtung war speziell für die Harnblase gedacht, in die sie über den Harnleiter eingeführt wurde. Im Gegensatz dazu schuf das in ↗ **Abb. 1** gezeigte Instrument, ein in den 1960er-Jahren hergestelltes Laparoskop, eine Ansicht der Bauchhöhle über einen kleinen chirurgischen Schnitt, der unterhalb des Bauchnabels erfolgte. Beim Blick in dieses Instrument wurden Betrachtende mit Aspekten einer unbekannten Welt konfrontiert: anatomische Strukturen, die durch die Linsenanordnungen verzerrt waren, durch Insufflation gedehnte Gewebe, Organe in einem künstlichen Licht, die durch ein enges Sehfeld fragmentiert wurden. Ordnung in diese Phänomene zu bringen, war das wichtigste Anliegen der Endoskopikerinnen und Endoskopiker vor und nach Nitze und sie standen vor gewaltigen Herausforderungen. Endoskope beschränkten die Zuschauerschaft nicht nur auf eine einzige Betrachterin bzw. einen Betrachter (wie es vor der kameragestützten Endoskopie gängige Praxis war), sondern sie rissen die betrachteten anatomischen Objekte auch radikal aus ihrem Kontext.[2] In

1 Für eine Übersicht über einige dieser Instrumente siehe Claudio Pogliano: Lumen in obscuris. The winding road of modern endoscopy. In: Nuncius, 26, 2011, Heft 1, S. 50–82.

2 In diesem Sinne sind endoskopische Bilder mit anatomischer Modellherstellung vergleichbar, beispielsweise den Wachsembryonen von Adolf Ziegler, vgl. Lorraine Daston, Peter Galison: Objectivity, Cambridge/London 2007, S. 327; sowie Nick Hopwood: Embryos in Wax: Models from the Ziegler Studio,

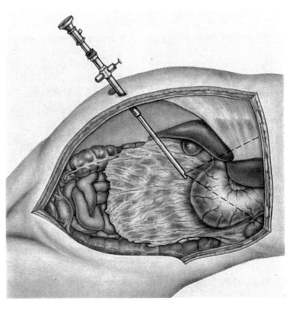

der Mitte des 20. Jahrhunderts rückte die Fotografie als bevorzugtes Mittel zur Lösung dieser interpretativen Herausforderungen in den Fokus und Fotografien wurden allgemein übliche Werkzeuge für Diagnose und Lehre. Dieser Beitrag beleuchtet die Rolle der Fotografie bei der Lenkung der endoskopischen Praxis und folgt den Spuren der Statusverschiebung endoskopischer Fotografien, von einfachen Nachbildungen innerer Erscheinungen hin zu Vermittlungsstrategien von interpretativer Kompetenz.[3]

1: Eine angeschnittene schematische Darstellung einer laparoskopischen Untersuchung des Oberbauchs. Diese Abbildung erscheint in einem Kapitel namens „Orientierung im Oberbauch", in dem der Zusammenhang zwischen besonderen Detailansichten und verschiedenen laparoskopischen Manövern und Patientenlagerungen erläutert wird.

Frühe Potenziale der endoskopischen Fotografie

Unter den wohlbekannten frühen Versuchen einer inneren Fotografie standen die von Brubaker und Holinger aufgenommenen Kodachrome-Standbilder von Kehlkopf, Bronchien und Speiseröhre ganz am Anfang einer Periode, in der wissbegierige Ärztinnen und Ärzte das Potenzial der endoskopischen Bildgebung untersuchten.[4] ⊿ **Abb. 2** Obwohl Brubaker und Holinger ihre Bemühungen selbst in eine längere Zeitlinie von fotografischen Versuchen einordneten, setzten ihre makellosen Farbbilder neue Standards hinsichtlich der Schärfe und wurden von zeitgenössischen Stimmen lobend gewürdigt. Die Schwierigkeiten, exakte Fotografien aufzunehmen, waren damals hartnäckig und zahlreich und wurden dadurch verschärft, dass dem Wohl der Patientinnen und Patienten Vorrang gegeben werden musste. Die Farbfotografie, die wegen der vielversprechenden diagnos-

Cambridge 2002, S. 35. Zur ‚exotischen' Natur endoskopischer Bilder siehe ferner Jose Van Dijck: The Transparent Body: A Cultural Analysis of Medical Imaging, Seattle 2005) S. 69–70.

3 Geschichten der Endoskopie, die für diese Arbeit herangezogen wurden, umfassen: Grzegorz S. Litynski: Highlights in the History of Laparoscopy, Frankfurt a. M. 1996; James M. Edmonson: History of the instruments for gastrointestinal endoscopy. In: Gastrointestinal Endoscopy, 37, 1991, Heft 2, S. 27–56; W. Y. Lau, C. K. Leow, Arthur K. C: History of Endoscopic and Laparoscopic Surgery. In: World Journal of Surgery, 21, 1997, Heft 4, S. 444–453.

4 J. D. Brubaker, Paul H. Holinger: The Larynx, Bronchi, and Esophagus in Kodachrome. In: The Journal of the Biological Photographic Association, 10, 1941, Heft 2, S. 83–91.

These reproductions are taken from Kodachrome still transparencies. Original circles were about 0.4 to 0.5 inch in diameter. Top Left, Mirror view during phonation. Top Right, Mirror view of normal larynx showing epiglottis, vocal cords and tracheal rings. Bottom Left, View through laryngoscope showing arytenoids, vocal cords, and tracheal rings. Bottom Right, Mirror view during phonation. Papilloma of left vocal cord.

The above are single frame enlargements from 16 mm. Kodachrome movie film given here to show image diameter in relation to full frame. Top Left, Vocal cords as seen through 1/2 inch bronchoscope. Top Right, The carina at the bifurcation of the trachea (1/2 inch bronchoscope). Bottom Left, Normal vocal cords direct through laryngoscope at 10 inch distance. Bottom Right, Right main bronchus at junction of middle lobe (1/2 inch bronchoscope).

Figure 5. Black and white reproductions from Kodachrome.

2: Diese frühen fotografischen Darstellungen von Kehlkopf, Luftröhre und Speiseröhre besaßen eine ungewöhnliche – zu ihrer Zeit gefeierte – Klarheit. Die vorliegende Reihe beeindruckt mit gleichbleibender technischer Präzision. Spätere Bildsequenzen bemühten sich um explizite Befunddarstellungen, um visuelle Erwartungen zu lenken und zu strukturieren.

tischen Möglichkeiten begehrt war, erforderte eine höhere Lichtintensität als monochrome Reproduktionen, während der menschliche Puls und die Atmung Sichtfelder in ständige Bewegung versetzten, was die Bemühungen verkomplizierte, Bilder durch längere Belichtungszeiten zu gewinnen.

Enthusiastische Stimmen der 1940er-Jahre ließen sich davon nicht abschrecken, sondern wiesen auf die zahlreichen Möglichkeiten der endoskopischen Fotografie hin. Dabei sticht besonders das Argument heraus, dass Fotografien das Sehen *verbessern* und daher die diagnostische Genauigkeit erhöhen könnten, indem pathologische Aspekte offengelegt werden, die von einem untersuchenden Arzt ursprünglich nicht gesehen wurden (und vielleicht auch nicht zu sehen waren).[5] 1941 veröffentlichten Thomas Horan und Graham Eddy, zwei Ärzte, die in Detroit zusammenarbeiteten, eine Publikation, in der sie ihre Erfahrungen mit der intraabdominellen Farbfotografie beschrieben und behaupteten, dass solche Fotos eine Diagnose ermöglichten, die aus einer Anfangsuntersuchung der Leber des Patienten nicht erhalten werden konnte:

„*Not observed by the examining eye but suggested in the photograph is a grease appearance on the surface of the liver which may be explained by the increased fat content shown in the biopsy stains [...]. There are reasons to hope that the careful, leisurely scrutiny of similar enlarged photographs or their projection on a screen may reveal details of value in diagnosis which are not appreciated during the time of routine peritoneoscopy.*"[6]

5 Mirjam Brusius: Beyond Photography: An Introduction to William Henry Fox Talbot's Notebooks in the Talbot Collection at the British Library. In: British Library Electronic Journal, 2010, Heft 2, S. 1–41.

6 Thomas Horan, Graham Eddy: Intra-Abdominal Photography in Color. In: Surgery, Gynecology and Obstetrics, 73, 1941, Heft 3, S. 273–276, S. 273.

Die Autoren zitierten andere Fälle, in denen Fotografien die Diagnose unterstützten, einschließlich Aufnahmen einer syphilitischen Leber, die eine Unterscheidung zwischen den am Krankheitsverlauf beteiligten Lappen und denen mit regenerierendem Narbengewebe erlaubten.

Weit häufiger als das Argument einer Verbesserung des Sehens war jedoch die Idee, dass endoskopische Fotos einen pädagogischen und didaktischen Wert haben. Dies war ein Hauptargument von André Calamé, einem in Genf arbeitenden Chirurgen, der 1956 über seine Verwendung von Blitzfotografie während laparoskopischer Untersuchungen berichtete. „It is manifestly clear", schrieb er, „that photographic recording of laparoscopic observation will provide irrefutable evidence of what can be observed by the trained eye." Fotografien wären darüber hinaus wichtige Werkzeuge, jene Art von trainiertem Sehen einzuführen, die sich Calamé wünschte. Er bemerkte häufige Frustrationen bei seinen Studenten, die mit der laparoskopischen Methode kämpften, und interpretierte diese Probleme als Quelle für den großen Widerstand gegenüber dieser Methode. Daher machte er sich daran, „the importance for teaching purposes of a faithful colour reproduction of laparoscopic observation" zu zeigen. „Laparoscopy", führt er weiter aus, „requires initiation, and nothing can take the place of the accuracy and sharpness of a good photograph in teaching someone to recognize what he is examining."[7] So könnten Fotos nicht nur die Privatsphäre des endoskopischen Bereichs aufheben, indem sie ihn für viele Augen zugänglich machen, sondern sie könnten auch exakte Interpretationen vorführen, indem sie zeigen, wie eine solche Interpretation ablaufen sollte.

Andere wiederholten Calamés Glauben an die didaktische Kraft von Fotografien.[8] So schrieb ein amerikanischer Arzt 1959 über endoskopische Fotografie: „The visual perception of an intravesical lesion accurately photographed is, beyond question, the most logical and precise manner of creating a more lasting mental impression as to the difference between the normal and pathological."[9] Derartige Zuschreibungen sollten die Fotografie jedoch nicht allein als einen Anstoß zur Auseinandersetzung mit einer ursprünglichen Anatomie etablieren – oder jedenfalls nicht nur. Studierende der Endoskopie sollten stattdessen lernen, Fotos als letzten Bezugspunkt zu interpretieren und das Lesen der Bilder in ihre klinische Beurteilung mit einfließen zu lassen. Jahrzehnte

7 André Calamé: Laparoscopic Photography. In: Medical and Biological Illustration, 6, 1956, Heft 3, S. 148–157.

8 Zum Beispiel Lowrain McCrea: The Manifold Value of Endoscopic Photography in Surgery. In: The Journal of the International College of Surgeons, 32, 1959, Heft 6, S. 636–641; sowie Harold Lindner: Peritoneoscopic Photography with Intra-abdominal Electronic Flash. In: Medical and Biological Illustration, 15, 1965, Heft 3, S. 146–147.

9 McCrea (s. Anm. 8), S. 637.

später argumentierten der amerikanische Chirurg George Berci und seine Kollegen ähnlich zugunsten der Einführung von fotografischen Endoskopiedokumentationen und betonten dabei deren Beziehung zur menschlichen Fehlbarkeit: „It is hard to memorize and describe pathologic disorders if one has had only a fleeting glimpse of quickly changing events."[10] Präzise Farbfotos könnten flüchtige Endoskopieerscheinungen festhalten, was die Schwäche des Gedächtnisses und die für geschriebene Fallnotizen typischen Fallstricke vager Beschreibungen ergänzte. Die fachkundige Interpretation machte Fotografien zum „Arbeitsobjekt" der Medizin, zu primären Materialien für die endoskopische Diagnose und Betrachtung.[11] Das Einfügen dieser Fotos in Patientenakten spiegelt diese Vorrangstellung wider und stellte sie zugleich sicher. Einmal festgehalten, boten Fotos Zugang zu den Augen vorheriger Behandelnder, erlaubten Vergleiche und wurden zur Hauptquelle für eine klinische Entscheidungsfindung.

Solche Vorteile basierten auf der Genauigkeit – oder der potenziellen Genauigkeit – fotografischer Abbildungen. Die Befürworter der Fotografie lobten die makellose Schärfe der Kamera und bejubelten Bilder, die frei von subjektiven Verzerrungen sein und so eine frühere Tradition der Abbildung von anatomischen Strukturen mit Wasserfarben ersetzen sollten.[12] Autoren wie Calamé kritisierten die Verwendung von Wasserfarben für endoskopische Beobachtungen in Worten, die den Historikern im Bereich sowohl der Fotografie als auch der Objektivität wohl vertraut sind: „Faithful as these reproductions may be, they still leave too much scope for the artist's interpretation and imagination."[13] Aber selbst wenn sie den Willen des Betrachters erfolgreich eliminierten, beendeten Fotos keineswegs den Streit um die Darstellung des endoskopischen Bereichs. Verbesserungen bei der Visualisierung, einschließlich der Faseroptik-Technologie und des Aufkommens von flexiblen Endoskopen, gingen mit neuen Problemen bei der endoskopischen Darstellung einher. Die Einführung einer scharfen inneren Fotografie beendete ein Dilemma, nur um andere zu erzeugen.

10 George Berci, Gino Hasler, James G. Helmuth: Permanent Film Records. In George Berci (Hg.): Endo-scopy, New York 1976, S. 242.

11 Lorraine Daston: Beyond Representation. In: Catelijne Coopmans, Janet Vertesi, Michael Lynch, Steve Woolgar (Hg.): Representation in Scientific Practice Revisited, Cambridge/London 2014, S. 320–321.

12 Wie zum Beispiel in J. Caroli, Mlle P. Ricordeau, A. Fournes: La laparoscopie simple et combinée son importance dans le diagnostic des maladies hépato-biliaires. In: Semaine des Hôpitaux de Paris, 26 April, Paris 1954, S. 1671–1691.

13 Andre Calamé (s. Anm. 7), S. 149. Zum Ziel der Verwendung von Fotos zur Eliminierung der Subjektivität in einer Darstellung siehe Martin Kemp: A Perfect and Faithful Record. Mind and Body in Medical Photography before 1900. In: Ann Thomas, Marta Braun (Hg.): Beauty of another order: Photography in science, NewYork/Oxford 1997; Mirjam Brusius: Inscriptions in a double sense. The biography of an early scientific fotograf of script. In: Nuncius, 24, 2009, Heft 2, S. 367–392; Lorraine Daston, Peter Galison: Mechanical Objectivity. In: dies.: Objectivity (s. Anm. 2), S. 115–190.

Serielle Lenkung

Anfangs waren dies häufig pädagogische Dilemmata. Probleme beim Erkennen anatomischer Strukturen waren bei Studierenden wohlbekannt – frühe Fotografien beleuchteten zum Beispiel gezielt die Leberlappen, um die Aufmerksamkeit zu lenken – und ließen sich nicht einfach durch eine schärfere Bildgebung lösen. Probleme bei der pathologischen Interpretation waren ähnlich hartnäckig. Sie wurden durch die charakteristische Verzerrung der endoskopischen Linsen noch verschlimmert, wie von den Autoren einer 1961 erschienenen Publikation über intraabdominelle „Photolaparoskopie" beschrieben:

> *„The distortion of perspective peculiar to all wide-angle lenses and the lack of uniform illumination of the visual field make it difficult to judge size, color, and shape correctly from a single image. With some experience one can overcome this difficulty by viewing organs and structures from varying angles at the various distances."*[14]

Mit anderen Worten, durch die Reproduktion von typischen Verzerrungen konnten einzelne Fotografien erfolgreich eine dauerhafte Schwierigkeit der endoskopischen Praxis *vermitteln*, sie aber nicht lösen. Nur eine kumulative Seherfahrung konnte die Probleme der technischen Verzerrung überwinden. Isoliert betrachtet, konnte ein objektives Foto der Art wie von Calamé angepriesen nur verzerrte Fragmente von erkrankten oder normalen Teilen reproduzieren, wodurch die interpretativen Zwickmühlen des endoskopischen Bereichs insgesamt nur wiederholt wurden. Zwar waren isolierte Bilder wertvoll, wenn sie in einer Patientenakte archiviert oder für eine gemeinsame Betrachtung vergrößert wurden, jedoch waren sie für eine Orientierung nutzlos. Sie waren unfähig, das Spektrum von Ansichten zu umfassen, das für eine Relativierung von technischen Entstellungen notwendig ist, ganz zu schweigen für eine Nachbildung der vielseitigen Erfahrung, die einem profunden Urteil zugrunde liegt.

Auch konnte ein einzelnes Bild die Beziehung zwischen der Seherfahrung des Endoskopikers und der Positionierung des Patientenkörpers nicht spezifizieren. Während der Endoskopie müssen die Instrumente typischerweise bewegt werden, damit der Endoskopierende eine zusammenhängende Gesamtansicht eines Organs oder einer Körperhöhle erhält. Ganz eindeutig konnte ein einzelnes Foto nicht darauf hoffen, der Komplexität der Hand-Augen-Koordination auch nur nahezukommen. Um diese Beschränkungen zu überwinden, mussten fotografische Strategien über das ursprüng-

14 Gustave Uhlich, Earl G. Merritt: Intra-Abdominal Color Photography (Photolaparoscopy). In: American Journal of Digestive Diseases, 6, 1961, Heft 4, S. 322–331, S. 329 [Hervorh. d. A.].

liche Ziel der getreuen Wiedergabe des Aussehens von anatomischen Strukturen hinausgehen. Sie mussten irgendwie den kumulativen und prozesshaften Charakter des endoskopischen Navigierens abbilden, um die Praxis durch gelenkte Erwartungen zu lenken. Auf diese Weise nutzte das 1967 erschienene Handbuch von Albert Decker, *Culdoscopy* (der Name bezeichnet eine Methode zur Visualisierung der weiblichen Beckenorgane mit einem optischen Instrument, das durch eine Douglas-Punktion, engl. auch cul-de-sac puncture, eingeführt wird), Schwarz-Weiß- und gelegentlich auch Farbzeichnungen, um die Position der Patientin und den Winkel des Endoskops innerhalb einer geschlossenen Körperhöhle zu zeigen.[15] Der *Color Atlas of Laparoscopy* von Beck und Schaefer, der drei Jahre nach Deckers Handbuch publiziert wurde, nutzte ähnliche Kombinationen aus Fotografien und Illustrationen, um die visuellen und taktilen Erfahrungen wieder zusammenzuführen. Wie Uhlich und Merritt verwiesen auch sie auf die Probleme, die sich bei der Visualisierung in Bezug auf die Positionierung der Instrumente ergeben:

> „*The length of the instrument permits [...] a close-up view of the object. Details such as the lobular structure of the liver, capillaries, lymphatics, or minute peritoneal lesions are thus easily recognized [...]. [O]ne gains a fair scanning view of larger intra-abdominal areas upon withdrawal of the instrument. Aside from axial rotation and advancement or withdrawal, there is a third swaying manoeuvre possible, by pivoting the laparascope* [sic] *about the point of entrance through the abdominal wall. By utilizing these various possibilities [...] one can visualize an object from various points. The examiner thus inadvertently gains a mosaic-like high-fidelity composite picture.*"[16]

Wie könnte dieses detailgetreue Kompositbild stattdessen übermittelt werden? Wenn nicht durch ein einzelnes Bild, welche Anzahl wäre dann ausreichend?

Quantität selbst war keine Lösung. Eine willkürliche Zusammenstellung von endoskopischen Fotos multiplizierte nur die Begrenzungen von jedem einzelnen. Die Autoren rieten stattdessen dazu, die Fotos basierend auf dem Urteilsvermögen einer langjährigen Erfahrung selektiv zu präsentieren und solche Bilder zu Vergleichszwecken und zwecks Betonung typischer oder instruktiver Merkmale seriell anzuordnen. Mit anderen Worten, die Fotografien übten ihre pädagogische Wirkung am zwingendsten in einer Serie aus, als Abfolge von Bildern, die nicht unbedingt eine konti-

15 Albert Decker: Culdoscopy, Philadelphia 1967.
16 K. Beck, H. J. Schaefer: Color Atlas of Laparoscopy, New York/Stuttgart 1970, S. 9.

nuierliche Ansicht einer Struktur nachahmte (auch wenn dies eine Möglichkeit war), aber dennoch Elemente eines besonderen interpretativen oder visuellen Vorgangs implizierte.[17]

Serialität beanspruchte mehrere Vorteile. Zunächst bot sie ein Mittel, die verzerrte Sicht von Endoskopen zu domestizieren, indem die Betrachtenden mit charakteristischen Verzerrungen vertraut gemacht werden. Zum Beispiel beginnt der Atlas von Beck und Schaeffer mit sechs endoskopischen Fotos einer Streichholzschachtel aus verschiedenen Winkeln und Entfernungen. In jedem Foto ist die Annäherung des Laparoskops an den Gegenstand mit einem Pfeil angegeben, wodurch die Natur der Verzerrung aus jeder Position gezeigt wird. ↗ **Abb. 3** Dies gilt auch für andere Handbücher, wie etwa *Endoscopy* von George Berci, das Bilder von maschinengeschriebenem Text enthält, der wiederum aus verschiedenen Entfernungen betrachtet wird. Durch diese Wiederholung der Sehszenarien konnten serielle Fotos von Alltagsgegenständen das verzerrte Aussehen von genauer untersuchten Strukturen beherrschbar machen, wobei das studentische Sehwissen der groben Anatomie mit fragmentierten endoskopischen Daten abgeglichen wurde.

3: Eine fotografische Serie, die Ansichten einer Streichholzschachtel aus verschiedenen Blickwinkeln (bei gleichem Abstand) zeigt, um typische Verzerrungen zu verdeutlichen. „We have shown these conspicuous distortions intentionally", gaben die Autoren an. Wenngleich im Peritonealraum „one rarely encounters straight lines and flat areas", zeigten die Bilder doch „how the image of an object can be changed drastically by changing the viewing direction and maneuvering the objective about the object". Sie gaben weiterhin an, dass „by viewing various sequential aspects of an object, the examiner gains a true impression".

Zweitens brachten die serialisierten Fotografien die verschobenen Segmente von Organen (wieder) in den Kontext einer vertrauteren anatomischen Abfolge, die deren Kontinuität mit anderen Strukturen zeigte und die Normalität oder Pathologie ihres Aussehens durch Vergleich mit anderen erkrankten oder gesunden Teilen hervorhob. ↗ **Abb. 4** Zum Beispiel: der bläuliche Farbton einer gesunden Gallenblase gegenüber dem vergrößerten, rötlichen Aussehen bei einer akuten Cholezystitis oder die glatte

17 Zur Geschichte der Serialität: Nick Hopwood, Simon Schaffer, Jim Secord: Seriality and Scientific Objects in the Nineteenth Century. In: History of Science, 48, 2010, Heft 3/4, S. 251–285.

4: Leber: Folgeschäden von Hepatitis. Eine von vielen Serien, die ein charakteristisches endoskopisches Erscheinungsbild eines kranken Organs vorführt. Beck stellte jedem Bild einen unterweisenden Kommentar sowie endoskopische Fotografien von gesunden Organen zur Seite.

Oberfläche einer gutgenährten Leber gegenüber der charakteristischen weißen Narbenzeichnung bei viraler Hepatitis.[18] Dabei waren Strategien von Abfolge und Vergleich entscheidend: Erstere bildete eine holistische Anatomie nach, Letztere definierte Norm und Abweichung. Serielle Bilder verbanden die endoskopische Sicht nicht nur wieder mit dem menschlichen Körper auf dem Operationstisch, sondern auch mit der typischen pathologischen Vielfalt in der Natur.

Schließlich destillierten serielle Fotos die langjährige Erfahrung der für ihre Auswahl und Organisation Verantwortlichen heraus und spiegelten wider, welche visuellen Informationen von geschultem Personal als grundlegend für die Kultivierung intraoperativer Fähigkeiten angesehen wurden. Diese Ambitionen werden in mehreren der einleitenden Bemerkungen im Atlas von Beck und Schaefer erwähnt, in dem ganze Organe über mehrere Kapitel in serialisierte Fragmente aufgelöst werden. Die Autoren beschrieben, dass ihre Illustrationen „were selected from the wealth of some 10,000 available photographs" und dass „[i]n some instances we disregarded technical shortcoming in favor of the importance of a specific subject", und schließlich: „We have emphasized typical findings and not casuistic details."[19] Ihre Kommentare definieren die Verwendung der Serienfotografie und auch die erkenntnistheoretischen Fragen, die mit ihnen einhergingen. Fehlerlose Reproduktionen wurden dem Gegenstand, die Kasuistik der Allgemeingültigkeit untergeordnet. Die Serialität adressierte mit einem Schlag die Probleme der verzerrten Sicht, der ungeordneten Anatomie und der Unerfahrenheit der Beobachtenden. Darüber hinaus war die Serialität ein Nachbild der Praxiserfahrung. Durch die Verbindung von Leser- und Autorschaft, Studierenden und Lehrenden brachte sie die Wiederholung der zerlegten Ansichten,

18 Beck, Schaefer (s. Anm. 16), Abb. 30 und 42 bzw. 72 und 88.
19 Beck, Schaefer (s. Anm. 16), S. vi–vii.

die so spezifisch für alle endoskopischen Erfahrungen ist, zum Ausdruck und verfestigte sie dabei als eine Abfolge, mit dem Ziel interpretative Erfahrenheit zu vermitteln. Das übergeordnete Ziel war trainiertes Sehen und eine Bereicherung der visuellen Fähigkeiten. Wie einer der Autoren des Vorworts bemerkte: „Having good pictures at hand doesn't give one the right to make a diagnosis by matching, of course – far from it. But study of good pictures forces the laparoscopist to look for more and, consequently, to see more at his succeeding examinations."[20]

Vervielfachung des Blicks

In den 1970er-Jahren waren serielle Fotografien Standardkomponenten von Endoskopieatlanten und ihre unzähligen Funktionen hatten die Grenze zwischen Präsentation und Repräsentation nachhaltig verwischt. Die hier skizzierte Zeitlinie – von dem Ideal der Fotos frei von künstlerischen Vorurteilen (wie bei Calamé) bis zum Aufkommen einer gelehrten Auswahl aus den Bildern eines unendlich komplexen Gebiets (wie in Atlanten des späten 20. Jahrhunderts) – rekapituliert einige vertraute Phasen der Geschichte der wissenschaftlichen Fotografie und Bildgebung in Atlanten, insbesondere die Verschiebung vom Glauben an die reine Darstellung zu einer Privilegierung von Variationen und Prozess, Vielfältigkeit und Veränderung, und nicht zu vergessen einer Anerkennung der synthetischen Qualität aller Beobachtungstechniken.[21] Das Aufkommen der Kinematografie und des Fernsehens in den 1980er-Jahren verlagerte einige der Probleme, die dem Streben nach scharfen Fotos des späten 19. Jahrhunderts zugrunde lagen, aber erst nachdem die Endoskopie Strategien gefunden hatte, um interpretative Dilemmata aufzuklären und zu adressieren. Unter diesen Strategien ragt die Serialität heraus. Was Endoskopikerinnen und Endoskopiker in Fragmente zerlegt hatten, konnten Atlanten in seriellen Anordnungen wiedervereinen, um Erwartungen zu lenken, das Sehen zu trainieren, die Sinne neu zu koordinieren und den unerträglich privaten Bereich des endoskopischen Sehens aufzubrechen.

Dieser Text wurde aus dem Englischen übersetzt.

Der Autor möchte sich für die inhaltlichen Anregungen und die konstruktive Kritik zu diesem Beitrag bei seinen Kolleginnen und Kollegen bedanken, allen voran bei Thomas Schlich, Cynthia Tang, Cosimo Calabrò und den Teilnehmenden der Arbeitsgruppe Chirurgiegeschichte an der McGill University.

20 Beck, Schaefer (s. Anm. 16), S. viii.
21 Daston, Galison (s. Anm. 3), Kap. 3 und 6.

1: Michael Yon: Aircraft painting helicopter landing zone in Kandahar Province, 2011.

Bildbesprechung

Nina Franz

Painting the Target

Eine dem Online-Magazin des Kriegsberichterstatters Michael Yon entnommene Abbildung zeigt den Blick durch den „Strohhalm" eines Infrarotsichtgeräts. ↗ **Abb. 1** Yons Beschreibung zufolge handelt es sich um ein auf die Kamera montiertes, monokulares Nachtsichtgerät des Typs PVS-14. Ein grün eingefärbter Kreis, schwarz umrahmt, darin ein fast lotrecht absteigender Strahl, der, von außerhalb des Bildausschnitts kommend, in einen Punkt auf einer wenig konturierten Fläche mündet. Das Bild stammt aus einem Blog-Eintrag Yons,[1] den dieser im November 2012, gleich nach dem Anschlag auf die US-Vertretung in Bengasi, verfasste, während er sich selbst als *embedded journalist* in Afghanistan aufhielt. Das Bild hat Seltenheitswert, denn es ist die einzige öffentlich verfügbare, dokumentarische Aufnahme einer militärischen Praxis, die als „Lasern", „Sparkling"[2] oder „Painting the Target"[3] bezeichnet wird. In Berichten von Drohnenpiloten[4] ist sie zentral für die bildvermittelten Verfahren ferngesteuerter Militär

einsätze. *Laser designation* und *laser guidance* sind Technologien, die es erlauben, ein Ziel aus größerer Entfernung, aus der Luft oder vom Boden mit einem Laserstrahl niedriger Frequenz zum Abschuss zu markieren. Lasergelenkte Geschosse oder *Smart Bombs* erfassen die von der Markierung reflektierte Strahlung mittels eines Suchers und werden so zu ihrem Ziel gelenkt.[5]

Die mit künstlichem Licht jeher gegebene Macht, verborgene Dinge aus der Dunkelheit zu lösen und damit zu Zielen zu machen,[6] erfährt mit dem Verfahren des *Laserns*, bei dem Licht auf hochintensive Art gebündelt, verstärkt und auf einen Punkt gerichtet wird, eine Zuspitzung. Das Wort „Laser" steht, seiner technischen Definition nach, für *Light amplification by stimulated emission of radiation*. Atome werden mithilfe eines Oszillators zu einem höheren Grad von Aktivität stimuliert, woraufhin sie Licht abgeben, während sie zu ihrem ursprünglichen Aktivitätslevel zurückfinden. Werden alle Atome innerhalb der stimulierenden Welle miteinander synchronisiert, dann entsteht daraus ein kohärenter, sehr starker, pulsierender Strahl auf einer einzigen Frequenz.[7] Der amerikanische Konzern Texas Instruments entwickelte die

erste lasergeführte Bombe namens Paveway, die ab 1968 im Vietnam-Krieg eingesetzt wurde.[8] In den 1980er-Jahren begann, zunächst unter Verbündeten der USA, die Proliferation lasergelenkter Präzisionswaffen.[9]

Seit 2001 befinden sich lasergelenkte Hellfire-Raketen an Bord von bewaffneten Drohnen der Typen Predator, Reaper und Grey Eagle. Über das integrierte *Multi-Spectral Targeting System*[10] werden Ziele erfasst, markiert und beschossen. Die Laser-Markierung erfolgt an den Monitoren der Kontrollstationen, fernab von ihren Einsatzorten in Afghanistan, Pakistan oder im Jemen. Für einen Menschen, der vom Zielstrahl erfasst wird, ist er ohne Infrarotsichtgerät nicht wahrnehmbar. Aber auf den Monitoren der Kontrollstationen erscheint das Ziel wie von einem grünen Lichtstrahl erleuchtet. „Painting the Target" bedeutet also zweierlei: eine Manipulation von Pixeln auf einer zweidimensionalen Fläche, durch die der Cursor das Ziel als solches am Bildschirm erzeugt, und eine Markierung des Ziels, sei es eine Landebahn, ein Objekt oder ein Mensch, am Zielort der Handlung. Als *gemaltes* bzw. *angemaltes* Objekt wird das Ziel dabei gewissermaßen selbst zum Bild und die Bildgebung zum tödlichen Akt. Den aus dem Himmel kommenden Strahl nennen Drohnenpiloten angeblich „Light of God".[11] Das evoziert das Phantasma einer allsehenden, allmächtigen Gewalt – und damit die Fiktion einer olympischen Macht, die ferngesteuerte Späh- und Waffensysteme idealiter verkörpern.

In dem oben zitierten Bericht warnt Yon vor den potenziellen Risiken beim Einsatz der Lasermarkierung.

„What can be said is that to crank up an IR laser in a relatively advanced country [...] risks identifying the lasing source even more than the target. The Libyans may use normal camera gear, or have cheap night vision gear that can be bought all over the world. They might just use smart phone cameras."[12]

Schon eine Kamera mit frei im Handel erhältlicher Nachtsichtoptik kann also die ungleichen Sichtverhältnisse vorübergehend *resymmetrieren*, die Umkehrung der Bildgebung wird dabei zum taktischen Manöver. Im grün durchfärbten Bild des Nachtsichtgeräts wird nicht nur das Ziel, sondern auch die Quelle der Markierung sichtbar und damit potenziell selbst zum *Target*.

1 Michael Yon: Painting the Target. In: Michael's Dispatches, http://www.michaelyon-online.com/painting-the-target.htm (Stand: 10/2015).
2 Matt J. Martin, Charles W. Sasser: Predator. The Remote-Control Air War over Iraq and Afghanistan. A Pilot's Story, Minneapolis 2010, S. 1, S. 31.
3 G. Kurt Piehler (Hg.): Encyclopedia of Military Science, New York 2013, S. 242.
4 Vgl. Martin, Sasser (s. Anm. 2), S. 43–44; Matthew Powers, Brandon Bryant: Confessions of a Drone Warrior, GQ Magazine, 2013, http://www.gq.com/story/drone-uav-pilot-assassination (Stand: 10/2015).
5 Man unterscheidet genauer zwischen „semi-active laser homing", bei der eine Bombe oder Geschoss mit einem entsprechenden Empfänger („Seeker" oder „Tracker") ausgestattet ist und der „beam-riding"-Variante, bei der das Geschoss direkt auf dem Strahl entlang gleitet. Vgl. Filippo Neri: Introduction to Electronic Defense Systems, Boston/London 2006, S. 257.
6 Vgl. Paul Virilio: Die Sehmaschine, Berlin 1989, S. 83–108; Paul Virilio, Hubertus von Amelunxen: Töten heißt, erst den Blick rüsten; ins Auge fassen. In: Fotogeschichte, Jg. 12, 1992, Heft 43, S. 91–98; Friedrich Kittler: Eine Kurzgeschichte des Scheinwerfers. In: Michael Wetzel, Herta Wolf (Hg.): Der Entzug der Bilder. Visuelle Realitäten, München 1994, S. 183–189.
7 Kenneth Macksey: The Penguin Encyclopedia of Weapons and Military Technology. Prehistory to the Present Day, London 1993, S. 192.
8 Paul G. Gillespie: Weapons of Choice. The Development of Precision Guided Munitions, Tuscaloosa 2006, S. 81f.
9 Gillespie (s. Anm. 8), S. 133.
10 Raytheon, Multi-Spectral Targeting System (MTS), http://www.raytheon.com/capabilities/products/mts/ (Stand: 02/2016).
11 So heißt es in einer viel beachteten Szene aus „5.000 Feet is the Best", einer Video-Arbeit des israelischen Künstlers Omer Fast. Ob es sich dabei um ein authentisches Zitat handelt, ist unklar. Die Gottes-Metapher scheint aber verbreitet, „[s]ometimes I felt like God hurling thunderbolts from afar", schreibt Matt J. Martin in seiner „Pilot's Story", vgl. Martin, Sasser (s. Anm. 2), S. 3; dazu auch Gregoire Chamayou: A Theory of the Drone, New York 2015, S. 36ff.
12 Yon (s. Anm. 1).

Spielbesprechung

Thomas Lilge

Das Alternate-Reality-Spiel *Ingress*

ColonelBroitzem schleicht durch eine kleine Gasse in Mapo-Gu, einem Ausgehviertel im Norden Seouls. Während die Vergnügungssuchenden feiern, bahnt sich der Agent auf der Rückseite der Bars und Clubs seinen Weg durch Stapel von Müllsäcken und dicht geparkte Autos. Sein Blick suchend und tastend im Zwielicht der untergehenden Sonne. Die Mauer, auf der sich das Objekt befinden muss, liegt bereits verschattet, aber irgendwo hier muss es sein! Aus einer dunklen Ecke beargwöhnen ihn zweifelhafte Gestalten – Agenten der Gegenseite? Dann hat er sein Ziel erreicht. Mit kalten Fingern installiert er rasch acht Resonatoren und beobachtet befriedigt, wie sich das Portal, das in der realen Welt aussieht wie ein harmloses Wandgraffiti, grün zu färben beginnt. Ein Blick auf den Scanner macht klar: In diesem Viertel ist noch viel zu tun, verdammt viele feindliche Portale in der näheren Umgebung. Schnell weiter.

ColonelBroitzem lautet mein Agentenname im Spiel *Ingress*, das 2013 von Niantic Lab, einem Google-Ableger veröffentlicht worden ist. *Ingress* ist ein *Alternate Reality Game*, ein Genre, bei dem die Grenzen zwischen realen Erlebnissen und erfundenen Szenarien von den Machern des Spiels, *Puppetmasters* genannt, gezielt verwischt werden. Versteckte Hinweise, sogenannte *Rabbitholes*, ziehen die Spielenden in das Spieleuniversum hinein; über Webseiten, Social Media, E-Mails und Messenger-Dienste werden Narrative publiziert, die die Spielergemeinde mit Hintergrundinformationen und Neuigkeiten versorgen. *Ingress* ist das bis dato erfolgreichste Spiel dieser Kategorie, eine Million Menschen engagieren sich jeden Tag, elf Millionen Mal wurde das Spiel insgesamt heruntergeladen.[1]

Sobald man das Spiel startet, erscheint der Startbildschirm, der den mit Google Maps Sozialisierten zugleich vertraut und fremd erscheint. ↗ **Abb. 1** Vertraut ist die perspektivisch geneigte Vogelperspektive auf ein Straßenmuster; der Ein-

1: Startbildschirm von *Ingress*.

druck von Fremdheit entsteht zunächst durch die fast grell anmutende Ästhetik. Die namenlosen Straßen sind in einem gedeckten Blau visualisiert, der Stadtraum zwischen den Straßen erscheint schwarz und bietet damit den leuchtendfarbigen Elementen des Spiels eine stark kontrastierende Bühne. Ebenso wie das Interface von Google Maps fordert auch diese Visualisierung zur Interaktion auf. Doch beim Versuch, mittels der *Pinch-to-Zoom*-Geste aus dem *Ingress*-Startscreen herauszuzoomen, erweist sich dies als unmöglich. Man kann zwar hineinzoomen, die maximale Sichtweite aber ist auf ca. 500 Meter begrenzt. Auch ein Verschieben des Kartenausschnitts ist unterbunden. Diese, im Vergleich zu Google Maps, eingeschränkten Handlungsoptionen auf der Interaktionsebene mit dem Bildschirm wirken sich unmittelbar auf das Selbstgefühl aus: Man fühlt sich geradezu eingesperrt. Die elementaren Leistungen von Karten, das Herstellen von Übersicht und Orientierung und damit das Ermöglichen von

2: Das 2014 realisierte Feld *Blue66*.

Planbarkeit zukünftiger Bewegung im Real-
raum, werden durch die genannten Funktions-
einschränkungen fast vollständig eliminiert und
zum Teil in ihr Gegenteil verkehrt: Hier bewegt
sich die Karte nur, wenn man sich selbst bewegt.
Zugleich entsteht dadurch etwas Neues, denn
diese Einschränkungen erweisen sich als in das
Interfacedesign implementierte Spielregeln mit
Aufforderungscharakter: „Wenn Du mitspielen
möchtest, musst Du Dich bewegen!"

Diese Handlungsanleitung wird durch
weitere visuelle Elemente verstärkt: Im unteren
Drittel des Kartenausschnitts kennzeichnet ein
grünes Dreieck den aktuellen Standort. Um
dieses Dreieck herum ist ein orangener Kreis
gezogen. Nur wenn Spielende sich den Spiel-
elementen soweit nähern, dass diese in seinen
Kreis geraten, können sie mit ihnen interagieren.
Sobald durch die Bewegung im Realraum ein
Portal im Kartenausschnitt erscheint, entsteht
zwischen dem Dreieck, dem Kreis und dem am
Kartenrand erscheinenden Portal eine Möglich-

keitsbeziehung, die zur Realisierung auffordert:
„Gehe noch 500 Meter und Du kannst mit die-
sem Portal interagieren und Spielfortschritt
erzeugen."

Diese Abhängigkeit der Interaktionsmög-
lichkeiten im Spiel vom realen Standort, kom-
biniert mit der Abhängigkeit von anderen Spie-
lerinnen und Spielern, die nicht sichtbar sind,
verstärkt das bereits durch die Visualisierungen
erzeugte Momentum, das zur Aktivität moti-
viert: Wann, wenn nicht jetzt? Wer, wenn nicht
ich? Auf der Webseite des Spiels wird hingegen
eine Übersichtskarte angeboten,[2] die Zoom-
Funktionalität bietet und den aktuellen globa-
len Spielstand anzeigt. Die Welt ist hier farbig
aufgeteilt in die Territorien der rivalisierenden
Fraktionen. Punktestände und im Sekundentakt
eintreffende Nachrichten aus aller Welt signali-
sieren: Der Kampf um die Besetzung von Ter-
ritorium ist in vollem Gang. Die Motivation zur
Bewegung im Realraum durch die Kombination
aus globaler Aktivitätsvisualisierung und territo-

rial begrenzter Möglichkeit der Spielteilnahme funktioniert: 127 Millionen Kilometer sollen die *Ingress*-Spieler im Jahr 2014 bereits zurückgelegt haben.[3]

ColonelBroitzem ist auf dem Weg zu seinem nächsten Einsatzgebiet: die Hongik University in Seoul. Die Portale sind schwierig zu finden. Ich muss aufpassen, nicht aufzufallen. Den zentralen Sportplatz überquere ich dreimal, das dritte Mal bleibe ich in der Mitte stehen, halte mein Handy vor mich, drehe mich im Kreis – und bekomme fast ein Frisbee an den Kopf. Hier prallen buchstäblich Welten aufeinander. Ich erobere im Bereich der Universität drei Portale und bin dann in der Lage, diese Portale zu verlinken. Das entstehende Dreieck ist ein sogenanntes Feld, seine Größe maßgeblich für den persönlichen, als auch für den Spielstand meiner Fraktion.

Unter dem Codenamen *Blue66* arbeiteten 2014 über 200 Agenten der Widerstand-Fraktion in einer international konzertierten Aktion mehrere Monate an einer streng geheimen Mission. Am 6. Juli war es soweit: Zwischen Deutschland, Griechenland und der Ukraine spannte sich ein riesiges Feld auf, 840 Millionen *Mind Units*, womit im Spieljargon Menschen bezeichnet werden, wurden unter die Kontrolle der Resistance gebracht, die realisierte Verbindung zwischen den Portalen betrug durchschnittlich 1.928 Kilometer. ↗ **Abb. 2**

Die Möglichkeit, einzelne Portale zu Feldern zu verbinden, erhöht die Komplexität des Gameplays und ist ein weiteres Element, dass den Spielenden über die App auf ihren mobilen Endgeräten, im Spiel *Scanner* genannt, zu Bewegungen im Realraum motivieren soll. Sobald ein Portal erobert wurde, besteht die Möglichkeit, eine Verbindung zu einem weiteren Portal herzustellen. Gelingt es schließlich, ein drittes Portal zu verbinden, entsteht ein Feld. Mit jedem dieser Schritte steigt das Gefühl von Verantwortung und Zuständigkeit für diese Portale an. Dies wird ästhetisch gestützt und verstärkt: Sobald ein Portal erobert wurde, nimmt es die Farbe der Fraktion der Eroberer an. Sobald zwei Portale verbunden wurden, wird dies durch fluoreszierende Lichtbögen zwischen diesen Portalen visualisiert. Wird schließlich ein Feld geschlossen und die Lichtbögen gleißen in einem das Stadtgebiet überspannenden Dreieck, so erfährt man deutlichen Besitzerstolz: Das vom Feld abgedeckte Territorium wird als Eigentum empfunden. Die Portale selbst wabern in Fraktionsfarben wie Fahnen in den Himmel und erzeugen den Eindruck von Vitalität und Produktivität, die Lichtbögen markieren als Energie gewordener Maschendrahtzaun das eigene Grundstück, sie signalisieren aber auch Verletzlichkeit. Die eigene Schöpfung bezaubert den Eroberer um den Preis permanenter Bedrohung durch Angriffe der feindlichen Fraktion.

Die auf dem Bildschirm pulsierenden Portale und Links dramatisieren den gewohnten Stadtraum, das Smartphone wird mit zunehmender Spieldauer immer stärker zu einem Instrument, das Einsichten in eine andere Welt ermöglicht. Das Nahe und Gewohnte ist nicht das, was es scheint: Es gibt eine andere Welt am gleichen Ort. Das Handy funktioniert somit als eine Art *Engyskop*,[4] denn es macht das Nahe sichtbar, es ermöglicht ein anderes Schauen, der Blick wird mit einer neuen semantischen Funktion ausgestattet: Hinter der gewohnten Oberfläche verbirgt sich eine alternative und alarmierende Schicht. Durch dieses Engyskop erblicken Agentinnen und Agenten wabernde Links, Portale und Felder, die in ihrer Kombination eine Atmosphäre unruhiger Dringlichkeit errichten. Dieser mit Entscheidungsoptionen aufgeladene Handlungsraum formuliert durch die derart zentrierte Kartenausrichtung einen deutlichen Imperativ: „Tu etwas! Erobere Portale!"

Bei einer beeindruckend großen Anzahl von Menschen funktionieren die hier skizzierten Spielmechaniken: Hunderttausende investieren tagtäglich erhebliche Mengen Energie, um innerhalb der Spielökonomie von *Ingress* Punkte zu sammeln und den Aufstieg zum nächsten Level zu bewältigen. Sie wandern lange Strecken durch den Realraum, sie kollaborieren international, eignen sich komplexes Wissen an und schreiben Anleitungen, Blogs und Wikis. Haben wir es hier mit einer gigan-

tischen, als Spiel getarnten Datensammelaktion von Google zu tun? Ist es nicht angesichts der tatsächlichen Herausforderungen unserer Zeit unangemessen, seine Fähigkeiten innerhalb eines artifiziellen Ökosystems zu verschwenden? Aus der Perspektive von gesellschaftskritischen Spielenden und Spieleentwicklern ist aber die Frage am interessantesten, was man vom Erfolg dieser und vieler anderer Spiele lernen kann. Wie müsste ein Interface und ein Spielsystem aussehen, das ähnliche Motivationskräfte freisetzt für die Lösung des Flüchtlingsproblems in Europa, für die Bekämpfung von Korruption in Entwicklungs- und Schwellenländern oder für den Kampf gegen die globale Erwärmung?

1 http://mic.com/articles/119366/one-million-people-around-you-are-playing-an-alternate-reality-game-you-can-t-see#.hcuoAAdei (Stand: 11/2015).

2 https://www.ingress.com/intel (Stand: 03/2016).

3 http://www.androidauthority.com/ingress-releases-year-two-stats-awesome-infographic-568090/ (Stand: 03/2016).

4 „Engýs" entspricht im Altgriechischen „nahe", siehe https://de.glosbe.com/de/grc/nahe (Stand: 08/2015)

Bildnachweis

Titelbild: Niggel Roddis: Royal Air Force Opens the Control Center for Unmanned Aircraft Systems. Getty Images, 2014.

Ammon: 1a: Computer Aided Medical Procedures (CAMP), Technische Universität München. **1b:** © 2012 IEEE. Reprinted, with permission, from: N. Navab, T. Blum, L. Wang, A. Okur, T. Wendler: First Deployments of Augmented Reality in Operating Rooms. In: IEEE Computer, Bd. 45, Heft 7, S. 4855. **2:** Sir Herbert Austin, Entwurfsskizze des Austin Seven, 1920er. BL Heritage Ltd, Studley, Warwickshire. In: Ken Baynes, Francis Pugh, The art of the engineer, Guildford 1981, S. 15. **3:** © British Motor Industry Heritage Trust. **4:** Courtesy of Culture Coventry. **5a-e:** Foto: Henner Behre, marcel-breuer-schule. **6:** © Gramazio Kohler Research, ETH Zürich. **7:** „sARc – Spatial Augmented Reality for Architecture" Bauhaus Universität Weimar, Univ. Prof. Dr.-Ing. habil. Oliver Bimber, www.jku.at/cg; Univ. Prof. Dr.-Ing. Frank Petzold, www.ai.ar.tum.de. **8:** Courtesy of College of Business, UIUC.

Hoel: 1: St. Olavs Hospital – Operating Room of the Future (FOR). **2a-d:** Charité – Universitätsmedizin Berlin, Thomas Picht. **3–5:** SINTEF – Department of Medical Technology, Frank Lindseth.

Kapur: 1: C. M. Tempany, J. Jayender, T. Kapur, R. Bueno, A. Golby, N. Agar, F. A. Jolesz: Multimodal imaging for improved diagnosis and treatment of cancers. In: Cancer, 121, 2015 Heft 6, S. 817–27. **2:** K. D'Andrea, J. Dreyer, D. K. Fahim: Utility of Preoperative Magnetic Resonance Imaging Coregistered with Intraoperative Computed Tomographic Scan for the Resection of Complex Tumors of the Spine. In: World Neurosurg., 84, 2015, Heft 6, S. 1804–1815. **3:** N. Y. Agar, A. J. Golby, K. L. Ligon, I. Norton, V. Mohan, J. M. Wiseman, A. Tannenbaum, F. A. Jolesz: Development of Stereotactic mass spectrometry for brain tumor surgery. In: Neurosurgery, 68, 2011, Heft 2, S. 280–289. **4:** D. L. Schwartz, A. S. Garden, J. Thomas, Y. Chen, Y. Zhang, J. Lewin, M. S. Chambers, L. Dong: Adaptive radiotherapy for head-and-neck cancer. Initial clinical outcomes from a prospective trial. In: Int J Radiat Oncol Biol Phys, 83, 2012, Heft 3, S. 986–993.

Vertesi: 1: NASA, JPL-Caltech, Cornell University.

Mentis: 1–4: Helena Mentis.

Lammer: 1+9: Christina Lammer: Herzensangelegenheiten, Standbild, Super 8, Farbe, 2015. **2, 5–8:** Christina Lammer: Operationsfilm Bauchaortenaneurysma, Standbild, HD, 2015. **3:** Christina Lammer: Patientin, Aktzeichnung, Graphit, 2015. **4:** Christina Lammer, Johannes Lammer: Bauchaortenaneurysma, Bleistiftzeichnung, 2011.

Väliaho: 1: Holzschnitt von Robert Hooke: Philosophical Experiments and Observations, London 1726. **2:** Johann Zahn: Oculus artificialis sive Telescopicum, London 1685, Abb. XXI. **3:** Robert Hooke: Micrographia: Or Some Physiological Descriptions of Minute Bodies Made by Magnifying Glasses with Observations and Inquiries thereupon, London 1665, Platte 34.

Gregory: 1: United States Air Force, Photograph, Tech. Sgt Kevin J. Gruenwald **2:** United States Air Force, Photograph, Tech. Sgt Demetrius Lester.

Whitfield: 1: Kurt Beck, H. J. Schaefer: Color Atlas of Laparoscopy, New York/Stuttgart 1970, S. 13. **2:** James D. Brubaker, Paul H. Holinger: The Larynx, Bronchi and Esophagus in Kodachrome. In: The Journal of the Biological Photographic Association, 10, 1941, Heft 2, S. 1–41, S. 90. **3:** Kurt Beck, H. J. Schaefer: Color Atlas of Laparoscopy, New York/Stuttgart 1970, S. 11. **4:** Kurt Beck, H. J. Schaefer: Color Atlas of Laparoscopy, New York/Stuttgart 1970, S. 45.

Franz: 1: Michael Yon: Aircraft painting helicopter landing zone in Kandahar Province, 2011.

Lilge: 1: Thomas Lilge **2:** https://plus.google.com/103805943542403432692/posts/Wi9oXNadm3g (Stand: 12/2015).

Bildtableau I: 1: Ulrich Stadler: Der technisierte Blick, Würzburg 2003, S. 294. **2:** © Ivan Sutherland. **3:** © army.mil. **4:** Foto: Google. **5:** Foto: Barend Havenga. **6:** © Fraunhofer MEVIS. **7:** © Rockwell Collins. **8:** Courtesy of General Atomics Aeronautical Systems, Inc. All Rights Reserved. **9:** National Archives and Records Administration. **10:** Hugo Gernsback: Television News, March-April 1931, S. 11. **11:** © Eames Office LLC. **12:** Mit freundlicher Genehmigung von Dr. Arun Prasad, Apollo Hospital, Neu-Delhi, Indien, www.surgerytimes.com. **13:** Vertov-Sammlung, Österreichisches Filmmuseum, Wien. **14:** Courtesy of NASA/Ames/Wade Sisler 1989. **15:** © Rimini Protokoll, Fotografin: Pigi Psimenou. **16:** Archiv Zamp Kelp. **17:** © Alfons Schilling, courtesy of Nachlass Alfons Schilling, Wien. **18:** Wonder Stories. **19:** Courtesy of Jason Leigh, Electronic Visualization Laboratory, University of Illinois, Chicago. **20:** © Shmulik Blum – Undersea Hunter Group. **21:** © MEGA Museum of Electronic Games & Art. **22:** ImmersiveTouch. **23:** Bernardo Fuller, Public Domain, https://commons.wikimedia.org/wiki/File:Fort_Belvoir_Community_Hospital_astounds_with_groundbreaking_technology_and_devotion_to_patient_care_120530-A-AJ780-009.jpg (Stand: 03/2016). **24:** © User: Minecraftpsyco, CC-BY-SA-4.0, https://commons.wikimedia.org/wiki/File:Sensorama-morton-heilig-virtual-reality-headset.jpg (Stand: 03/2016). **25:** ImmersiveTouch.

Bildtableau II: 1: Courtesy of National Center for Supercomputing Applications, University of Illinois, Urbana-Champaign. **2:** © Vicon Motion Systems Ltd. **3:** © Koninklijke Philips N.V. **4:** Chris Harrison, Carnegie Mellon University, USA. **5:** © User: culturevis, CC BY-NC-SA 2.0, https://www.flickr.com/photos/culturevis/9222091721/sizes/l/ (Stand: 03/2016). **6:** © IRCAD Augmented Reality System 2015. **7:** Mit freundlicher Genehmigung von Max Hoffmann, Institutscluster IMA/ZLW & IfU der RWTH Aachen. **8:** Plain Dealer file photo (Cleveland, OH) © 2016. **9:** © 2010 IEEE. Reprinted with permission from S.H. Rizzi, C.J. Luciano, P.P. Banerjee: Haptic Interaction with Volumetric Datasets Using Surface-based Haptic Libraries, in: Proceedings of the Haptics Symposium 2010, Waltham/MA, S. 243–250, Abb. 4. **10:** © Nazim Haouchine. **11:** © Kleindiek Nanotechnik GmbH. **12:** © User: Beademung, https://commons.wikimedia.org/wiki/File:R%C3%BCckfahrkamera.JPG (Stand: 03/2016). **13:** A.N. Bogatchev, S.V. Fedoseev, V.N. Kashirin et al.: Special Mobile Robot STR-1 for Liquidation of the Accident Consequences at the Chernobyl Nuclear Power Plant. In: FSR2001. Proceedings of the 3rd International Conference on Field and Service Robotics, June 11-13, 2001, Helsinki 2001, Abb. 7. **14:** Joe Hendricks, Public Domain, https://commons.wikimedia.org/wiki/File:AirTrafficControlUSSWashington.jpg (Stand: 03/2016). **15:** © peostri.mil. **16:** Anne Braun: Historische Zielscheiben, Leipzig 1981, S. 15, Abb. 4. **17:** MGM/Warner Bros. **18:** © IWM (CH 11887). **19:** Bundesarchiv, N 1275 Bild-204, Fotograf: unbekannt. **20:** Science and Invention Magazine, Cover 02/1925. **21:** © Harun Farocki Filmproduktion, Berlin.

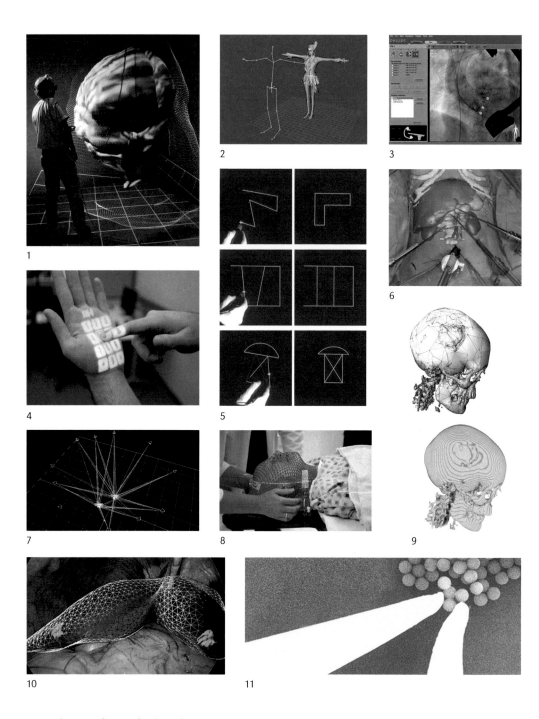

1: Visualisierung des Projekts CAVE (Cave Automatic Virtual Environment), 1992. **2:** Vicon Motion Systems: Motion Capturing Software Pegasus, Kalibrierungsposition. **3:** Philips: HeartNavigator, Überlagerung einer Echtzeit-Röntgenaufnahme mit CT-gestützter Planung (farbig). **4:** Microsoft OmniTouch: Projektion einer Benutzeroberfläche auf eine Hand, 2011. **5:** Ivan Sutherland: The Sketchpad's Use of Constraints, 1963. **6:** Das Augmented-Reality-System des Krebsforschungs-Instituts IRCAD während einer Operation, 2015. **7:** OptiTrack Tracking Tools, Software für das omnidirektionale VR-Laufband Omnideck 6, Still. **8:** Tracy Boulian: Positionierung einer thermisch-plastischen Maske zur Tumorbehandlung mit Gamma-Knife-Radiochirurgie. **9:** Oberflächen- und Volumen-Rendering eines Schädels, Studie zur Verbesserung von 3D-Simulationen, 2010. **10:** Nazim Haouchine: simulierte Gewebeüberlagerung, INRIA, Institut für angewandte Mathematik.

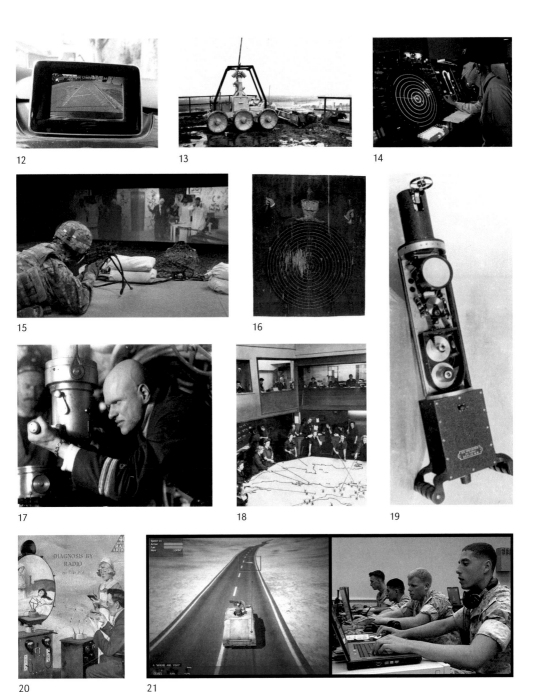

11: Kleindiek Nanotechnik: Nanomanipulation, Gripping microspheres, 2006. **12:** Rückfahrmonitor mit Hilfslinien, Mercedes-Benz, 2015. **13:** Ferngesteuerter STR-1-Rover bei Aufräumarbeiten auf dem Dach des Kernkraftwerks Tschernobyl, 1986. **14:** Radarbildschirm im Air Traffic Control Center, USS George Washington, 1996. **15:** Engagement Skill Trainer (EST), Cubic Corporation. **16:** Niederländische Zielscheibe, Öl auf Holz, Museum Arnhem, Anfang 19. Jahrhundert. **17:** Andrews Engelmann als U-Boot-Kommandant an einem Periskop im Film „Mare Nostrum", Still, 1926. **18:** Goodchild A (F/O): Operations Room at Royal Air Force Fighter Command, Rudloe Manor, Wiltshire, 1943. **19:** Maschinengewehrkamera von Oskar Messter, Zielübungsgerät für den Luftkampf, geöffnet, ca. 1917/18. **20:** Hugo Gernsback: Diagnosis by Radio, 1925, Detail. **21:** Harun Farocki: Ernste Spiele I: Watson ist hin, Videostill, 2010.

Autorinnen und Autoren

Dr. Sabine Ammon
EU-Forscherin (Marie Skłodowska-Curie Fellow), Forschungsprojekt „Epistemology of Designing –
The Example of Architecture", Institut für Architektur, Technische Universität Berlin und Institut für
Philosophie, Technische Universität Darmstadt

Nina Franz
Institut für Kulturwissenschaft und DFG-Exzellenzcluster Bild Wissen Gestaltung, Humboldt-
Universität zu Berlin

Kathrin Friedrich
DFG-Exzellenzcluster Bild Wissen Gestaltung, Humboldt-Universität zu Berlin

Prof. Dr. Derek Gregory
Peter Wall Distinguished Professor, Department of Geography, University of British Columbia,
Vancouver

Prof. Dr. Aud Sissel Hoel
EU-Forscherin (Marie Skłodowska-Curie Fellow), Forschungsprojekt „Styles of Objectivity. Agency,
Alignment and Automation in Image-Guided Surgery", Institut für Kulturwissenschaft, Humboldt-
Universität zu Berlin und Norwegian University of Science and Technology, Trondheim

Dr. Tina Kapur
Leiterin des Programms für bildgeführte Therapie, Department of Radiology, Brigham and Women's
Hospital/Harvard Medical School, Boston, Massachusetts

Dr. Christina Lammer
Leiterin des künstlerischen Forschungsprojekts „Chirurgische Gesten/Performing Surgery", Akademie
für bildende Künste Wien

Thomas Lilge
Koordinator des gamelab.berlin, DFG-Exzellenzcluster Bild Wissen Gestaltung, Humboldt-Universität
zu Berlin

Dr. Helena Mentis
Leiterin des Bodies in Motion Lab, Department of Information Systems, University of Maryland,
Baltimore County

Moritz Queisner
DFG-Exzellenzcluster Bild Wissen Gestaltung, Humboldt-Universität zu Berlin

Anna Roethe
DFG-Exzellenzcluster Bild Wissen Gestaltung, Humboldt-Universität zu Berlin

Dr. Pasi Väliaho
Reader in Film and Screen Studies, Department for Media and Communications, Goldsmiths,
University of London

Dr. Janet Vertesi
Assistant Professor, Department of Sociology, Princeton University

Dr. Nicholas Whitfield
Forschungsprojekt „Disrupting Surgical Practice: The Rise of Minimally Invasive Surgery, 1980–2000",
Department of Social Studies of Medicine, McGill University, Montreal